# FANTASY ART MASTERS

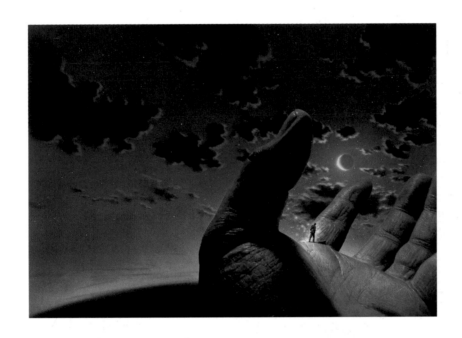

WATSON-GUPTILL PUBLICATIONS/NEW YORK

# FANTASY ART

**The BEST in Fantasy and SF Art Worldwide**

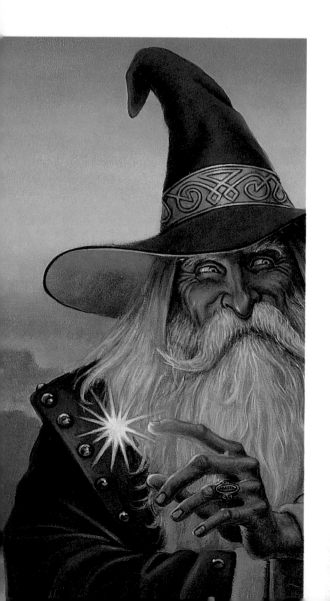
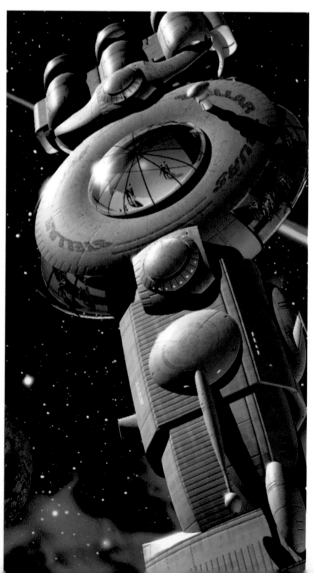

# MASTERS

## DICK JUDE

First published in 1999 by
Voyager, an imprint of
HarperCollins *Publishers*
77-85 Fulham Palace Road
Hammersmith, London W6 8JB

First published in the United States in 1999 by Watson-Guptill Publications,
a division of BPI Communications, Inc. 1515 Broadway, New York, NY 10036

**Library of Congress Catalog Card Number: 99-63580**

*Editor:* Diana Vowles
*Designer:* Anthony Cohen

ISBN 0-8230-1636-6

Set in Monotype Perpetua and Gill Sans
Color origination by Colourscan, Singapore
Printed and bound in Italy by Rotolito Lombarda SpA

First printing, 1999
1 2 3 4 5 6 7 8 9 / 07 06 05 04 03 02 01 00 99

Page 1: Chris Moore, *The Cosmic Puppets*

Page 2: Don Maitz, *Grand Avatar* (detail), Fred Gambino, *Pulsar* (detail), Dave McKean, *A Part, And Yet Apart* (detail)

Page 3: Chris Moore, *Now Wait for Last Year* (detail), Rick Berry, *Red Prophet: Animal Man #84* (detail), Brom, *Peace* (detail)

Page 4: Don Maitz, *Dragons on the Sea of Night*, pencil sketches

Page 5: Dave McKean, *Obsolete* (detail)

Page 6: Alan Lee, *The Sword in the Stone*

Page 7: Fred Gambino, *Nightwings*

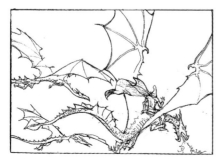
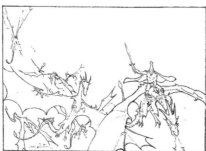
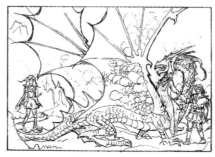
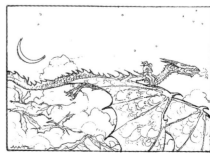

## DEDICATION
To Alison, Rhiannon and Felix, who certainly deserve this dedication as the book was written in time normally reserved for them.

## ACKNOWLEDGEMENTS
To each of the artists for their unlimited generosity of time, co-operation and support.

To Cathy Gosling not only for offering me the project but for then having the patience to let me stumble through it.

To Caroline Churton who deftly caught the pass from Cathy.

To Jane Johnson who first suggested my name as the possible author of the book.

To Alison Eldred for her extra special help.

To Diana Vowles for being so thorough with the words and to Anthony Cohen for his flair with the design.

Thanks also to the J. R. R. Tolkien Estate Limited for permission to reproduce paintings based on *The Lord of the Rings*.

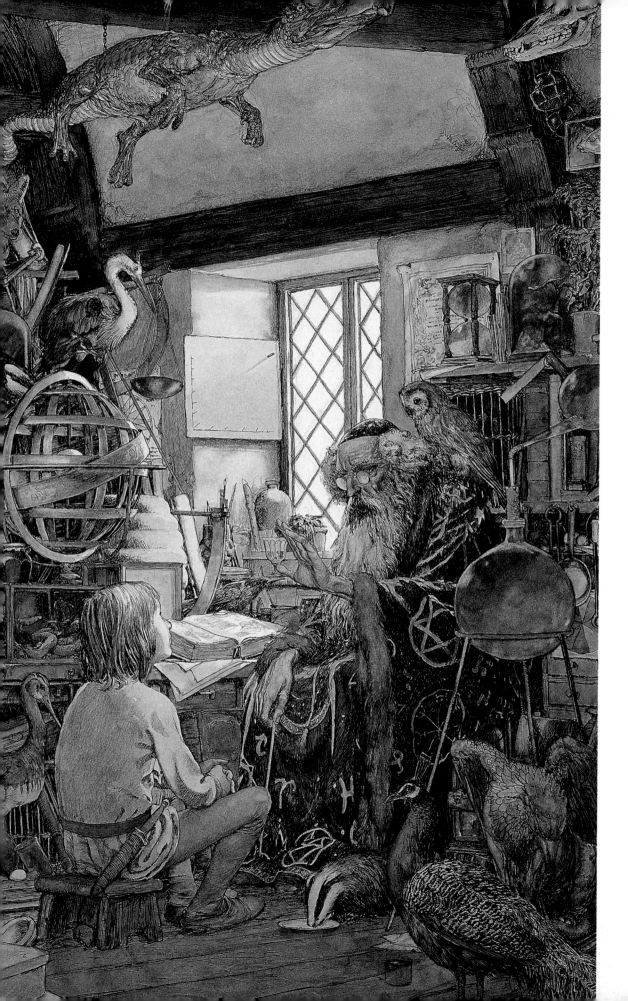

# FANTASY
# CO

# ART MASTERS

# NTENTS

# Introduction

The history of fantastic illustration can be said to find its origins in mainstream art. Artists such as Leonardo da Vinci and Hieronymus Bosch produced work of such imaginative strength that they can surely be described as the earliest of fantastic illustrators, while echoes of Gustave Doré's engravings of Milton's *Paradise Lost* and Dante's *Divine Comedy* can be found in many examples of line drawings printed in the pulp magazines of the 1930s and 1940s. As the genre developed further, both Surrealism and Pop Art became frequent touchstones as the sophistication of the editors and buying public grew to allow experimentation with less graphic images. Both schools of art contained modern icons already appropriated by the authors – images of smeared reality sufficiently ambiguous and alien to be the most fitting jacket illustration for the genre.

Regardless of this lofty pedigree, science fiction and fantasy art was initially mired in the limited medium of black and white line illustrations and garishly colored paintings which, for many years, often illustrated the more prurient aspects of the developing genre. It would be very hard to find current examples of robots raping the voluptuous daughters of their creators; not only have sexual politics developed considerably since then but the buying public would certainly associate such images with genres now quite divorced from the type of fantasy dealt with by science fiction. The vivid and unsophisticated nature of the early illustrations is unsurprising given the era in which these were produced, the lack of real science information available to the general reading public, the obvious desire for editors to sell as many copies as possible and the abominable quality of the paper used in the covers and interior pages. Yet, to many people, these pictures still have a nostalgic charm.

## FROM PULP TO PIXELS

In general terms, if the package had a rocket on the cover then the text within was usually science fiction. A mythical beast, frequently a dragon or unicorn, meant fantasy. The often obligatory scantily clad woman suggested cheap thrills in either genre, an exotic promise often not delivered by the story. Illustrators of the calibre of Virgil Finlay, although still forced to draw titillating homages to the Frankenstein myth, produced exceptional work even by today's standards. This lowbrow, if sometimes technically excellent, work laid the foundations for a tradition that would last 30 years and would only be finally broken by the general exposure of the buying public to hard science facts broadcast as a result of the space race.

Traces of this tradition can still be found in many female-and-spaceship covers that continue to appear frequently within the genre, particularly on American publications. Nowadays, however, the character featured in the jacket illustration often does appear in the story within, although certain art directors still seem to feel that accentuating or even shamelessly exaggerating the physical charms of the novel's female lead character will increase the potential sales.

Along with the evolution of fantastic illustration came new media. Acrylics and airbrushing have almost completely replaced oils and watercolors and have certainly sidelined the paintbrush as the main tool in the field of fantastic illustration. With acrylic paint the artist can use most of the techniques of oils, but acrylics dry faster and so enable equally vivid paintings to be produced in a small fraction of the time; airbrushing allows techniques detailed and convincing enough to satisfy a generation who have been brought up on movies and have increasingly come to accept the hyper-real as commonplace.

Even with these advances in the field of graphic visuals, with the cascade of information showered from orbital technology came images far more convincing and fantastic than the most sensitive fantasy illustration. Computers made possible the unimaginable calculations involved in lifting millions of tons of precision engineering into geosynchronous orbit, for manned visits to the moon and robot trips to the inner planets. They enhanced the images beamed from each of these trips, afforded spectral analysis of distant moons and galaxies and, most important of all, allowed the rest of earth-bound humanity to share in truly cosmic visuals that are now fixed in the racial conscious forever. Just as they have enhanced the scientists' ability to determine the nature of the "big out there," computers have

**Fred Gambino, *Recoil*, Virgin Interactive Games, 1998 Digitally created**

**Opposite: Jim Burns, *Muscle Ship of the Lalandian Hegemony Precision De-warps Over Blood Lake, Faraway, Deneb System*, unpublished, 1989 Acrylics on board, 76 × 61 cm (30 × 24 in)**

augmented the artists' range of techniques in producing images inspiring enough to keep pace with the genuine glories of the universe.

## FROM SYLVAN GLADES TO CYBER ENVIRONMENTS

In this book, 10 of the leading exponents of the truly fantastic art that now represents the genre describe their inspirations, frustrations and joys, their techniques and their working methods. Some of the brightest talents in the business discuss the traditional methods of image rendering – brush, airbrush, paint and photography – as well as the future of illustrative techniques, the fusing of all the above and the growing potential of computer graphics and digital art.

Many of the artists here, although adept in the field of painting, now regularly produce work with the aid of the computer. They hold the tradition of the brush in one hand and the potential of the pixel at the fingertips of the other. During the 20th century humankind consumed forests of wood pulp on books for recreational purposes; now we are looking toward a near future where whole movies will be created by the imaginations of artists like these, animated digital art in its entirety, with no contribution by actors, save possibly the voice-overs. If demand for books shrinks in this brave new wired world and with it the demand for book jacket illustration, the talents of these illustrators will be reapplied in visualizing computer graphics in the fantastic environments of virtual reality and the computer game.

The first section of this book, Hairy Sticks and Pigments, deals with artists who create their work entirely in the time-honored tradition with paint, ink

**John Howe, *Gate of Ivory* by Robert Holdstock, Voyager, 1998**
**Watercolor and inks on paper,**
**55 × 85 cm (21 1/2 × 33 1/2 in)**

10

and paper. Their landscapes of faeries, pirates, trolls, elves, Amazons, demons and heroes are discussed by four of the very best artists now working: Alan Lee, Don Maitz, John Howe and Brom.

The middle section, Paintbrush to Pixel, concentrates on those artists who have begun to add computer programs to their range of tools without abandoning traditional painting techniques; they simply employ whichever approach is most appropriate for the job at hand. Here Jim Burns, Rick Berry and Chris Moore demonstrate the best of the old combined with the shock of the new.

The closing section, entitled The Digital Realm, features three artists who have more or less left the painting aspect of their professional lives behind and now work almost exclusively with digitally manipulated imagery. This is not to say that they never paint – indeed, within their digital images one can find many examples of high painterly skill and technique – it just means that their art is all assembled and processed in a computer. Steve Stone, Fred Gambino and Dave McKean explain the freedom and speed of computer art, once the mysteries of wire frames, rendering and sketching have been unravelled.

There is no longer a need for pencilled thumbnail sketches and color roughs to be couriered to anxious publishers. Now, with a bit of compression, massive image files can be sent from the artist's computer straight down the telephone line and into the computer of the waiting art director for approval. Should the demand come for a radical change it is no longer a case of "back to the drawing board" to start from scratch, since a few judicious taps on the keyboard can recolor or reposition whole elements of the composition.

Of course the trade-off for this new convenience is that there is no longer an original piece of work to sell on to a collector after the client has used the piece to sell whatever it was commissioned for. How will the term "original" be defined in the new millennium? By owning the only print run off before the "delete" button wipes the file? Or by owning the disc on which the image data are held? If the latter, how does the artist guarantee that numerous copies cannot be run off and sold, and how does the art collector know that the artist hasn't already backed up the file that has just been purchased as original?

## THE BEST IN THE FIELD

*Fantasy Art of the New Millennium* offers a complete range of the different styles, techniques and choices of subject matter available to the viewer within the ever-expanding realm of fantasy art. This anthology of the brightest and

**Dave McKean,** *Tribute to Emerson, Lake and Palmer,* **Magna Carta Records, 1998 Photography and digital**

best in the field is dramatic evidence of the limitless potential for new techniques made possible by technology that advances almost hourly. It is also proof that fantastic illustration has moved far from its initial roots within the ghetto culture of pulp fiction and out into the daylight of everyday life on posters, television and CD covers.

Finally, attention should be drawn to a comment made by each of the artists within: regardless of what tools are used to produce the image it is only through the traditional approach of observation, dedication to hard work and practice that anyone can develop the ability to convincingly render visions of wonder and magic. Without this foundation the most expensive computer, camera, airbrush and pigment remain just flashy tools and will accomplish nothing.

# HAIRY STICKS
# AND PIGMENTS

This section features artists who work entirely with traditional media. The highly accomplished watercolor artist Alan Lee allows us into his worlds of myth; the celebrated American artist Don Maitz discusses his classical approach to fantastic illustration and his innovative uses for a toilet seat; John Howe explores the leafy glades and dark caverns of myth and magic; and the section closes with an insight into the mind and techniques of the acclaimed American dark fantasy artist Brom.

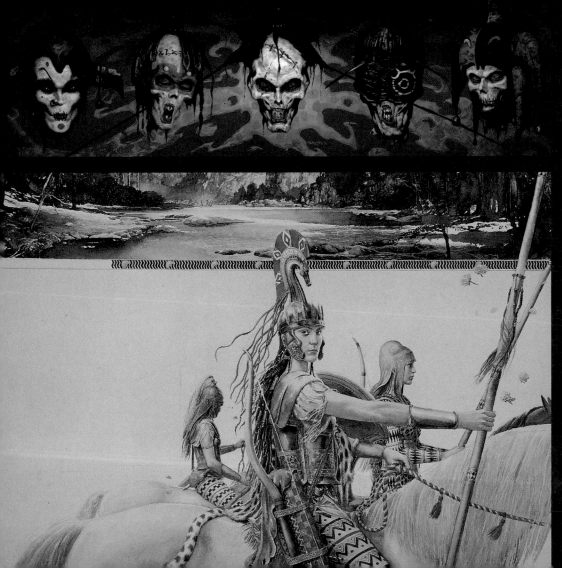

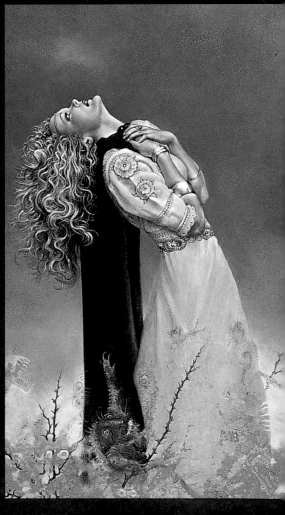

Opposite: John Howe, *Celtic Myth* (detail); Top left: Brom, *Silent Quintet*; Bottom left: Alan Lee, *Amazons*; Above: Don Maitz, *Mort Gant Gold* (detail)

# Alan Lee

*"I work in watercolor with as little underdrawing as I can get away with. I like the unpredictability of a medium which is affected as much by humidity and gravity as by whatever I wish to do with it."*

Although the housing estate on which Alan Lee grew up had displaced cows and fields, it was not far from the edge of the green belt. An interesting bit of no-man's-land known as Little Britain wedged between suburb and farmland, it was an area of canals, rivers, gravel pits, gypsy encampments and concrete ruins left over from the war, dotted with thickets of woodland and scrub. This playground, also popular with lightly armed gangs of lads from surrounding villages, mad dogs and courting couples, had a lasting effect upon the young Alan's imagination and when he started to read Tolkien and other tales of quest and romance it provided the raw material for his visualizations.

"The first books I remember reading were fairy stories, and visits to the local library soon became focused on the myths and legends section – but my fate was really sealed when I was allowed to stay up late one night to watch Alexander Korda's wonderful fantasy film *The Thief of Baghdad*. As a child I built castles from earth, stone or cardboard, creating stories with plastic knights and imaginary monsters. However, I soon discovered that it was just as satisfying to play out these dramas and romances with pencil and paper and when I found that one piece of paper was not enough for all the convolutions of a story my drawings started to take the form of comic strips."

## THE LEARNING CURVE

"I first conceived the idea of becoming a book illustrator when I was 15, but when I started college the following year I found that art was a more serious pursuit than I had previously realized – hard-edged abstraction was the current orthodoxy – and drawing for pleasure became something I did in my spare time. On the first day of art school I was told to unlearn everything I thought I'd learnt. I should have said 'I haven't learnt anything yet,' but I didn't know that at the time.

"Although my love of drawing never left me, it wasn't until I'd stumbled from that foundation course,

"These doodles are probably the product of an undisciplined mind, but they have the effect of loosening my drawing hand and stirring my imagination. They are also an involuntary response to having a pencil in my hand and a surface within reach."

dazed and confused, and spent 18 months alternating between working for a printing company and attending to a graveyard, balanced by periods of pure idleness, that I signed up for a graphic design course. There, as long as I fulfilled the occasional brief, I was allowed to spend as much time as I liked illustrating Irish myths and other more congenial fare and I rediscovered my desire to be an illustrator. During my hiatus from learning I'd also discovered Tolkien, which sent me

## BIOGRAPHY

❖ Born in 1947 in Harrow, Middlesex, Alan Lee studied graphic design at Ealing School of Art in London from 1966 to 1969. During this time he concentrated upon the depiction of Celtic and Norse myths, and a preoccupation with myths and legends has stayed with him throughout his career.

❖ Alan left London in 1975 to move to the more inspirational environment of Dartmoor, in Devon, where he concentrated on book illustration and long-term projects rather than the one-off commissions that had been his career to date.

❖ His reputation was established with *Faeries*, a volume of fairy lore produced in collaboration with Brian Froud and published in 1979. He then devoted time to his long-cherished ambition to illustrate *The Mabinogion*, the important collection of medieval Welsh legends published by Dragon's Dream in 1982.

❖ Since then Alan has worked with many contemporary specialists in fantasy, including Joan Aiken, Peter Dickinson and Rosemary Sutcliff. He has also contributed designs for several media projects, including Ridley Scott's *Legend* (1983), Terry Jones's *Eric the Viking* (1989) and a TV movie, *Merlin* (1997).

❖ The 50 watercolor illustrations that he produced for the centenary edition of *The Lord of the Rings* possibly mark his crowning achievement to date. He also spent a large part of a year in New Zealand working on designs for the Peter Jackson films based on that trilogy.

❖ Alan received the Best Artist Award in the World Fantasy Awards of 1998, announced at the 24th World Fantasy Convention in Monterey, California.

**_Fairy Rings_, from _Faeries_ by Brian Froud and Alan Lee, Bantam, 1979 Watercolor on paper, 32 × 25 cm (12¹/₂ × 9³/₄ in)**

A poor mortal wanders into a fairy ring and is caught up in a dance in which several years pass in a single night. The stretched faerie folk and their grotesque companions are finally placed as subjects in a painting rather than left as obsessive doodles in the borders that accompany so many Alan Lee pieces. Hints of many of Alan's influences are strong in this piece, as are those of his colleague on this project, Brian Froud.

15

Doodles (above) are the release of creative energy, while a sketch (right) is effectively the scaffolding of a successful watercolor.

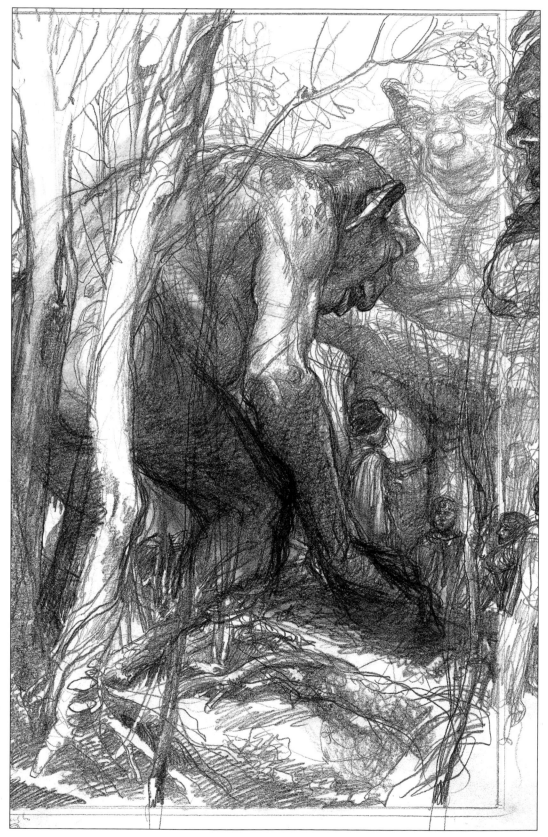

back to the myths and folklore books I'd devoured as a child and to wonderful new names such as Aubrey Beardsley, Edmund Dulac and Arthur Rackham. From then on my path was set.

"I left Ealing School of Art in 1969 with a portfolio consisting of illustrations of Irish legends and other equally uncommercial samples of my work. After a short period working as a park keeper, I started visiting publishers and agents. They usually responded by showing me samples of the kind of work they liked to publish and asking if I could do something similar. However, a few art directors responded positively and one, David Larkin of Panther Books, offered me five paperback covers. This first commission for a series of excellent, very 1960s, comic novels by Colin Spencer was well received and I was able, with a set of shiny proofs in hand, to return to the agency which had been most direct in its dismissal of me on my first visit, reasoning that if they did take me on they would be likely to promote my work with equal determination. Not only did they take me on, I also rented space from

them and for the next four years I worked in a studio in Soho alongside a group of very experienced and brilliant illustrators, picking up work they were too busy or expensive to take on, as well as tips about techniques and table manners.

"I did many bad paperback covers and magazine illustrations before I realized that my work went better if I wasn't trying to produce what I thought was expected – highly realistic work in acrylics – so I settled back into watercolor, the medium I had always loved best. I also decided to abandon the strange practice I had adopted of hiring models and spending an unhappy hour or two maneuvering them into awkward poses for photographs, followed by an equally miserable hour in the darkroom producing a little gray print, the faint image of which I would then trace off with the aid of a Grant projector. I went through this laborious process dozens of times without producing anything I was even mildly pleased with before going back to making it all up.

"A couple of years into my career I went back to art school for a morning a week to take anatomy classes, which gave a boost to my abilities to make figures look a little less like dummies. It was probably the most useful educational experience I'd had."

## DOODLES IN THE MARGINS

"I had always drawn. The margins of my schoolbooks were disfigured with doodles, and later I filled sketchbook after sketchbook with mindless streams of contorted figures and creatures which formed a more interesting accompaniment to whatever I should have been applying myself to at the time – the most dull working drawings for the most boring illustrations were always framed by a chaotic record of the energy they should have contained.

"It soon became established that any work with a 20th-century or futuristic setting would be better handled by those who could manage their cameras and acrylics. The few science fiction covers that I did had a quaintly Victorian look – which was fine for H.G. Wells but not for Arthur C. Clarke – so I found myself specializing in the 19th century or earlier. Fortunately this included many of the great classics of literature and

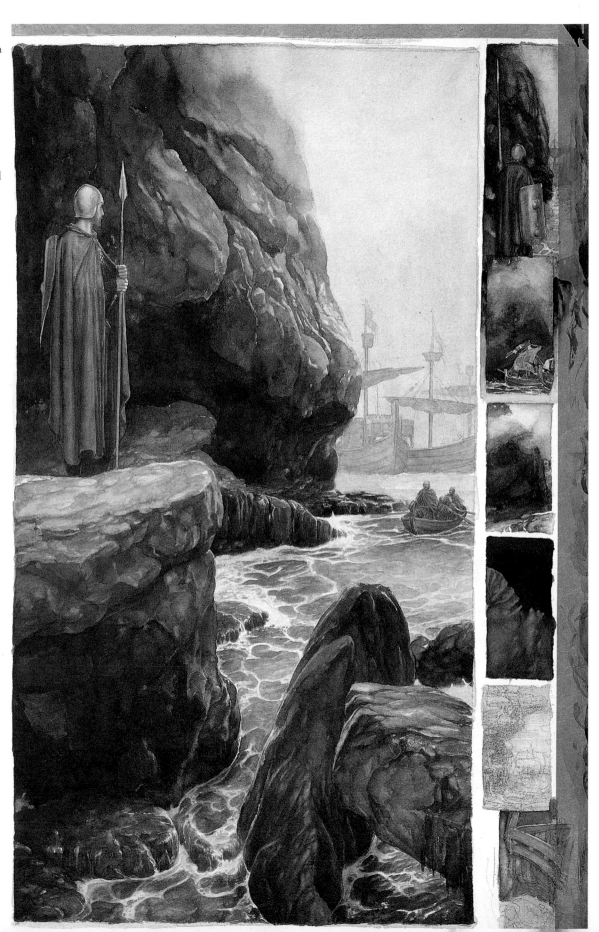

**Branwen, Daughter of Llyr, from The Mabinogion, Dragon's Dream, 1982**
**Watercolor on paper, 40 × 26 cm (15³/₄ × 10¹/₄ in)**

The King of Ireland comes to Wales to ask for the hand of Branwen from her brother Bran the Blessed. Note the extensive thumbnails working out color schemes, perspectives and composition even as the main painting progresses.

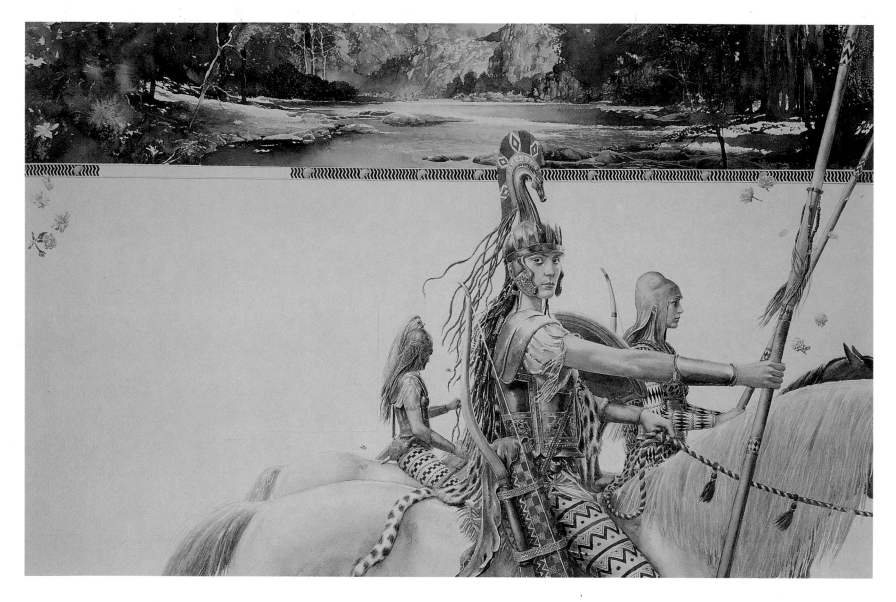

lots of excellent ghost and horror stories as well as 'bodice rippers' and historical romances for *Woman's Own* magazine. I also had many commissions that drew me back to my first loves, myths and fairy tales, and was occasionally invited to provide covers for books that had affected me deeply as a reader – the works of Alan Garner and T.H. White, for example, and, best of all, Mervyn Peake."

## INTO THE SHIRE

"In 1975, I moved to Devon. The artist Brian Froud had rented space in the same building in London and he came too. This was partly because we wanted to live in an inspirational environment, but also because we thought it would encourage us to do more of our own work and move toward book illustration. I also

wished to spend as much time as possible sketching and painting from nature, and the terrain of Dartmoor contains such a rich variety of landscapes – as many moss-covered boulders, foaming rivers and twisted trees as my heart could ever wish for. As I had expected, the flow of one-off cover and magazine illustrations slowed down but it was, fortunately, replaced by longer-term commissions.

"I spent a year or so producing 125 color illustrations for a poorly paid book on 'the mysterious' which mysteriously disappeared, but then had the good fortune to meet Ian and Betty Ballantine, the founders of Ballantine Books in New York. I did some work for them on a book called *Once Upon a Time*, which was edited and designed by David Larkin, and shortly afterward they invited Brian and myself to collaborate

*Amazons,* **from** *Black Ships Before Troy* **by Rosemary Sutcliff, Francis Lincoln, 1993 Watercolour on paper, 40 × 65 cm (15³/₄ × 25¹/₂ in)**

An army of Amazons, led by their queen, ride to the hopeless defence of besieged Troy. Alan says this is his Zena, Warrior Princess, and certainly that series would benefit from his visual input. The falling flowers allude to the doomed nature of the Amazons' quest, while their queen's proud expression suggests to us they are resigned to their fate and will die with honor. The attention to period detail, the exquisitely rendered Mediterranean glade and the understatement are all trademark touches of this artist.

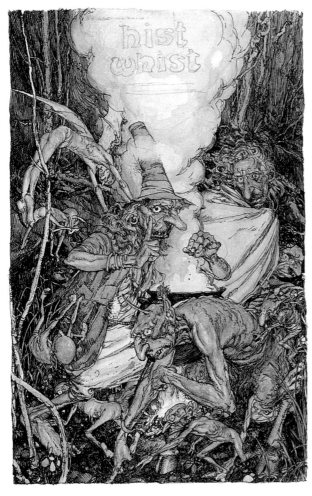

**Right: *Hist Whist*, Fontana, 1979**
**Pen, ink and watercolor on paper, 36 × 27 cm (14 × 10½ in)**

The traditional approach to this piece allows Lee's admiration of Arthur Rackham to come through strongly. It was preceded by a highly detailed pencil, pen and ink sketch (above).

on a book about fairies to follow their successful publication of *Gnomes* by Rien Poortrliet.

"The success of this book, *Faeries,* enabled me to devote two years to illustrating one of my favourite books, *The Mabinogion*. This collection of early Welsh literature – so full of magic and poetry – is still one of the most beautiful books I know. To research the illustrations, I visited many of the places mentioned in the stories. One of the great pleasures in illustrating this type of material is the freedom of interpretation it offers. Whatever descriptions the stories contain are brief and powerfully evocative but not overdetailed, and the characters and themes are multilayered. Much older myths may be discerned through the fabric of medieval storytelling."

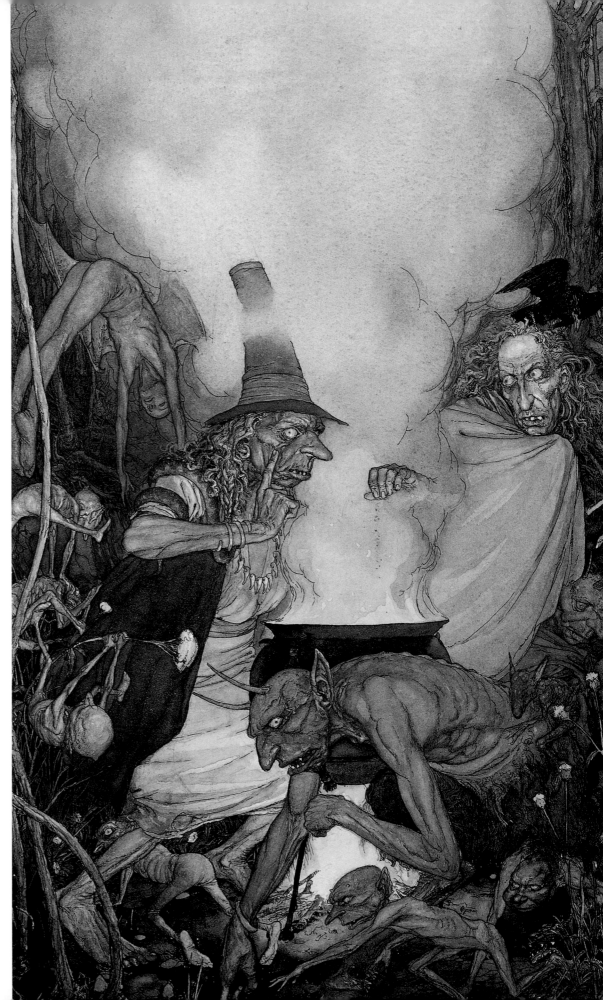

## THE BEAUTY OF ILLUSTRATION

"I work in watercolor with as little underdrawing as I can get away with. I like the unpredictability of a medium which is affected as much by humidity and gravity (the way the heavier particles in the wash settle into the undulations of the paper's surface) as by whatever I wish to do with it.

"The methods and materials that I use may make me seem like an old reactionary doggedly ignoring modern technology. In fact I am fascinated by information technology and the possibilities for exploring the digital otherworld, but I'm content just to gaze on in awe for the time being. Though I have enjoyed my occasional foray into the world of film – it's very exciting when two-dimensional drawings become models, sets and a reasonably convincing episode in a movie – I get more real pleasure from making and reading books. The world has become so full of amazing images that for something to make a real impact on me it needs to have substance – a tangible surface. The tactile pleasure of a book, still one of the most simple and elegant information retrieval systems, together with the worlds it can open up, is a more satisfying substitute for real life.

"Illustration is a sedentary and unadventurous way to earn a living. Apart from frequent walks in the woods in search of inspiration, not much else happens that bears comparison to the worlds that are explored on paper, so opportunities for travel are very welcome. I've been to Greece twice collecting reference for the Rosemary Sutcliff retellings of Homer and have had an extended stay in New Zealand trying to re-create Middle Earth for the films of *The Lord of the Rings*, directed by Peter Jackson. With John Howe and a group of talented and energetic New Zealanders, I have been producing ideas to aid the visual interpretation of the story. The drawings are a useful reference point for the director, the production designer and all the other professional and pragmatic minds involved in the project to aim at, improve upon or discard."

## THE SWORD IN THE STONE

"For the cover illustration of T.H. White's classic novel *The Sword in the Stone* I wanted to reproduce a densely detailed re-creation of Merlin's room, and because of my admiration for the work of Arthur Rackham and some of his contemporaries I chose the time-honored technique of pen, ink and watercolor.

"I posed myself in a mirror to help with the drawing of Merlin, and my daughter became Arthur as she sat on a stool watching television. The composition was enlarged from a little thumbnail sketch for the working drawing. The important elements were traced onto

watercolor paper and the rest of the increasingly cluttered interior was drawn in.

"I then inked in with a fine mapping pen and used more pencil to develop form and soften the lines before applying a wash of a warm color such as burnt sienna. This was to ensure that the successive washes of blues and neutral tints would retain some warmth. As I painted, the lighter areas were washed back with clean water and the highlights were picked out with the wet point of a brush from the surface of the hot-pressed watercolor paper."

***The Sword in the Stone*
Pencil sketch**

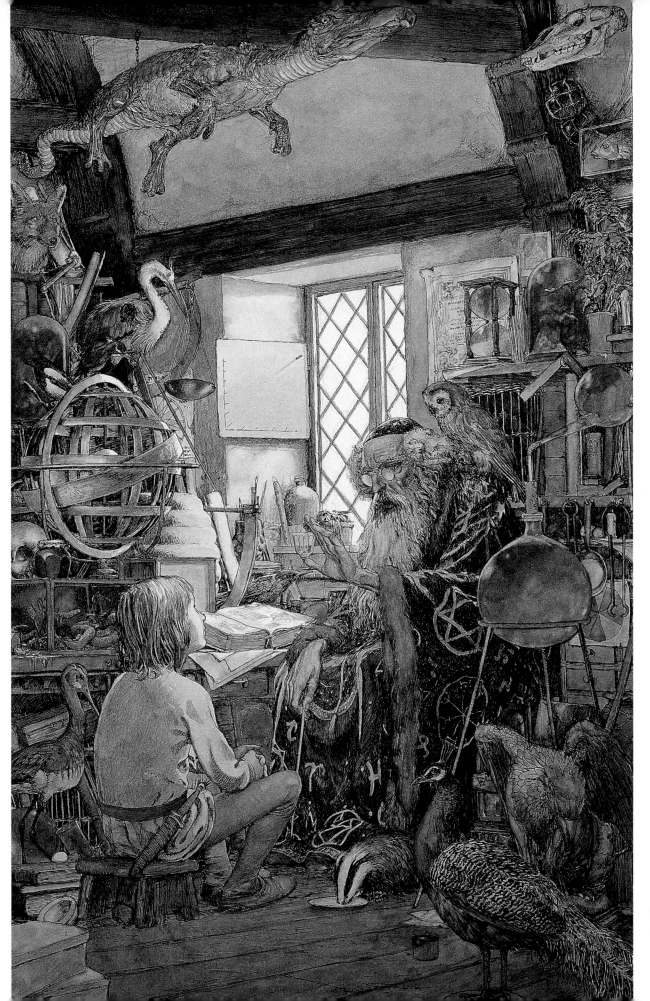

*The Sword in the Stone* by T. H. White,
Collins, 1977
Pen, ink and watercolor on paper,
91.5 × 63.5 cm (36 × 25 in)

## THE PROUD ONE OF THE CLEARING

"Not my title, but the name of the knight encountered by Peredur as he begins his journey toward fame, King Arthur and the Grail in the story from *The Mabinogion*. I wanted to paint the picture in a very heavy loose wash and so masked out the knight, his horse and the design on the horse's caparison with masking film. I like to mix colors on the paper as much as possible, working wet-into-wet, and sometimes adding salt for extra texture. I was pleased to see when it had dried that the color had not become lighter and in need of another wash.

"I then painted in the armor and the other details and it all worked out quite well. This is quite unusual. It is more often the case that the first washes look lovely with sparkling textures and subtle color modulations until the last bit of white paper is filled, at which point the painting immediately looks messy and insipid. Then I'll tell myself that one more wash will turn the picture into a masterpiece – and a week later I'm still tinkering with it, trying to breathe life into the tired and overworked surface. This is part of an elaborate confidence trick I regularly perform on myself, i.e., that any picture or project will need only a fraction of the time that it actually takes to complete it.

"If I could forecast realistically the number of hours, weeks and months any particular endeavor will need, I would be discouraged from the start. Fortunately, the sleepless nights are forgotten as soon as the pictures are handed in, and the printing press invariably seems to iron out their fretted-over surfaces."

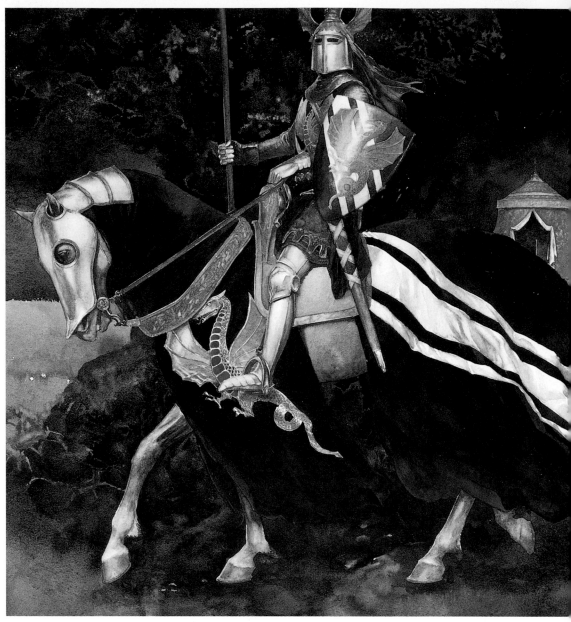

***The Proud One of the Clearing*, from *The Mabinogion*, Dragon's Dream, 1982**
**Watercolor on paper, 35 × 34 cm (13³/₄ × 13¹/₂ in), plus watercolor sketch**

## MERLIN

"I usually do lots of preparatory sketches before tackling a finished work – sketches from life, compositional studies and pages of refinements and alternatives for any figures. Once, though, I went straight from one small thumbnail sketch to the finished piece and created the character of Merlin without any of the usual preliminary work. This was done for a magazine called *From Avalon to Camelot* which flared briefly and beautifully in Chicago in the mid-1980s.

"I've had cause to draw Merlin a number of times – twice for covers for *The Sword in the Stone* as well as for *The Book of Merlin* and illustrations in *Castles* and *Merlin's Dreams* – but I think this is the drawing I like the best:

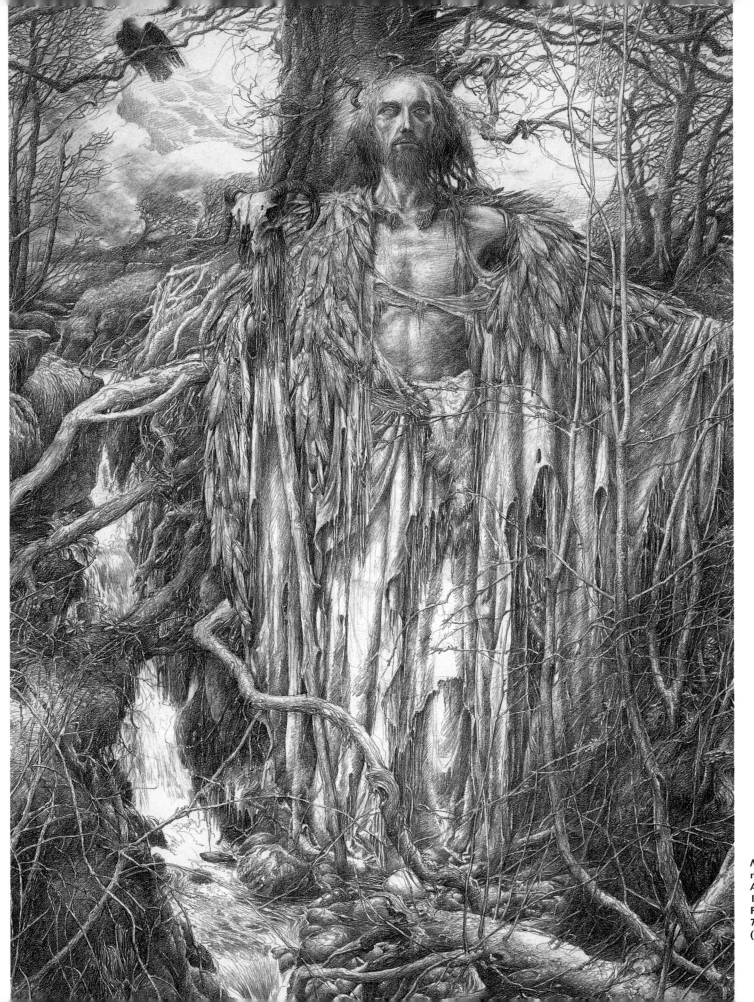

*Merlin*, for the
magazine *From
Avalon to Camelot*,
**1984
Pencil on paper,
70 × 46 cm
(27$^1$/$_2$ × 18 in)**

Merlin as a shaman, living wild in the woods, his cloak of tattered feathers representing the flights he will take when he enters his divinatory trance."

## IN MORIA

"I loved this scene in the book *The Fellowship of the Ring*, which takes place in the enormous Dwarrowdelf chamber, the vast cavernous interior dimly illuminated by flashes from Gandalf's staff or by a single shaft of light. It never struck me as at all anomalous that dwarves would build on such a gigantic scale. The first sketches were very rough and suggestive, but it was necessary to produce quite elaborate perspective drawings to make sure it would all work as a painting.

"Very often a pencil drawing will look correct, the flaws in the drawing and perspective only becoming apparent when the image is rendered in color. However, having done the groundwork so that the stone would look like stone and not rubber, it was necessary to lose a lot of the details to try to regain something of the atmosphere of the original sketch."

**In Moria**
**Pencil sketches**

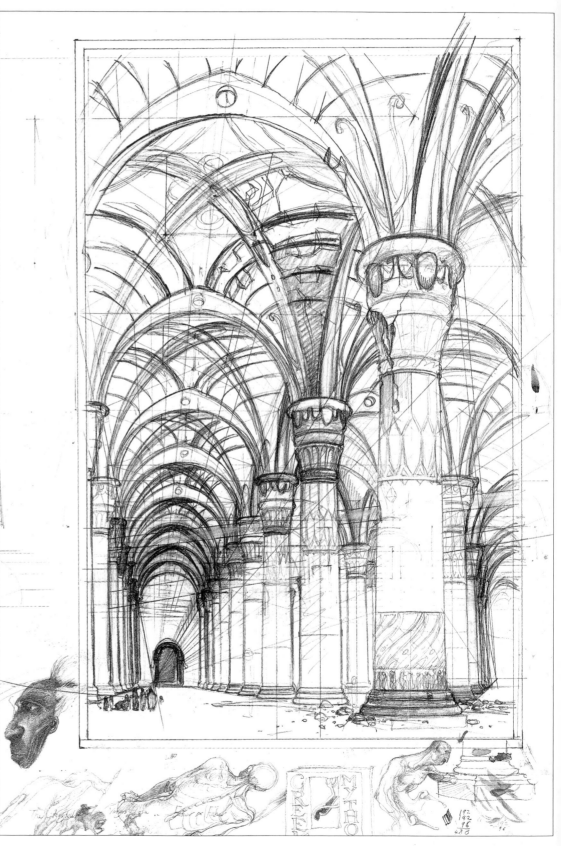

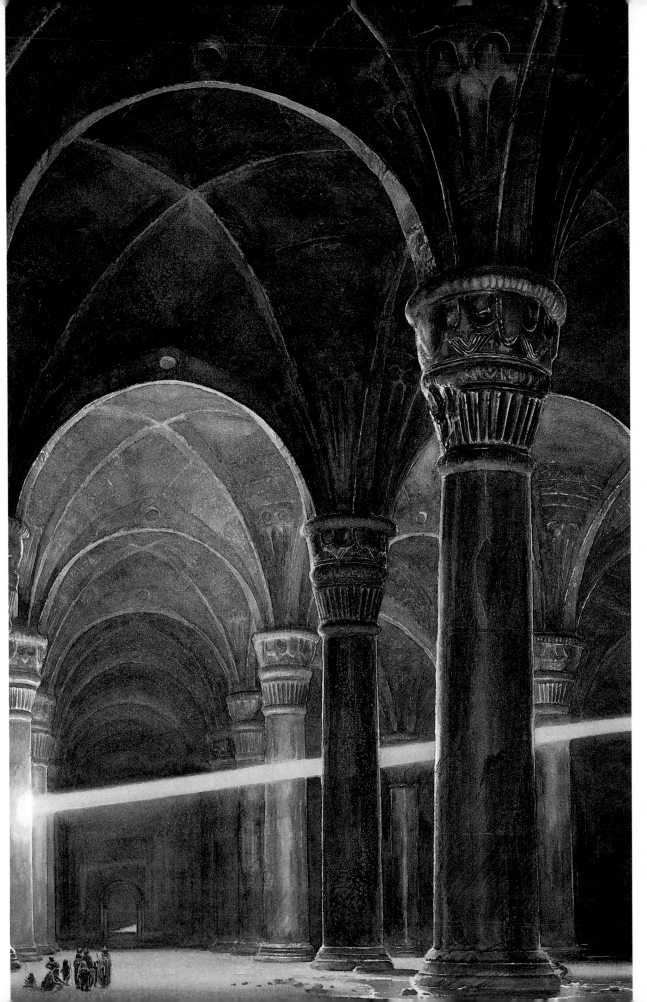

***In Moria***, **from the centenary edition of**
***The Lord of the Rings*** **by J. R. R. Tolkien,**
**HarperCollins, 1991**
**Watercolor on paper, 50 × 25 cm**
**(19¹/₂ × 9³/₄ in)**

A classic exercise in restraint. The vigorous
and dramatic approach in the preliminary
pencil sketch (opposite page, left) captures the
atmosphere of this vast, benighted hall, as with
so many Alan Lee pictures, reducing the
protagonists almost to insignificance. Next
comes the carefully constructed perspective
drawing (opposite page, right) to ensure there
is nothing left to chance when the pigment is
finally applied, but much of this detail is then
sacrificed to achieve the Stygian mystery of
the Dwarrowdelf (left).

25

***Tol Brandir***
**Pencil sketch**

It is the attention to detail during the drawing stage which allows the confident, fluid brushwork of the paintings.

## TOL BRANDIR

"This was painted on a sheet of delicate handmade hot-pressed paper, part of a dwindling supply that I've been hoarding for the past 30 years. I haven't found anything produced more recently that works in quite the same way. I like to create an atmosphere, the stillness of which will be broken by the dramatic events which are about to unfold, in this case the imminent death of Boromir, the flight of Frodo and the breaking of the Fellowship of the Ring, the climax of the first book.

"I read *The Lord of the Rings* as a teenager and felt that Tolkien had taken every element of all the myths and legends I'd read to that date and woven them into a seamless narrative. More importantly, he had created a vast, beautiful landscape that dwarfed its inhabitants and would endure long after they had departed. For this reason, when illustrating the centenary edition, I allowed the landscapes to predominate. In some scenes the figures are so small as to be barely discernible; I could have focused on Boromir and Frodo, but the author is doing that and I'm always concerned that I shouldn't interfere too much with the picture the author is building in the reader's mind. This approach also suits my preference for drawing landscapes rather than people."

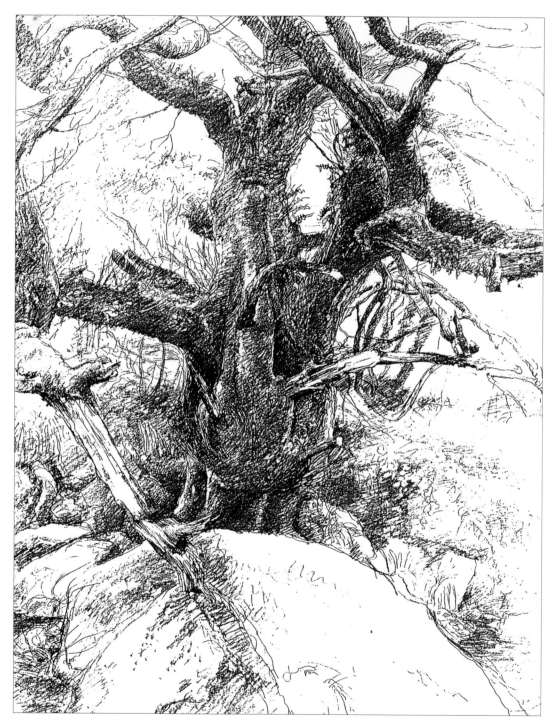

***Tree Study***
**Pencil sketch**

His recreational studies of the trees and rocks to be found on his beloved Dartmoor provide perfect reference for many of Alan Lee's scenes from *The Lord of the Rings* and for much of his other work. His sketchbooks brim with countless representations of the stark, primal beauty to be found in this landscape. The moorland of Devon is so powerful an attraction for Alan that he constantly returns to it as a source of inspiration.

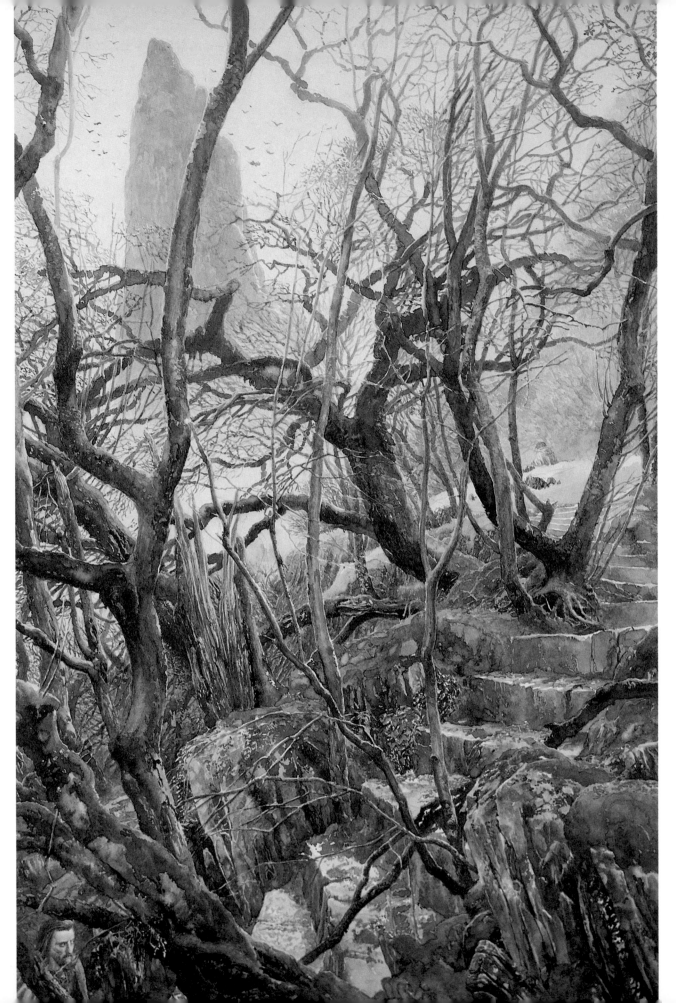

*Tol Brandir*, from the centenary edition of *The Lord of the Rings* by J. R. R. Tolkien, HarperCollins, 1991
Watercolor on paper, 35 × 26 cm (13³/₄ × 10¹/₄ in)

Lee has chosen a point just before the climactic action of *The Fellowship of the Ring* and has perfectly captured that feeling of calm before the storm. In the mist-drenched winter landscape the figure of Frodo is reduced almost to invisibility as he sits on the high chair, plagued with doubt. Equally subtle is the placement of the troubled Boromir, ascending the stair toward his confrontation with the Hobbit which splits the Fellowship. Rather than depicting the battle that follows this scene, as many would have done, Lee has elected to show off the beauteous, ancient majesty of Tolkien's world and leave the action to be imagined by the reader.

# Don Maitz

*"The concept of pushing a series of buttons and having one's artwork materialize on an electric screen gives me great pause and trepidation. I prefer the hands-on approach."*

Growing up in the small town of Plainville, Connecticut, Don Maitz was forced to stretch his powers of imagination because the location was just as plain as its name suggests. Drawing became such an important part of his life that he participated in the Famous Artist Art Correspondence Course by the age of 13. By 18, he was an honour roll student taking all the art classes the high school curriculum allowed and was also spending one evening a week at the University of Hartford's figure-drawing class.

By this time, he had inked a few pages of artwork first pencilled by a local professional artist which appeared in a superhero DC comic, and had also had a pencil drawing published as an advertisement in a Marvel Comics release titled *Kull the Barbarian*.

There were few people to encourage the young Don Maitz as he pursued his artistic skills, and initially his father was not numbered among those few. In his frequent lectures, he would say, "Whatsamattermitchu? Be SMART. Be a plumber, be an electrician, be a POLITICIAN, but don't be an artist!" Nor was his school guidance counsellor, who advised him that his academic grades were too good for him to waste his time going to an art school.

## NOT BAD FOR A FORMER BAGEL PAINTER

Nevertheless, Don did decide to pursue art training and enrolled at the Paier School of Art in Hamden, Connecticut. While at the school he earned money trying his hand at various illustration-related small jobs, one of which was painting faces on thousands of small bagels, a promotional ploy dreamed up by a local bakery. Eventually these were varnished and offered as necklaces to bagel-lovers.

Don graduated with flying colors in 1975—the best way to exit art school! This was no easy task as the work was challenging, the competition was stiff and the excellent teachers were demanding.

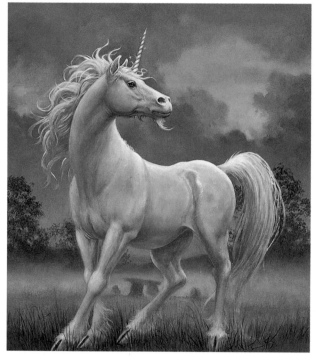

**White Unicorn, game, FPG, 1995**
**Oil on masonite, 35.5 × 28 cm (14 × 11 in)**

"The secrets of unicorns are locked within standing stones and, of course, unicorns hold the secrets to standing stones. This painting was stolen from a delivery truck en route to its premiere showing. If you see this original art, contact me through the publisher."

Still living in Plainville, the "plain villain" known as Don Maitz began taking his portfolio by train to New York City and showing the work to various book publishers. Many of the paintings in his portfolio were used on book covers and he began to receive further commissions from several publishers.

Now, after 20 years in the business of illustration, Don has had the satisfaction of seeing his artwork enhance book covers, magazines, posters, prints, puzzles, plates, greeting cards, software screensavers

## BIOGRAPHY

❖ Born on 10 June 1953 in Bristol, Connecticut, Don immediately began exercising his creativity. With works reminiscent of the artistic efforts by Early Man, Early Don too was involved in cave painting. Out of respect for his mother these first works were never available for public view.

❖ In 1971, Don entered the Paier School of Art in Hamden, Connecticut, as an Honor Society high school graduate who had already participated in an art correspondence course and a university figure-drawing class and had begun to publish material for comic-book companies. He graduated at the top of his class in 1975 and continued figure painting and portfolio preparation in the school's optional fifth year of study. This was interrupted by work commissioned by New York publishing firms.

❖ Since then, Don has been kept exceptionally busy. Among some 425 commissioned works is his character for Captain Morgan Spiced Rum, which has received widespread recognition in the USA. He has exhibited in several museums, has received numerous awards and has acted as a one-year guest instructor at the Ringling School of Art and Design in Florida.

❖ He currently lives in Florida with his wife, the artist and writer Janny Wurts. When they are not both slaving over some creative task, they can be found horseback riding, sailboarding, jogging, downhill skiing (rather difficult in Florida) and mowing the lawn.

❖ Don has authored two sold-out art books of his work, *First Maitz* (Ursus, 1989) and *Dreamquests: The Art of Don Maitz* (Underwood-Miller, 1993).

and, of course, bottles of Captain Morgan Spiced rum. Odd having the description "rum artist" be perceived as an accolade!

Don has received three Hugo awards, a Howard award and 10 Chesley awards for his efforts, as well as a Silver Medal and three Certificates of Merit from the Society of Illustrators, an Inkpot award and the Bronze Medal from the National Academy of Fantastic Art. His work has been shown in three museum exhibitions, two travelling shows and many galleries, and is in the permanent collections of two museums. He has lectured at schools and universities and has participated in convention gatherings both in the USA and abroad.

## ON COMPUTERS

Don says, "As students, we were not allowed the mechanical assistance of even a ruler in our still life and figure-drawing classes. This despite the fact that the work focused on extreme accuracy and proportion. We were given exposure to the airbrush as a creative tool but its application was reserved mostly for extremely technical illustration work. Basic drawing, figure painting, portraiture, still life, trompe l'oeil techniques, design, color theory and illustration were the fundamental elements of my training and these skills are what still give me the most satisfaction."

Don's natural tendencies and his creative training have made him intuitively resistant to embracing computer technology for generating images, and he will confess that computer manuals give him the willies.

"The concept of pushing a series of buttons and having one's artwork materialize on an electric screen gives me great pause and trepidation. I prefer the hands-on approach. This whole issue brings to mind the saying 'pick your own poison' — and my own inclination is to choose lead and cadmium toxins over EMF radiation."

## HAIRY STICKS AND PIGMENT

Don continues to work happily in realistic fashion with oil paints on panels and canvas using the time-honored custom of painting with "hairy sticks." He is well aware that this puts him in a diminishing group of artists known as traditional painters and he enjoys the irony of the fact that while the subject matter is fantastic, in its creation he employs mundane historical procedures, techniques and skills that have evolved over the course of centuries.

Don's preparation process typically starts by cutting 6 mm (¹/₄ in) of masonite to a predetermined size and then applying several coats of acrylic gesso and matte medium mixed with water. The preparatory sketch is

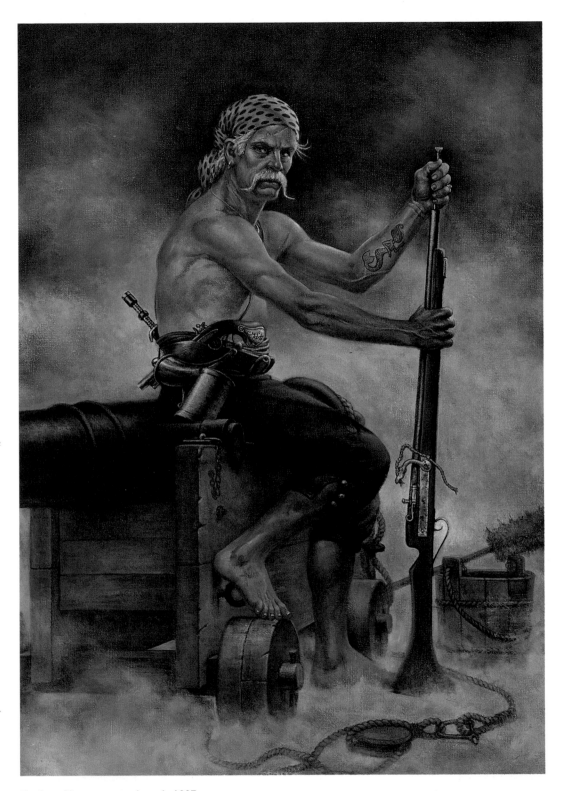

*Far from Home*, personal work, 1997
**Oil on canvas, 66 × 45.5 cm (26 × 18 in)**

"As the smoke clears on some dirty business, there is a moment's pause for introspection. Perhaps the rum and the greed have worn off just a little, inspiring a short lapse into homesickness."

enlarged as a line drawing onto tracing vellum. The image will then undergo the constant redrawing and refinement necessary to put flesh and clothes onto the bare skeleton of the concept.

"At this time, I usually get involved with additional research materials that will help visualize my initial concept – picture files, books, models, costumes, anything that might help realize the image currently taking shape in outline. When I am satisfied with the drawing, I transfer it onto the prepared masonite panel or canvas using a graphite transfer sheet.

"A thin coat of tinted matte medium then seals the drawing and prevents the loss of pencil lines when the oil paint is applied.

"I generally use Winsor and Newton oil colors with a thin medium of stand oil, damar varnish, turpentine, and a few drops of cobalt dryer. On the rare occasions I use acrylics, they are Golden Jar colors. Sometimes no color sketches are completed; sometimes no models are involved, other times they are posed and photographed after the painting has begun. I prefer to draw inspiration from the character developed in the story or from my imagination rather than from a person posing unless the job calls for it or the person selected is exceptional in some way. I paint thinly, using both glazing and scumbling techniques."

Glazing is the application of a transparent color (pigment suspended in a thinning agent – water or linseed oil or turpentine, depending on the medium) over an already-dry area of a painting to create a third color. Because light passes through the glaze, the color perceived by the eye has a translucent, glowing quality, which cannot be achieved by physical mixing. For example, the green obtained by applying a blue glaze over yellow will be different from the the green which would result if the same colors were mixed together on a palette.

Scumbling is the application of opaque paints (already dense paints, such as the cadmiums, mars black, titanium white, etc., or paint to which white has been added) to earlier stages of a painted surface. It is a way to restore value contrasts and depth of form to a painting in which successive glazings have resulted in an overly dark or flat effect.

Don explains, "There are as many different ways to apply paint as there are types of brushes available – glazing only, wet-into-wet, drybrushing, scraping, blending out brushstrokes or allowing them to show are just some examples. I have experimented with a variety of paint applicators such as palette knives, sponges, fingers, food wrap, glass plates and cotton rags, to name but a few."

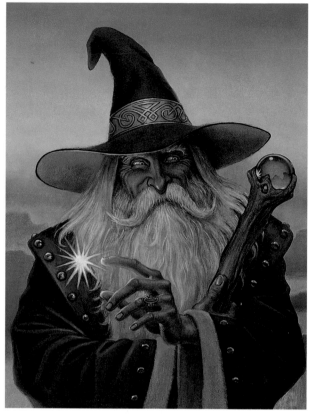

**Grand Avatar, game, FPG, 1995 Oil on masonite, 30.5 × 23 cm (12 × 9 in), plus pencil sketch**

"When a wizard is happy, everyone is happy – or else! This painting was also stolen from a delivery truck en route to its first exhibit. If you see this original art, contact me through the publisher of the book."

**Rimrunners by C. J. Cherryh, Warner Books, 1988 Acrylic on masonite, 76 × 51 cm (30 × 20 in), plus color sketch**

"Airbrushed acrylic paint was utilized throughout this work. To achieve the curved gradations and lines, I needed an oval-shaped device. My solution – our toilet seat."

## OTHER TOOLS OF THE TRADE

"Sometimes I use friskets. These are temporary barriers that stop paint from reaching a particular area. They work best on smooth surfaces. The most convenient is a product called frisket film, which is a sheet of plastic with low-tack adhesive on one side that can be cut into the desired shape. It is primarily used by airbrush artists. An alternative frisket is tracing paper stuck down with rubber cement. Rubber cement itself can act as a frisket, as does a product called liquid frisket which is a thinner, opaque version of this material. A variety of adhesive tapes can also be used to mask areas. Friskets are only limited by one's imagination – anything that can provide a template has potential, for

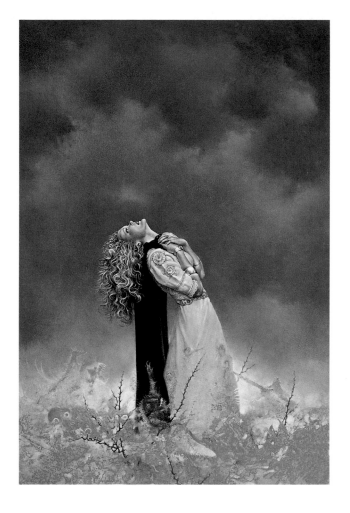

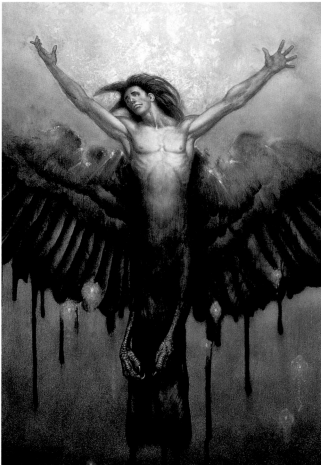

**Left and above:** *Redemption* **by
Janny Wurts, Donald M. Grant, 1997
Oil on masonite, 51 × 35.5 cm
(20 × 14 in), plus pencil sketch**

"This illustrates a moving short story
written by my wife that was included in
an anthology based upon the 'Crow'
personality which appears in comics
and movies. The character's actions
in relation to the kindred crow
spirit initiate his transformation and
ultimate redemption."

example plates, bowls, doilies, cotton, cardboard, leaves
and coins.

"Another important tool is the mahlstick. At one end
of the stick is a cloth- or leather-covered ball that rests
on the top edge of the painting so as not to disturb the
surface of the paint. I use an old broomstick inserted
into a hole cut in a tennis ball that is covered by cloth
and tied to the stick. This allows you to support your
hand while you get in close to all areas of a wet
painting and also works as an edge to rest the brush on
when you want to create a straight line. In painting a
large pirate ship, I used an old wooden crutch as a
mahlstick. Not only was it appropriate, but the curved
surface of the crutch provided the contours needed in
the wind-filled sails and the planking of the hull.

"I found a unique combination of frisket cutter and
mahlstick when doing a science fiction painting for the
cover to a book titled *Rimrunners*. I needed a large
shape with varying oval curves both to rest my brush
against for detailing curved lines and to be the template
for cutting the curved frisket shapes involved inside the

spacecraft. After some puzzling, I found my answer –
our toilet seat! It worked like a charm. It was indeed
appropriate that this book was called *Rimrunners*, because
this is what my wife and I became with the seat off the
toilet for two weeks!"

## THE WHAT AND THE WHY

"Although the 'what' I do normally results in selling a
product of some kind, the 'why' I do it is the fun I
get from telling a story visually within the scope of a
single image.

"My work involves presenting and detailing a visual
concept. This can represent an entire novel boiled
down to its essential elements or a painting which may
be derived from my own inspiration. Sometimes the
result becomes a personal expression that satisfies the
needs of another party separate from any form of
manuscript. This variation within the creative process
spices the results and inspires my inventiveness. The
combination of sources creates surprising variety from
painting to painting."

**Far left:** *Mont Cant Gold* **by Paul R.
Fisher, Berkley, 1984
Oil on masonite, 76 × 51 cm (30 × 20 in)**

"An evil sorcerer sends a diabolical mist to
slay a princess. Creatures formed from wisps
of vapor seize the young woman and drag her
down into the thorns." The yellow and gray
color scheme used here is one of the
artist's trademarks.

## SILVER LINING

"This is a self-inspired work. I conceived this painting to be a positive reinforcement for myself and also to lead viewers in an optimistic direction. Its message is that no matter how big or how dark the cloud above appears to be, there is always a silver lining and a patch of blue sky to discover if you choose to look for it. The tropical birds that are assisting the woman are intended to symbolize giving wings to thought. These birds are unique in another visual sense as their distinctive facial markings are rather reminiscent of a blindfold. This gives them a particular significance within this painting as a guiding influence for one's hopes as 'blind faith.'

"I did several drawings in pencil and charcoal before painting three color studies measuring about 6 × 12 inches [15 × 30 centimeters], using acrylics. I made a detailed line drawing at the actual size of the painting from a variety of source materials. These included the color and black and white studies already prepared, unused slide shots from a photo shoot for a previous project featuring a woman with beautiful hair, my wife modelling her wedding gown for the drapery and a feather arrangement constructed in the studio. The birds were composite creatures, assembled from a wide variety of library books on nature. The woman's expression and features were developed as the painting progressed and do not resemble any one person, instilling a spiritual quality.

"The lightning bolt at the bottom of the picture further emphasizes the title – when disaster strikes look for the silver lining – and by a handy coincidence its placement acts as a perfect vehicle for getting a 'charge' out of locating my signature."

***Silver Lining*, personal work, 1994**
**Oil on canvas, 101.5 × 76 cm (40 × 30 in)**

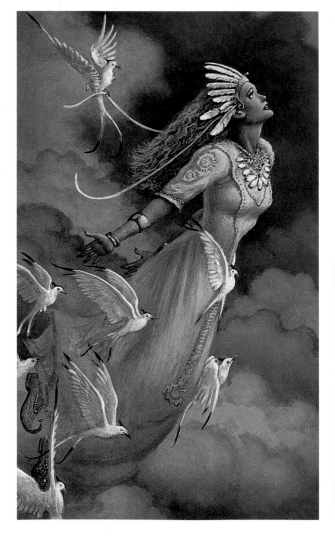

***Silver Lining***
**Pencil, charcoal and acrylic sketches**

"*Silver Lining* grew and developed from these black and white seeds planted in my sketchbook. My inspiration to paint an airborne girl interacting with birds was initially expressed in small pencil drawings. The concepts that best increased and solidified my intent were pursued in small acrylic color studies."

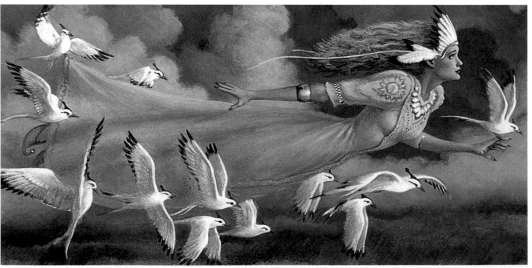

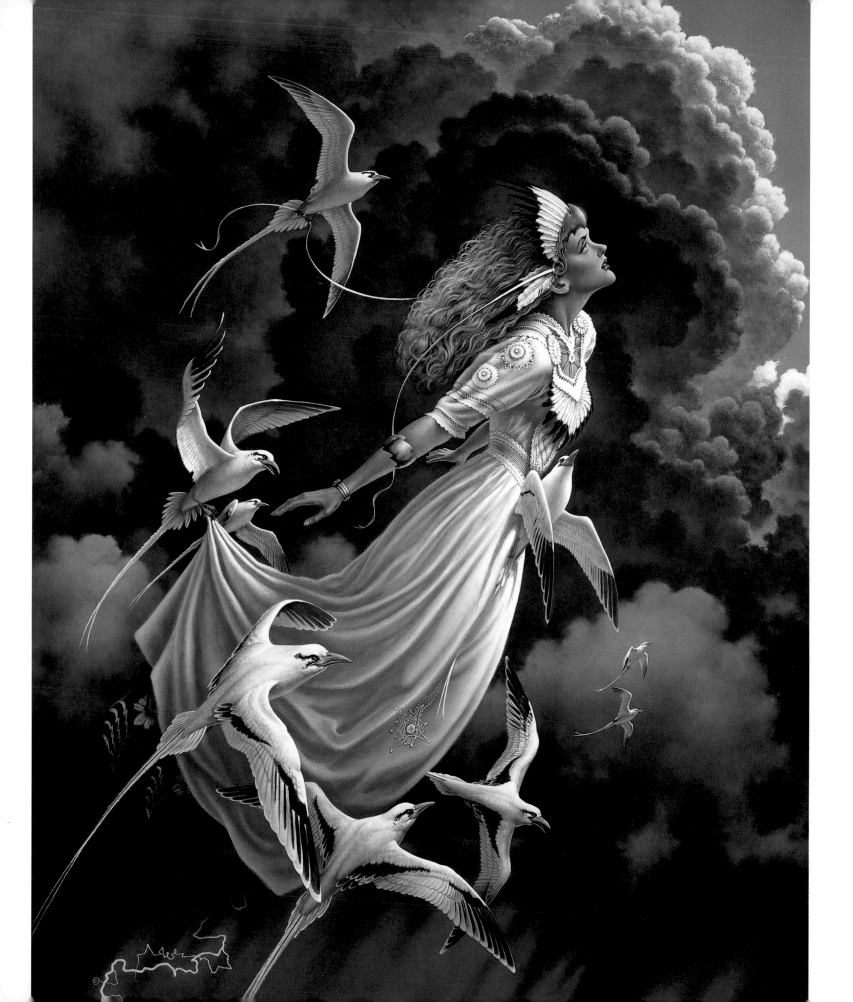

  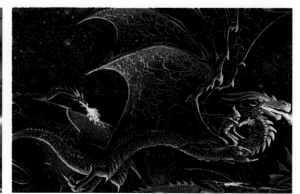

***Dragons on the Sea of Night***
**Acrylic color sketches**

Three small drawings were selected as potential cover designs by agreement between Don, the author and the publisher. They were enlarged, refined and painted using acrylic colors on masonite. One was then picked to reflect the direction of the cover illustration.

## DRAGONS ON THE SEA OF NIGHT

"This work was created as a wraparound cover for the fifth volume of the Sunset Warrior series. My familiarity with the story and with the author, Eric Lustbader, made this inspiring story even more fun to illustrate. I had painted the book covers for the first four volumes of this series for two different publishers.

"Eric has insisted on my work for several of his projects and we have become friends. This personal history makes the effort involved special. I discussed the concept and sketches with both the author and the publisher, which is not the normal procedure.

"A series of small pencil drawings were made proportional to the cover dimensions that indicated the front, back, spine and title areas. These and other slightly larger drawings were done from the notations I had made while reading the manuscript. Three possibilities from these initial small drawings were enlarged to about 6 × 9 inches [15 × 23 centimeters] and painted full color in acrylics. When one of these had been mutually agreed upon I was able to begin the painting. I used the manuscript as the primary research source, with no figure reference at all and only limited photographic material."

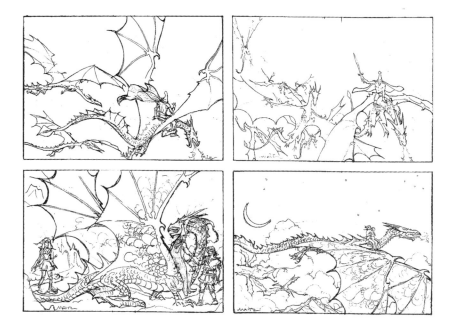 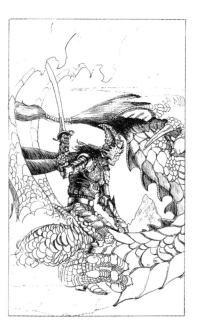 

***Dragons on the Sea of Night***
**Pencil sketches**

The cover concept was developed from the four pencil drawings on the far left. The drawing above inspired two of the color sketches. The pencil rendering on the immediate left was used as a study for the figure in the final painting.

***Dragons on the Sea of Night* by Eric Lustbader, Voyager, 1996**
**Oil on masonite, 57 × 76 cm (22¹/₂ × 30 in)**

The transferred line drawing on the gessoed masonite was refined yet again and then sealed with watered-down gray acrylic matte medium. This was slightly sanded before the oil paints were applied. A thin raw umber monochromatic underpainting was followed by the final opaque painting of the background elements, working forward to the flames, dragon and figure.

## MERLIN'S HARP

"This painting was created as the paperback cover to a story by Anne Eliot Crompton in which the daughter of the Lady of the Lake is Merlin's apprentice and the tale of King Arthur is told from her perspective. The art director commissioned me as a result of seeing a cover I had done which featured a pretty woman framed in a window.

"The tapestry this wood nymph is holding in front of her allowed me to include some elements from the legend of King Arthur – the Holy Grail, Merlin's harp, and Excalibur emerging from the lake and embedded in the stone.

"I came upon this hollowed tree when I was on a hike one day several years ago and am very grateful that I happened to have my camera with me. A friend posed in a costume borrowed from a local theatrical warehouse, holding a bit of cloth with some flowers in her hair.

"I first saw this painting reproduced in the form of a 'cover flat' which is used by the publisher's sales force to presell a book. I was disappointed, much more so than usual. The printing process commonly creates a reproduction that is not sympathetic to the actual painting. Inaccurate transparency film of the original art can skew the color separations, and the printing ink is limited to variations of only four colors. The screen size of the separations is also a factor, as is the skill of the printer. Amazingly, given these variables, this process can create beautiful reproductions, but, alas, not this time.

"As a result of some decision at the publishing house the painting was 'flopped'; that is, the image was reversed as if seen in a mirror. Interestingly, a mirror is an important tool in my studio to view my work as I paint because it gives a fresh perspective on how successfully or otherwise things are working together. However, this flopped cover image was not as I had intended it. In addition, the art was severely cropped. This means that only a portion of the original art was used on the book cover.

"My biggest disappointment, however, was with myself. Seen through the eyes of time, the painting showed me things I wished were different before the fateful day it was committed to film. When the painting was returned to me, I took some time to make the alterations I felt strongly about and then had the work rephotographed. A luxury that is rarely afforded me is to put a painting aside to make final adjustments before deeming the work finished. I am particularly blessed by having another artist in the studio to give me the benefit of a second pair of critical eyes."

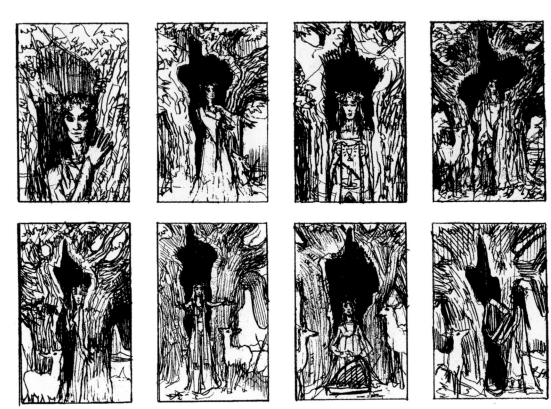

*Merlin's Harp* **thumbnail sketches (above) and final pencil sketches (below)**

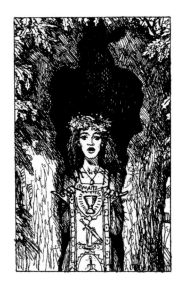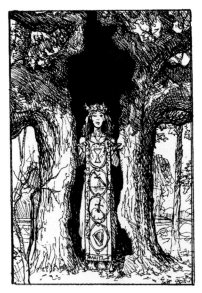

**Opposite:** *Merlin's Harp* **by Anne Eliot Crompton, Roc Books, 1996**
**Oil on masonite, 76 × 51 cm (30 × 20 in)**

Color roughs and the finished painting.

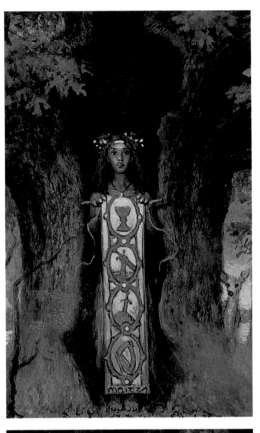

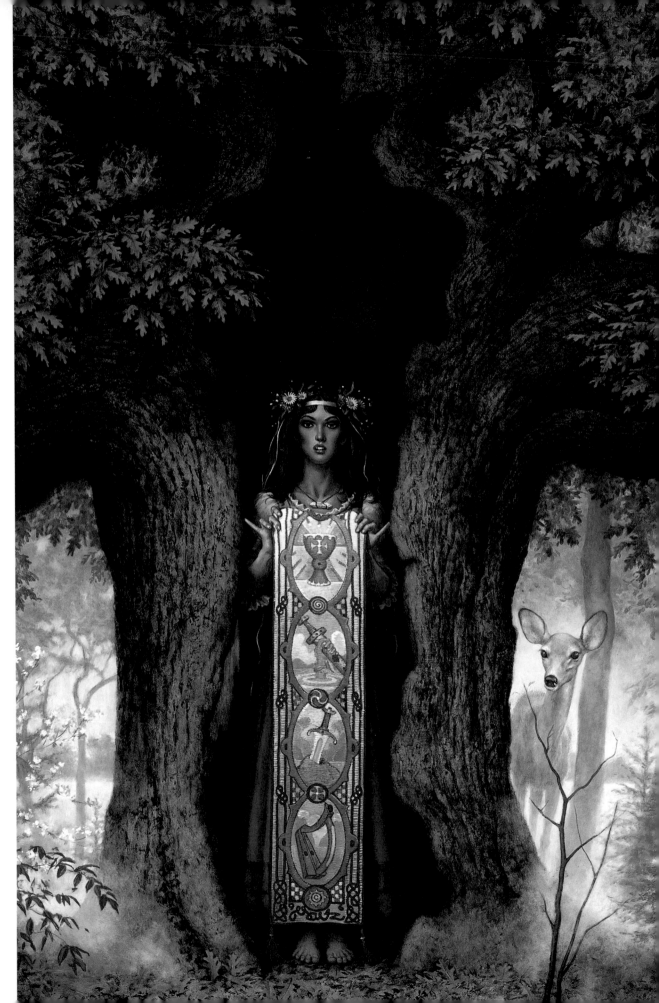

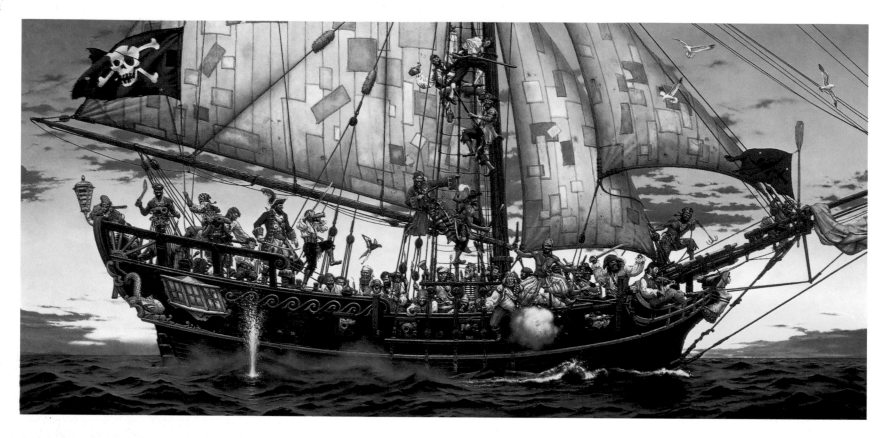

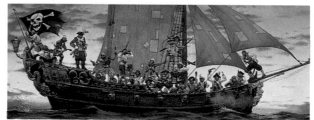

**Forty Thieves, poster, Greenwich Workshop, 1991**
**Oil on masonite, 101.5 × 213.5 cm (40 × 84 in), plus color**
**sketch**

"The boom of cannon and a horrible din with shouts and curses brings you to the windward rail where you see the fearsome crew of buccaneers. A black flag demands surrender yet the red flag offers no quarter. To those who resist, the motto is, 'Dead men don't bite!'"

The enormous scale of this painting required the use of a mahlstick to allow Maitz access to all areas of the surface. He chose a crutch, the ideal tool for this pirate extravaganza. His efforts were rewarded with a certificate of merit from the prestigious Society of Illustrators.

## CHASING THE WIND

"Hey, school's out! Can a mermaid leap out of the water further and swim faster than her dolphin friends? The keen eyes of the seagull will be the judge.

"This frolicking seascape was inspired by the thrill I experienced when several dolphins swam over to investigate me sailboarding in their accustomed waters. None of us leapt from the water but had a mermaid happened along at the time, I would have leapt clear out of my skin.

"Several drawings and color sketches were done to give flight to this idea. I chose a viewpoint very close to the water as if the scene were observed by someone swimming along the ocean surface. Silhouetting the figures against the sky also gives them the dramatic appeal of 'a fish out of water.'

"I really hope that somewhere in our oceans this spectacle is actually taking place. By presenting things that cannot be with all my skill and might, perhaps I am making them just a little bit less impossible."

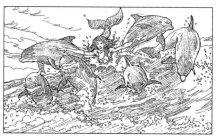

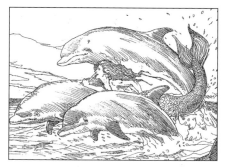

*Chasing the Wind*
**Pencil sketches**

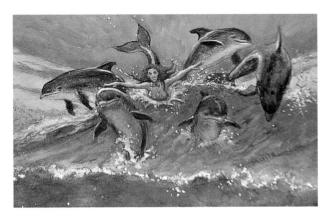
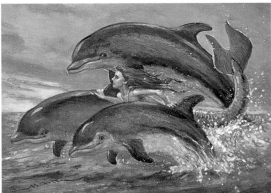
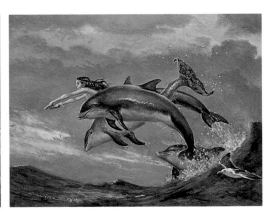

*Chasing the Wind*, personal work, 1996
Oil on canvas, 65 × 90 cm (25$^1/_2$ × 35$^1/_2$ in), plus color sketches

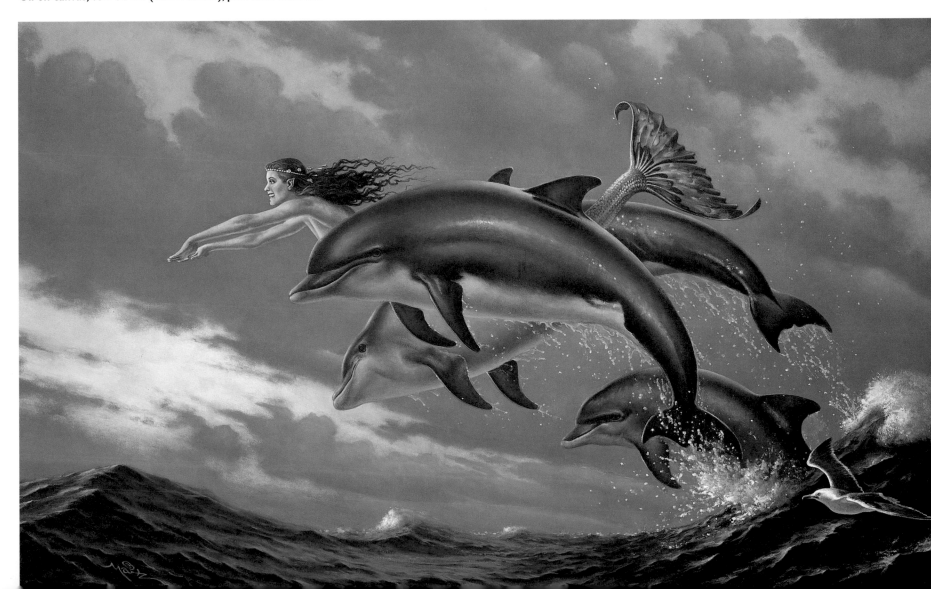

# John Howe

*"Although one is supposed never to judge a book by its cover, I was happily buying books because of their covers and probably then reading what was inside."*

John cannot remember a time when he was not drawing. It was certainly a handy talent for a child who was short-sighted and skinny and felt he possessed none of the requisite aptitudes for making himself popular at high school. Even with this early interest in art, he was often unable to enroll in art classes since his family habitually moved a couple of times in the school year and he would arrive at a new school whose art classes were already filled with students who had proved unfit for any vaguely academic discipline. He ended up in classes for typing or power mechanics and hated every moment of it.

Regardless of his daytime frustrations, John still feels that those were halcyon days. Like many a young person interested in the fantastic and possessing the meager funds of an adolescent, John would comb the secondhand bookshops in search of paperbacks featuring cover illustrations by Frank Frazetta. As was the case with so many aspiring artists of this generation, Frazetta was his inspiration. In the course of these bookshop quests John also came across the cutting edge of comic illustration: Barry Windsor Smith's highly detailed line drawing on Marvel Comics' *Conan the Barbarian*, the dark, Gothic brush illustrations of Bernie Wrightson on DC's *Swamp Thing* and the accomplished paintings of Jeff Jones.

He devoured books indiscriminately, although very few were children's books with the exception of a collection of animal stories by Thornton W. Burgess. His father read Westerns, detective novels and history books, so young Howe followed this example. They would bicker over whether or not they had already borrowed a certain title from the library, with John almost always being proved right since he never forgot a cover.

"Although one is supposed never to judge a book by its cover, I was happily buying books because of their covers and probably then reading what was inside. I read scores of books by Edgar Rice Burroughs and the like. More evolved literature had to wait until junior high school, but in the meantime H.P. Lovecraft,

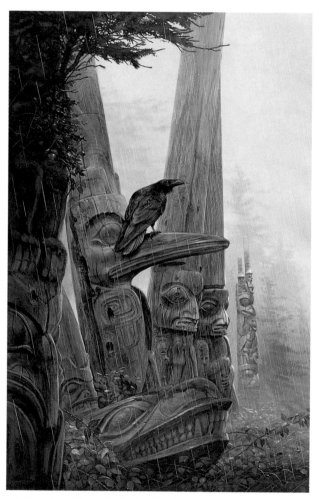

**Winter of the Raven by Janice Kay Johnson, Tor Books, 1994**
**Watercolor and inks on paper, 61.5 × 40 cm (24 × 15½ in)**

"I grew up with northwest coast Native American art, only to be stranded in Switzerland 20 years later with not a book or picture available on the subject when I needed it. I spent far more time writing to Canada to get reference than actually doing the cover."

### BIOGRAPHY

❖ John Howe was born in Vancouver, British Columbia, in 1957 and grew up on a variety of farms and ranches north of the American border.

❖ In 1976 he enrolled in an American college near Strasbourg in France then in 1977 progressed to the École des Arts Décoratifs, where he spent three years studying. He then moved to Switzerland to work on an animated film and from there commenced a career in illustration.

❖ He has worked in every aspect of the enormous European illustrated books industry, illustrating Bande Dessinée comics and numerous books — primarily fantasy, historical and children's titles. He is best known outside mainland Europe for his contributions to a wide range of Tolkien projects such as calendars, posters and jacket illustrations. His work receives its widest exposure as jacket art on books published in the USA, the UK and mainland Europe.

❖ He decorated the reception of the renowned Maison d'Ailleurs, the museum of science fiction in Yverdon-les-Bains, Switzerland, and has had personal exhibitions on show throughout Europe since 1983.

❖ He has produced backgrounds for animated television and spent several months in New Zealand in 1998 and 1999 developing concept art for Peter Jackson's film version of *The Lord of the Rings*.

❖ John still lives in Switzerland with his wife and son.

*Earthdawn, Terror in the Skies* by
**Shane Lacy Hensley, FASA
Corporation, 1994
Watercolor and inks on paper,
64 × 50 cm (25 × 19¹/₂ in)**

"Horseshoe crabs rank very highly
among my favorite creatures. I could
spend six months painting horseshoe
crabs, ravens and rhinoceroses if
someone were crazy enough to
commission me. As usual, the ships
were painstakingly masked off to
allow full development of the sky. The
clouds were built up in watercolor
on a white background, then masked
off to allow a heavy application of
gouache sky color. I often feel that
this process would involve less
fiddling about if I used acrylics, but I
prefer the transparent quality of
designer inks."

**Celtic Myth**, unpublished, 1996
Watercolor and inks on paper,
58 × 47 cm (23 × 18¹/₂ in)

"This painting was originally done as a sample for an aborted book on Celtic myth. More important to me than composing a mosaic of characters was the idea of a land of legend, a mythical isle girded by towering cliffs, peopled with all these legendary entities staring out to sea."

Tolkien and Robert E. Howard were the iconographic well from which I drew water."

All this served to fuel his imagination and his desire to become an illustrator, even though his was the only artistic bent within the family. The only evidence that there was any art within his gene pool was the "quite astonishing" pencil rendering of the castle of Chillon executed by his maternal grandmother, but at 16 she became a schoolteacher and never drew again.

"My mother used to help me to draw when I was small but I was bitterly disappointed by her abilities as a draftswoman by the time I was six or seven and remember crying with frustration over a drawing of a cow that she couldn't get quite right and that was beyond my capabilities to render."

Undeterred, John spent his youth doing countless copies of Frank Frazetta paintings in oil pastels, "just to make my life difficult," and dozens of enlargements of Kwakiutl and Haida designs. He discovered and fell in love with

**Mythago Wood by Robert Holdstock, Voyager, 1998**
**Watercolor and inks on paper, 55 × 89 cm (21¹/₂ × 35 in)**

"Holdstock is to me one of the best Celtic fantasy authors today. *Mythago Wood* is a wonderful book written with great style, insight and individuality. I bought it off a paperback rack in a Swiss ski station over a decade ago and immediately thought, 'Here's a book I'd love to illustrate.' I eventually got my wish."

**Mythago Wood**
**Pencil sketches**

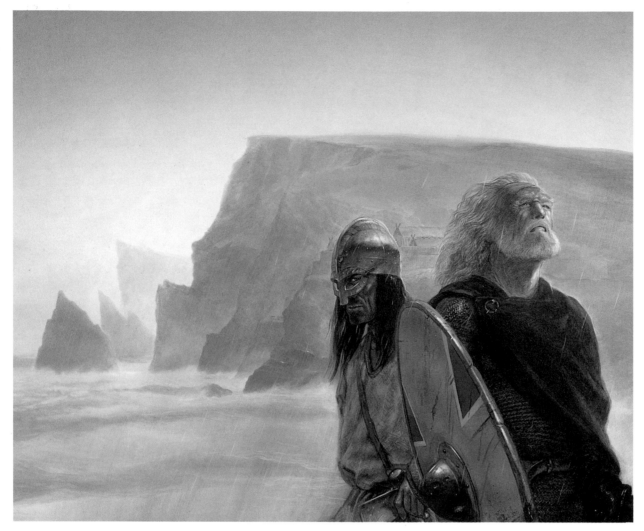

***The Wandering Fire* by Guy Gavriel Kay,
Voyager, 1991
Watercolor and inks on paper,
42 × 62 cm (16¹/₂ × 24¹/₂ in)**

"Kay's Fionavar Tapestry books are jammed
so full of potent imagery they are hard to
reduce to mere covers. I finally chose to do
covers designed to symbolize the four
elements: earth, air, fire and water. As the
sequence was a trilogy I kept wind in reserve
in case the decision to publish a boxed set
was ever made."

the incredible engravings of Gustave Doré, bought the
first *Lord of the Rings* calendar by the brothers
Hildebrandt, finished school and moved to France.

What had been intended to be a year travelling
abroad became more than half his life. After an
academically disastrous year at an American college near
Strasbourg, he enrolled in the illustration class in the
French art school downtown. Three years later he had a
diploma, the beginnings of a portfolio and an inkling of
what to try to do with the rest of his life.

John feels that self-taught artists are often much
applauded but even within the most structured
environment the majority of the real teaching and core
lessons can only come from oneself. There are few
secret recipes or magic techniques, and school is really
a closely planted but fertile garden in which it is good
to grow for a short time. It is only after this
experience that the real learning curve begins.

***Finn and Hengest* by J. R. R. Tolkien, HarperCollins, 1998
Watercolor and inks on paper, 45 × 65 cm (17¹/₂ × 25¹/₂ in)**

"*Finn and Hengest* is a grim tale of treachery and death in the pure
Beowulf tradition. I drew Hengest's hand covered with blood, fully
prepared for it to be judged too harsh and dropped. It made it to
the cover, though."

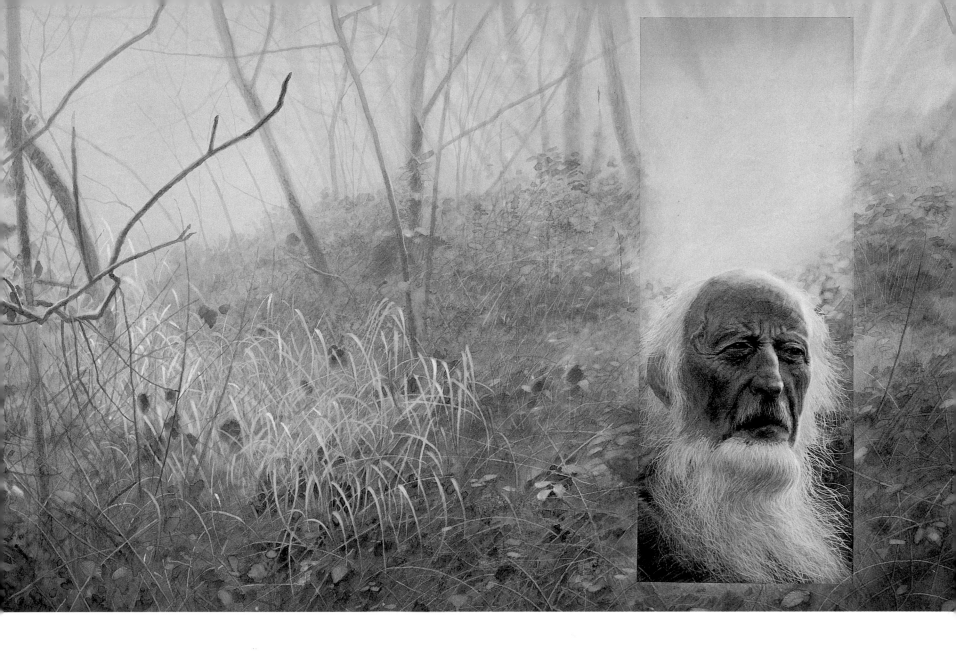

## MERLIN THE ENCHANTER

"There is no sketch for this image, only a succession of coincidences. I had the ambition to write a series of stories based on the Arthurian legend with each story to be told in the first person, beginning with Merlin and culminating with Sir Galahad. Each story was to interlock and open like a puzzle, each piece developing, from a new perspective, the events described in the others. Only when the reader perceived all the viewpoints would the picture be complete. Naturally it was deemed to be unpublishable, but the cover layout had by that time become established in my mind.

"Shortly after this I stumbled upon a photograph that was to inspire Merlin's appearance. In a magazine I saw a series of portraits illustrating an article by a Swiss writer, one of which was of a retired road-builder. After a bit of detective work I found myself having a rather solemn but friendly lunch with an elderly couple

in a huge dark house, listening to stories of hard times and, roads built on impossible mountainsides and many other tales of what the country had lost through industrialization and winter sports. I later returned and took hundreds of photos in an informal session to which my Merlin-to-be submitted with good grace.

"During a winter walk along the lakeside near our home, my wife and I stumbled into a landscape exactly as I've drawn it. I snapped a couple of photographs and filed them away to be forgotten in the short term.

"When there later came an offer to illustrate a graphic novel about Merlin, I jumped at the chance, did a couple of sample illustrations, squabbled over the money on offer and eventually had to abandon the whole project. One of the samples was lost forever, but the Merlin image was found and returned, frayed, torn and folded but at least back in my possession again. Perhaps the only true invention on my part is the tiny blue

*Merlin the Enchanter*, unpublished, 1989
**Watercolor and ink on paper,
36 × 55.5 cm (14 × 21¹/₂ in)**

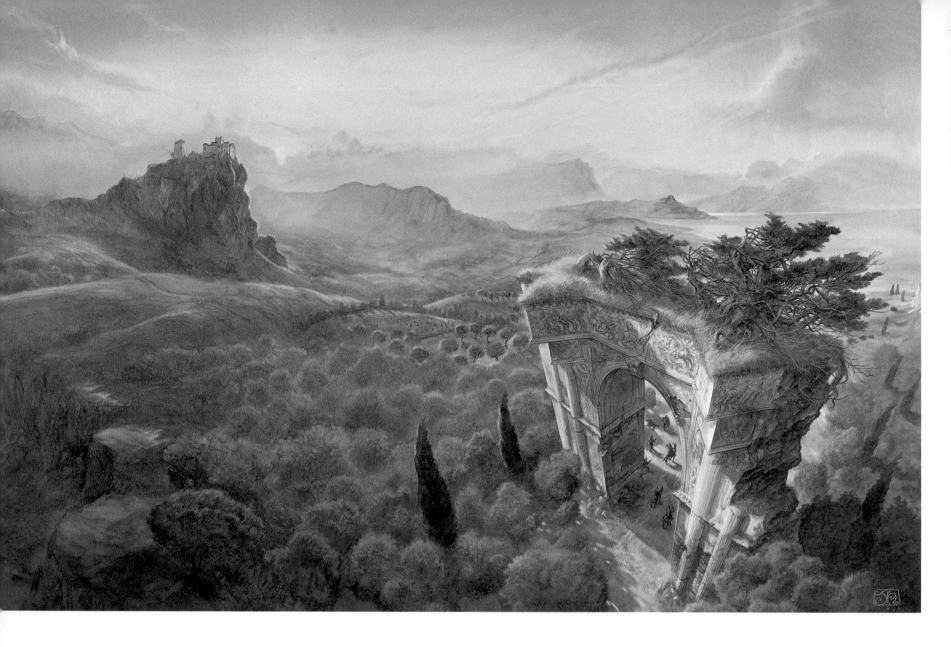

spiral tattoo near Merlin's eyebrow; the rest came direct from the reference material collected across the years specifically for this image.

"Several years later, during an exhibition, a young woman turned up, husband and family in tow, and said, 'We've never met – I'm Merlin's daughter.' Needless to say, I was enchanted.'"

## A SONG FOR ARBONNE

"Arbonne is a fictional realm akin to medieval southern France, with traces of a long-vanished civilization scattered about. A long-abandoned triumphal arch was chosen as the theme because an ambush takes place at its foot, but the treatment of the cover was left up to me. I cannot remember why I chose the perspective I did – possibly I thought it would be a simple matter to line up the top of the structure with the horizon – but the decision soon proved rather a reckless one. Drawing the arch meant using vanishing points yards away and when it came to the jutting cornices it was a nightmare to get all the lines in the right place. I did the arch first, then masked off parts of it as I filled in the landscape. Had I been more patient and the brief allowed more time I would have been more ambitious and spent much longer on the bas-relief and decorations.

"After everything had been pinned down I let the sun come up from behind the castle on the hill, bringing out the light on the hills and trees, which then meant some serious quality time deciding on where the shadows should fall.

"I particularly enjoy painting architecture with extravagant perspectives and the more natural challenges presented by landscapes. The calmest of scenes has energy within it to be exploited, even if it is just the air going somewhere. Painting such scenes is less ruled by a strict agenda or mandatory order – one is much

*A Song for Arbonne* by **Guy Gavriel Kay, Voyager, 1993**
**Watercolor and ink on paper,**
**41 × 69.5 cm (16 × 27¹/₂ in)**

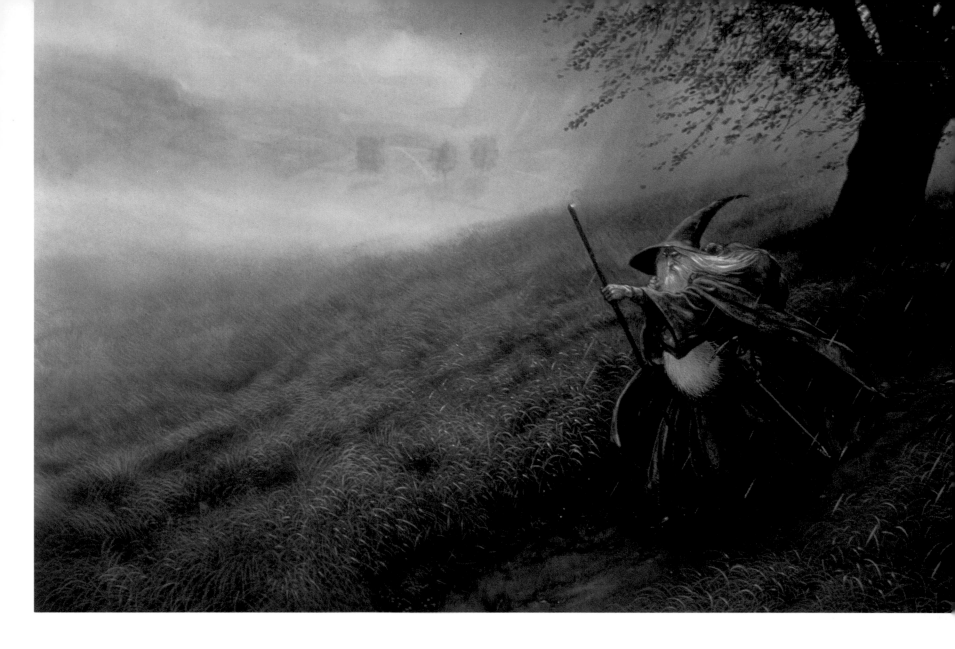

more at liberty to wander about inside the picture space in the manner of an ill-disciplined errant gardener, placing a hill here, a tree there as one's fancy dictates."

## GANDALF

"This Gandalf is one of my happiest pictures, the one in which I find the least things that I would change if I could. The composition fell into place of its own accord with the simple idea of Gandalf going somewhere in a hurry, as he often does in the story. Although he's immensely powerful, he's plagued by the concern that he will be too late in bearing ill news and also by knowing that his coming will not be happily met.

"As is typical I started with the background, which is a mix of repetitive building of layer upon layer of light washes, reducing the intensity of this effect by going over everything with a housepainter's brush and then bringing forward the desired elements again. This

**Top:** *Gandalf,* from the single-volume *Lord of the Rings,* HarperCollins, 1990
**Watercolor and ink on paper, 43 × 65 cm (17 × 25¹/₂ in)**

**Above:** *Gandalf*
**Pencil sketches**

normally happens three or four times until I feel the paper has had about all it can take or the far distance seems full enough. Then the painting came forward in steps with a little masking over a wash for Gandalf himself. Masking foreground figures is a thing I prefer not to do often, because having separated the outline of the shape from the background in such a manner they are then locked in place and any changes of mind result in an almost impossible process of attempting to merge new background layers with those already on the paper.

"Given the volatile character of inks, grass can be painted in dark green and then removed with a wet brush or added to with pencil crayon. The colored pencils I use have a tremendous range of greens, but grass needs blues and browns just as much. It is time-consuming to create such an effect, and one must be wary of becoming systematic, but it's not difficult.

"The finishing touch of the storm came from my airbrush, with the added touch of a few drops of colored-pencil rain. As well as adding more detail to the painting, this effect also adds to the sense of urgency we all feel about getting out of a coming storm, and the theme of the approaching storm is central to *The Lord of the Rings*. The figure of Gandalf is built up in heavy washes of ink. He became so solid I began to fear he would be anchored to the ground to the point that there would be no motion. I did dozens of sketches before he fell into place, using models for his clothes and accessories. The hat is an anachronism from the more innocent days of *The Hobbit*. I have often been asked if it's a self-portrait, but can honestly reply that it isn't because I don't have a lovely white beard like that."

## GANDALF AND THE BALROG

"Gandalf and the Balrog originally began as a sketch for the final confrontation between Glorfindel and the chief of the Balrogs on a mountaintop following the siege and fall of Gondolin in *The Silmarillion*. It began in a vertical format with a full moon, flying shreds of cloud and a rocky precipice. The original Balrog was considered a bit too grim for a cover and another scene was chosen. In retrospect, I can only agree with that decision.

"When, a couple of years later, I was left with a couple of months to fill in the 1997 Tolkien calendar, the sketch was taken from the drawer. The freedom of a landscape format, no title or spine text and no bar code or synopsis copy allowed the Balrog to spread its wings, Glorfindel became Gandalf and the pinnacle became the bridge of Khazad-dûm, but little else in the composition changed – everything important is going on in a few inches in the middle of the piece. Tolkien describes Balrogs rather sparsely, mentioning just a

sword, a whip, wings and some smoke and fire, which leaves a lot to the artist's imagination. I added the armor the creature wears as a reminder that there were once legions of the things and this last survivor may have kept his gear in his dark hideaway far below the bridge. Vermilion ink dropped on to wet black ink chased the black away and up out of the paper and pushed it aside, creating the great gouts of flame and rolling black smoke – partly by design, partly a shepherded accident.

"The rest of the picture was then just a matter of bringing up details bit by bit from the background, although there was some complicated fiddling in the area around Gandalf, whose position changed several times. The problem here was that I had masked his sword, Glamdring, to keep it pure white and his hand therefore had to stay in one spot, although his feet could keep shuffling around until finally coming to rest in the most dramatic pose. The lightning effects around his staff required extensive airbrush and pencil crayon work to render convincingly.

"This piece took roughly four days to complete, if we count this time in eight-hour days, but illustration takes time to work up to the starting point, with days spent sketching and moving to other pieces in a search for inspiration. From start to finish probably a good week's water flowed under this particular bridge. When I am asked how long a piece takes I am inclined to give my age as the answer, since I wouldn't have done any given picture the same way in the year preceding or following. Illustration has its roots in such a colossal set of circumstances and coincidences that each final painting practically needs its own curriculum vitae."

***Gandalf and the Balrog***
**Pencil sketches**

Top: The original conception – portrait format with the book jacket commission in mind, worked up from tracing paper roughs. Note the concentration of real drawing in the center of the piece, allowing space for the title, author and other lines of text.

Bottom: Although the Balrog was considered too grim for cover art, it proved ideal for a calendar illustration. The elf becomes a wizard and the mountaintop a bridge, and the Balrog is turned round to make full use of the landscape format.

***Gandalf and the Balrog***, **Tolkien Calendar 1997, HarperCollins, 1996**
**Watercolor, ink and crayon on paper, 48.5 × 67.5 cm (19 × 26¹/₂ in)**

All the background has now been developed with dramatic pyrotechnic flourishes which would have been wasted on a book jacket, where they would have been covered by text.

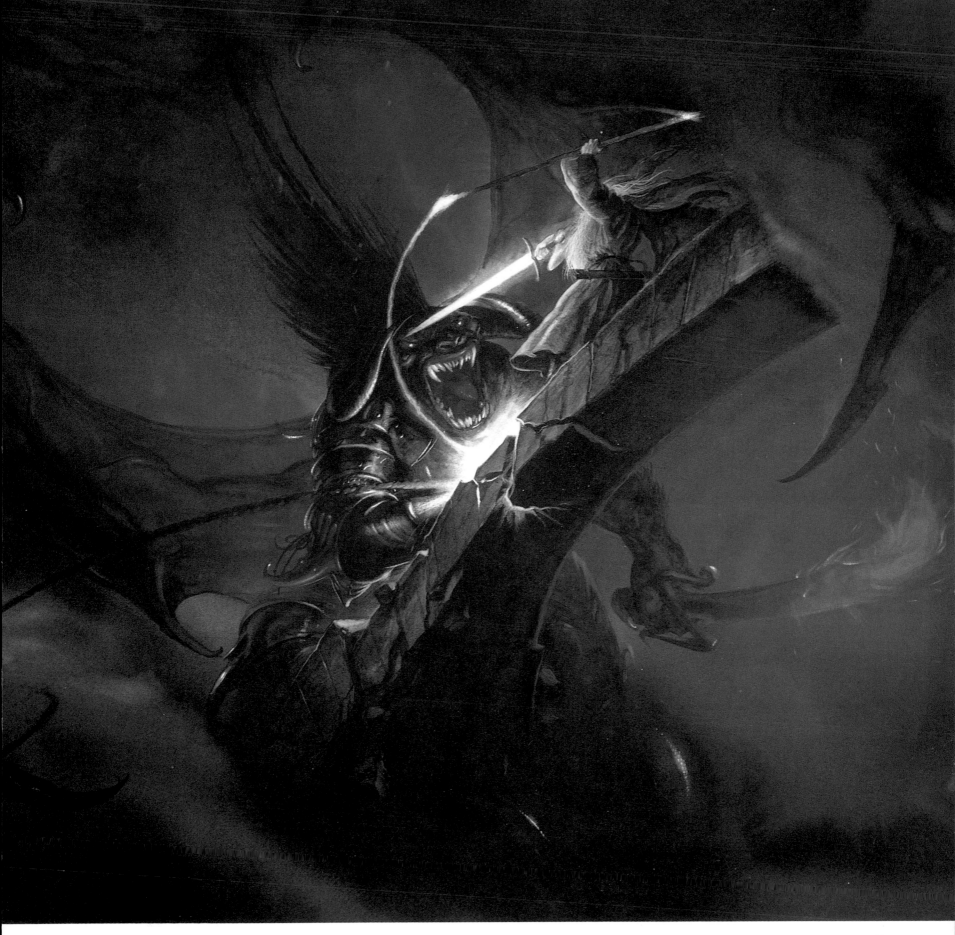

# Brom

*"When I can successfully bring to life something that previously only existed in my imagination, regardless of how warped it may be, that is when painting means the most to me."*

As a child Brom would get a vision in his head and lock himself away in his room. There he would work long into the night until he had brought to life the image that was obsessing him. That obsession is what keeps him painting as though possessed to this day.

"Creative periods so intense that I lose all sense of time are what I'd describe as art at its best. Periods when I'm working obsessively, oblivious to the world, the adrenalin pumping. Any artwork created under those conditions is fine art, regardless of where it ends up or what it is used for. Applying my talent to what interests me and following my own inspiration is to me the very definition of fine art. The projects that allow me the most freedom, the ones that set me free to pursue whatever current passion or twisted idea is struggling to express itself within me, those are the paintings that keep the obsession alive."

## HUBBLE BUBBLE – THE WORKING DAY

Surprising as it may seem, this master of the dark side is a morning person who by nature is up and painting by 7 a.m. Most of his day is spent with his mind brewing ideas until 4 p.m., which is when the cauldron runs out of steam and the magical energies drain from his soul. He will generally work six days a week (although depending on client and deadline this may creep up to eight), painting to the accompaniment of the atmospheric sounds of heavy, moody music which helps to set the tone and feel of his paintings. If it's overcast and rainy outside he's all the happier, and to ensure this is an all-the-more frequent part of his day, he and his family have recently relocated to the damp northwestern city of Seattle.

## DECISIONS, DECISIONS – THE CREATIVE PROCESS

There is a point in the creative process where each and every painting dictates its own direction as Brom searches for the perfect approach, technique and

**Peace, from the card game Dark Age, FPG, 1997**
**Oil on board, 30.5 × 20.5 cm (12 × 8 in)**

'The game was about future feudal states with a medieval theme, and I was commissioned to depict the title 'Politicking the Draft.' I opted to take a less than literal approach to such an abstract concept."

combination of materials. Prior to this moment being reached there are basic methodologies, goals and philosophies that hold true for most of his paintings.

"The basic technique in preparing for the painting usually remains fairly consistent. I do several thumbnail sketches in order to arrive at the fundamental pose and composition. Having decided upon this, I produce a

### BIOGRAPHY

❖ Brom was born on 9 March 1965 in Albany, Georgia. He cannot remember a time when he was not obsessed with the creation of the weird, the monstrous and the beautiful. The son of an army aviator, he spent his school years on the move, living in such places as Japan, Hawaii and Germany.

❖ He began his professional career at the age of 20, working as a freelance commercial illustrator in Atlanta, Georgia, and immediately attracted such clients as Coke, IBM and CNN. At the age of 24 he came on board full-time as a staff artist with TSR, the premier role-playing game company. He contributed his distinctive look to all the major TSR game and book lines and completely designed the look and feel of the best-selling Dark Sun world. His dramatic style reflected many early influences such as Frank Frazetta, Richard Corben, N. C. Wyeth and Norman Rockwell.

❖ In 1993 Brom returned to the freelance market and has since worked within every facet of the science fiction, fantasy and horror fields, specializing in the darker side of the genre. His distinctive, dramatic and often disturbing visions have appeared in books by such authors as Michael Moorcock, Anne McCaffrey and Terry Brooks; on games for TSR, FASA and White Wolf; on cards for Wizards of the Coast, FPG and Heresy; in comics for DC and Dark Horse; and on computer games for Broderbund, ID, Raven and SEGA.

❖ His art book *Darkwerks*, published in 1998, contains a powerful and haunting selection of these visions.

❖ He lives in Seattle with his wife, Laurie, and their two sons.

❖ E-mail: morb@jps.net

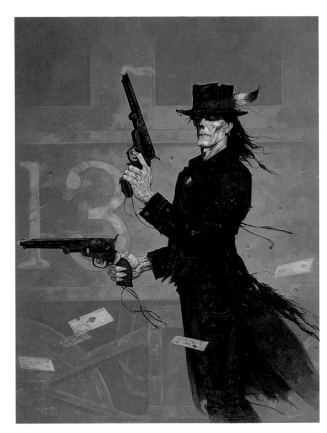

**Gunslinger,** **Deadlands game cover, Pinnacle Entertainment,**
**1996**
**Oil on board, 45.5 × 35.5 cm (18 × 14 in)**

"I was (pardon the pun) shooting for that Old West feel, lining up the
pale, stark figure against the atmospheric chromatic background."

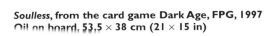

**Soulless,** **from the card game Dark Age, FPG, 1997**
**Oil on board, 53,5 × 38 cm (21 × 15 in)**

"I painted more than 135 paintings for the Dark Age card game as
well as art-directing the whole project. A little over halfway through
I became tired of painting small single-figure paintings, so I decided to
do a few large paintings with many figures and just crop out the
individual characters for the final cards."

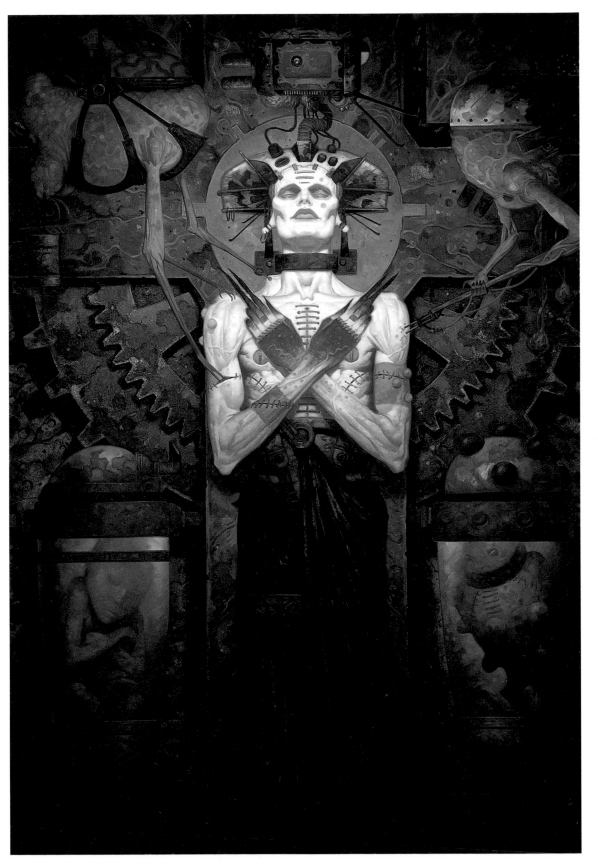

***Silent Quintet*, from The Art of Brom cards, FPG, 1996**
**Oil on board, 15 × 46 cm (6 × 18 in)**

"Each of these card sets contained 90 cards and just as they were about to go to press FPG realized they needed five more cards for the series. I painted one long card with five heads on it in about three days and we cut it into five separate images to finish the set."

fairly tight pencil drawing to lay out the proper proportions and to detail any other elements that are to be contained within the piece. When I am satisfied with this I transfer the drawing to the board, then, once I have underpainted the drawing in acrylic to block in the basic tones and colors, I finally go to town with oil paint.

"It is at this stage that each painting begins to shape its own destiny, determined by the final desired effect or mood and sometimes simply by dumb luck. Each and every decision plays a part in affecting the final outcome. How far do I wish to take the drawing? Do I want to work on a textured surface or do I sand the board smooth? Should I paint on masonite, illustration board or canvas? Should I paint large or small and in what combination of colors? Should I paint strictly from imagination or try to find the correct balance of photo-reference? All of the above can merge into thousands of combinations of possibilities, each branch of the decision tree leading you off on a slightly adjusted course, and the element of chance can take you into areas never before visited. The delight in exploring the unexpected, in following a new path through the forest of pigment, surface and texture to chance on a never-encountered glade, is one of the most potent of motivators."

## TO PHOTO OR NOT TO PHOTO?

In the fantasy genre there are two primary camps of painters. One group puts the emphasis primarily on the magic of the imagination, believing whatever is lost by not using photographs is more than compensated for by the uniqueness of individual interpretations. The other group stresses the need for literal anatomy with every sinew and vein in the correct position; these artists have a desire to make the imaginary world as tangible as possible, to bring a photorealism to the piece even at the cost of limiting themselves to what is available from photographic reference.

"When I can successfully bring to life something that previously only existed in my imagination, regardless of how warped it may be, that is when painting means the most to me. Regardless of this, I still feel that photos can be a valuable asset, that going to the trouble of tracking down the right source material to work out the structure and get the detail accurate is important. The awkward part is trying to find the right balance between imagination and reference. The key to using photos, or any other reference materials, is to avoid simply copying them. I try not to reproduce exactly every unexplained shape or shadow from such material, I seek instead to understand the underlying form. Once I have grasped the structures and textures, I can take this knowledge and apply it where it is needed. I can then expand, exaggerate, distort and shape the elements to fit my own vision."

## THE LABORATORY OF THE UNEXPECTED

This endless search for that elusive perfect combination of technique and approach coupled with a willingness to follow the meanders of the paint where they take him

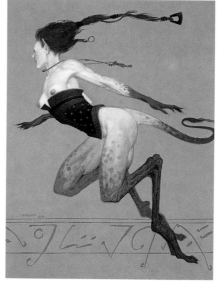

***Gazelle*, from the card game Dark Age, FPG, 1997**
**Oil on board, 30 × 20 cm (12 × 8 in)**

"Simply a self-indulgence, exploring my love of form, red hair and pale skin."

is at the core of what keeps the process of painting stimulating for Brom.

"I hope that one result of this search, of my need to draw as much as is possible with the paint, is that it will keep my paintings out of the trap of becoming predictable. In a sense each painting becomes somewhat of an experiment, which of course means there is always a risk of screwing up. But that all adds to the excitement and sometimes my biggest gains as an artist come from being forced to deal with a painting that is not working: through this discipline comes growth. On the other side of this coin are the little miracles that sometimes occur quite by accident; when paint seems to swirl magically into paint, forming textures and nuances my conscious mind would never have come up with.

"That is a large part of what keeps the drive going after all these years. The thrill of getting there, of watching a painting materialize as spontaneously as possible in front of me, never being quite sure of the final result until the last details and highlights fall into place. This excitement can often be lost when I get bogged down with too much preliminary work or rely too heavily on photo-reference."

## ELKHORN

"I had a lot of freedom on this painting and enjoyed jumping right into it with just the minimum of pre-production. The client wanted something with a dangerous faery world theme, but from there it was left entirely up to me.

"I did a few thumbnail sketches to work out the basic composition, then a very loose drawing to confirm the basic proportions and hint at the additional elements. I wanted to leave as much room as I could to let things happen in the paint. I kept the underpainting very abstract, simply focusing on building a sinister, moody palette and ominous shapes. After this I just let the paint go where it wanted, using the brush to draw in the extra details needed.

"The challenge was to draw attention to the main figure in a way that did not distract from the overall piece. I wanted this painting to be a bit more of a mood piece where the feeling of the place had as much relevance as the main character. The fiery side light pulls the eye to the central image but hopefully there are then plenty of other disturbing shapes surrounding this spotlight to attract attention and keep the viewer's eye floating around the painting."

*Elkhorn*, game cover, Global Games, 1997
**Oil on board, 46 × 40.5 cm (18 × 16 in)**

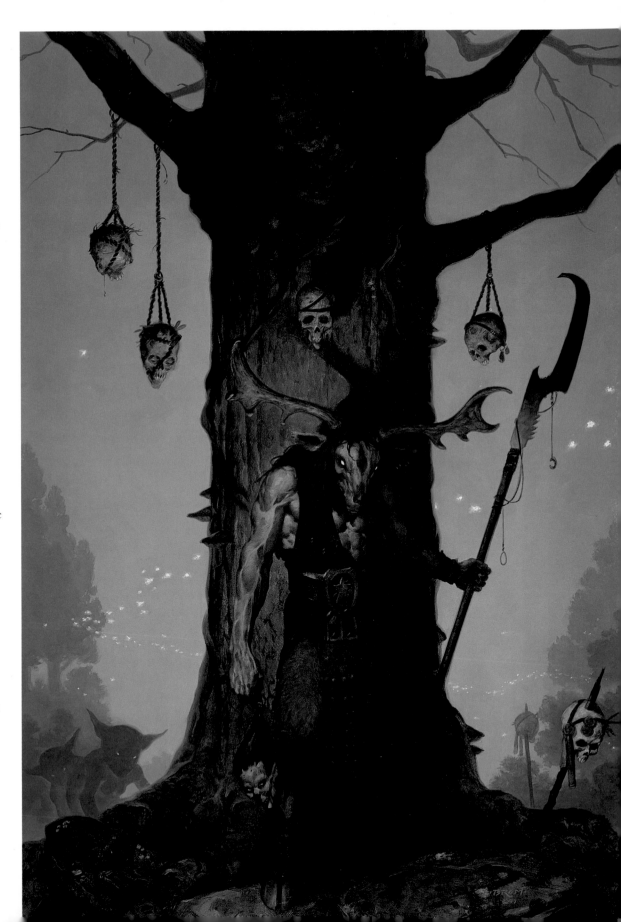

## DEMON SLAYER

"This represents much of what I enjoy in a painting. It was done entirely from imagination and presented an opportunity for interesting costumes, a strong dramatic central figure and, best of all, a few nasty beasts.

"The commission stated that the image should be of a Michael Moorcock character with the only constraint being that it must be an action scene. This in turn dictated that the most important element must be the dramatic pose of the central character.

"The basic pose was nailed down in several dozen stick-figure scribbles. I then concentrated on the composition of the main character and on the abstract shapes that would best frame and support it. After I had done a few more quick sketches I began to feel that I had a composition with the potential for a dynamic illustration.

"Since the character was now sketched and balanced in an action stance, the next step was to decide upon what he was in conflict with. I, of course, chose some hell-spawned demons, placing them entering the scene from the right. I then needed an element on the left to equalize the heavy darks of these creatures, hence the vase and rotten vines. I wanted the viewer's eye to flow around within the painting, to follow the action. The theory of my approach was that the eye should first notice the white locks of hair before following along the line of the flowing cape and down into the attacking beast. The eye should then travel along the demon's tail into the vase, up and onto the vines, into the sword and, in the case of the final magazine cover, to the logo.

"I left the background as simple as I could, since my primary interest is in character painting. To me the backgrounds are only there to frame and accentuate the main character. If the background gets too busy it only distracts from what I do best."

**Demon Slayer**
**Pencil sketches**

**Opposite:** *Demon Slayer, Inquest*
**magazine, 1997**
**Oil on board, 45.5 × 38 cm (18 × 15 in)**

The simply rendered background allows the eye to be caught by the flash of white hair and to follow the whiplash S shape of the foreground action of hero and demons. It also suits the purposes of the artist, who confesses to a far greater interest in character portraits than in backgrounds.

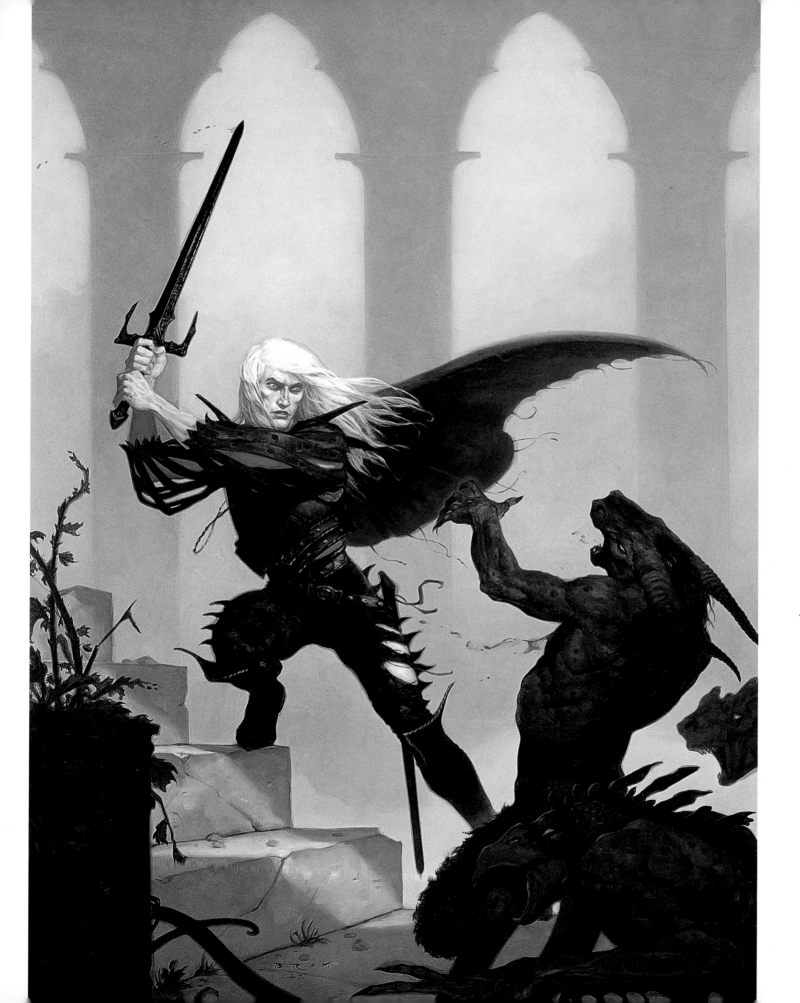

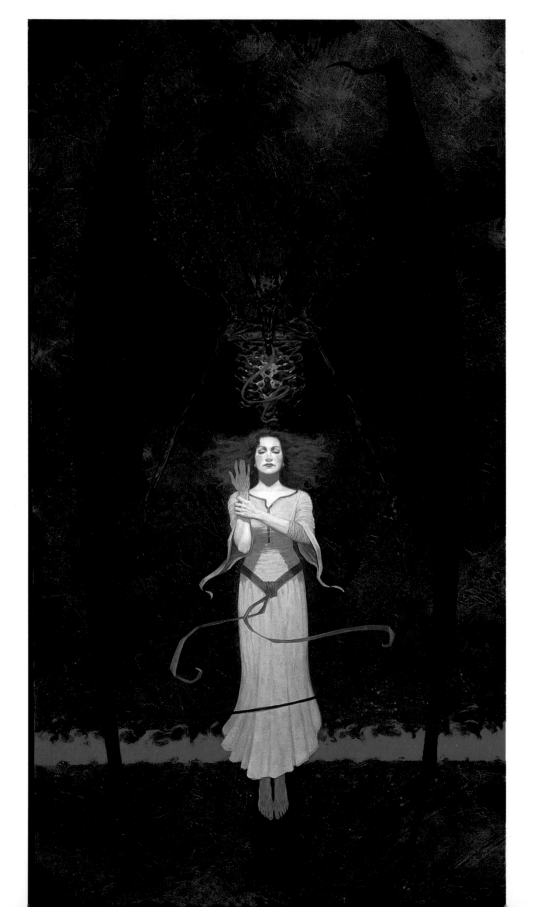

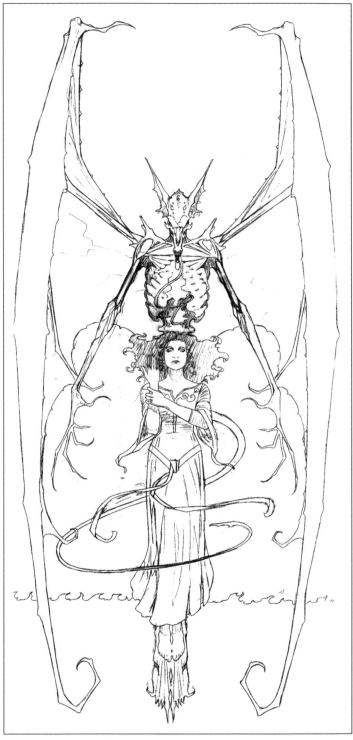

*Wit'ch Fire*
**Pencil sketch**

**Wit'ch Fire by James Clemens, Del Rey, 1998**
**Oil on textured board, 51 × 38 cm (20 × 15 in)**

## WIT'CH FIRE

"This piece is at the other end of the spectrum. It is much more designed and the elements work together to form an aesthetic composition of ideas as opposed to a literal interpretation of a scene.

"I was sent the manuscript to read, with instructions to come up with a few unique ideas and approaches. The book was very good – not afraid to get nasty. I felt immediately inspired.

"Once again, most of the groundwork was done in the sketching stage. This for me is a kind of artist shorthand – no pretty, well-rendered drawings, just quick scribbles and some notes for possible color schemes and compositional options.

"I had made a list of interesting elements while reading the story and used the layout stage to experiment with their visual potential. These roughs were presented to the art director and we brainstormed together on which one would best represent the unique feel of the book. After a few revisions we were both drawn toward the more design-orientated approach rather than just painting a scene from the book.

"Even though I knew I was to use photos for this project, I worked up the final drawing first. This enables me to get the best from both ways of working by allowing me the freedom to design the pose from my imagination before I am prejudiced by what has been recorded in the photograph and am trapped by reality. Hence the drawing of the young witch was already there to be merely augmented, rather than my producing a lame copy of photographic studies.

"After the necessary elements were in place to my satisfaction I photographed the model because I wished to convey the impression of a real person, as opposed to the caricature approach I often take. I made several studies of the model's face and hands and used them to incorporate the subtleties of reality into my drawing and to correct any glaring flaws.

"The drawing was then transferred to the board, and the underpainting began. I don't usually do any kind of preliminary color study; I prefer to work out the colors and tones by slowly building up the underpainting in acrylic and then form the shapes with later applications of oils. This part of the process is where the magic of painting comes from, watching unpredictable shapes arise from the colors rolling and crunching into each other, seeing flesh come alive and moods slowly settle in backgrounds.

"My main objective with this picture was to showcase the main figure of the floating witch. The focus was meant to be on her face, hands and flowing red hair. All the other elements are there to emphasize this focus

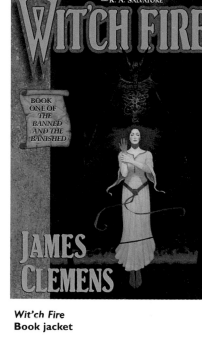

**Wit'ch Fire**
**Book jacket**

**Wit'ch Fire**
**Pencil sketch**

and to hint at the dark mood of the book. The demon is her major adversary in the story and I wanted him shrouded and subtle in the background to increase the feeling of menace and to avoid a major visual distraction from my chosen centerpiece. The chaotic, red-textured background further set the mood and fire was the only choice to pull every component in the picture together.

"I am very happy with the finished painting; I rarely get a chance to work with the emphasis on design and the witch came out very much as I had envisioned her, a success I cannot always claim. A face presents such a challenge, not only to make it unique and believable, but also aesthetically pleasing and, in this case, beautiful. Having achieved that, the most difficult and important part is to convey some sort of emotion. I'm not exactly sure why but this piece just seemed to convey the right emotions for me. Maybe it's her large closed eyes or the contrast of a beautiful woman entangled with such a horrendous demon."

**Ghoul Priestess**
**Pencil sketches**

The sketching process systematically eliminates unnecessary background detail in favor of the central character, which will be further developed at the painted stage. The impact that the magazine's logo will have on the design is also considered at this stage.

## THE GHOUL PRIESTESS

"This painting was very much inspired by a trip to the Tate Gallery in London. The aesthetic realism displayed by Waterhouse, Bouguereau, Lord Leighton, the Pre-Raphaelites and many other artists working in the latter half of the 19th century made a considerable impact upon me.

"One of the first things that you notice about paintings by the Pre-Raphaelites, and by the old masters too, is the size in which the artists chose to work. Most of their figures were painted close to life-size, which enables the artist to really let the brush flow over the form as opposed to becoming engaged in fiddly brushwork – a practice that I find myself indulging in far too much at times.

"Doubting that I would be provided with either the time or the resources to create a 12-foot-tall [3.6 meters] painting, I looked for an opportunity to design a piece that would allow me to paint just the upper body on this kind of scale. Luckily just such a chance came along when I was asked to create a cover for *Dungeon* magazine. The art director sent me the manuscript of one of the featured stories and gave me full freedom to interpret whatever I wished.

"The story focused on the ghoulish underworld, so my biggest dilemma was to decide which of the many great images from the story to use in the creation of the cover. I only needed a few quick sketches to nail down the composition and I was ready to go into the final drawing.

"After working out the form, the costuming and the incense vase, I shot a few photographs of my model to tighten up the anatomy. Then I grabbed a 4-foot-high [1.2 meters] canvas and began laying in the underpainting. Of prime concern at this stage was the necessity to exploit my love of costume design while retaining just as much of the painting's focus on the priestess's eerie white flesh, the pale skin being the most important part of the piece. I achieved this in the final painting by keeping the detail and tone of the elements muted and downplayed while using soft light to keep the flesh aglow. I allowed myself only a few strong highlights on the urn and the sword to keep the eye moving about the painting.

"This commission was a project for which I was allowed to pursue my inspiration. I found myself lost in the painting, my adrenalin pumping as it slowly came to life, obsessing about it day and night throughout its creation. How well I hit the numbers, how well it would be received by others, did not matter to me while I was painting it – I was simply and wonderfully lost in the joy of creating."

*The Ghoul Priestess,*
*Dungeon* magazine, 1998
Oil on canvas, 71 × 56 cm
(28 × 22 in)

# PAINTBRUSH
# TO PIXEL

In this section are grouped three artists who have started to add the massive potential of computers to their range of tools while still using traditional media. The doyen of SF airbrush illustration, Jim Burns, shares the secrets of his formidable techniques; the man responsible for the first digital SF cover, Rick Berry, provides clues to the mindset of an artist; and Chris Moore explains technique and graphically demonstrates the importance of keeping everything carefully filed for future reference.

**Opposite: Chris Moore, *Blindfold* (detail);
Left: Jim Burns, *To Hold Infinity* (detail);
Above: Rick Berry, *Demon***

# Jim Burns

*"From early childhood onwards, my main interest in art was always to try to bring a degree of photographic conviction to my efforts."*

The work of Jim Burns has long been the yardstick for the hyper-real, highly detailed, impeccably realized acrylic paintings that adorn the covers of science fiction novels. His characters fill us with a sense of déjà vu and leave us wondering why a certain face is so familiar, while his stylish futuristic fashions and architecture and his sleek, alien, but practical vehicles convince us that this future may well be possible when technology and science catch up. Needless to say, his work has spawned a school of less accomplished imitators, who are easily identified because few can come near him in terms of technique, color sense or vision. It is possible to reach a certain scene in a science fiction novel and recognize that this was the inspiration for the Burns cover painting.

Having created a style that can loosely be described as "photo-real" – albeit with beings in settings which have little or no connection with contemporary reality – Jim has imposed upon himself a discipline with regard to the manner in which he depicts his human characters. The more "real" a scene in a picture, the more convincingly real the people who inhabit that scene have to be.

Jim explains, "I seem never to have had it in me to create a stylized or distinctively individual way of working, though people do tell me that my work is identifiably my own. From early childhood onward, my main interest in art was always to try to bring a degree of photographic conviction to my efforts.

"That isn't to say that I was ever much cop at portraying the human form convincingly! At art college back in the late 1960s and early 1970s there was a drift away from traditional life drawing, and human anatomy as part of art training had long since disappeared. This is an ongoing situation, and I think it is a great shame – anyone who aspires to incorporate figure-work in their art would be well advised to spend as much of their own time as possible making good this deficiency.

"I am still hopeless at spontaneously drawing the human form. It's a skill I simply don't possess. I have

**Seasons of Plenty by Colin Greenland, Voyager, 1995
Acrylics on gessoed hardboard, 86 × 116 cm (34 × 45¹/₂ in)**

"The photo references show two of my daughters, Megan and Elinor, modelling for Tabitha Jute in Colin Greenland's own borrowed leather coat. 'Cool coat, Dad. Can we keep it?'"

"The Tabitha Jute study was done in pencil to try to refine the facial details and in particular Tabitha's somewhat unruly hairstyle. A close scrutiny of the transparency of the painting itself and the printed version will show some minor changes — mostly hard-to-spot refinements to detail in the background, but more importantly to the muzzle of the Thrant bodyguard. In the printed version he looks too much of a gentle pussycat and too little the unpredictable and dangerous creature described in the book, so when I got the painting back I gave him a bit of a snarl!"

## BIOGRAPHY

❖ Jim Burns was born in Cardiff on 10 April 1948 and received a grammar school education in South Wales. From 1966 to 1968 he trained as a pilot for the RAF, an episode which ended, in his words, "disastrously."

❖ He then enrolled at Newport School of Art and completed a foundation course, followed by three years at St. Martin's College of Art & Design in London studying graphics and illustration. In his third year at St. Martin's Jim completed his first commission, *The Last Command*, for which he was able to draw on his RAF experience as the illustration commissioned was of a World War II Lancaster bomber.

❖ His first science fiction illustration was for *Towards Infinity*, published in 1972 by Pan.

❖ Since 1980 the majority of Jim's work has been published in the USA. His output is not prodigious and the American work, with its higher fees, has made it easier for him to make a reasonably comfortable living. However, he prefers the latitude given by British publishers, who are less inclined than their U.S. counterparts to provide a brief for the cover.

❖ He has won many awards for his work, including two Hugo awards for Best Science Fiction Artist.

❖ His first collected work was *Lightship*, published by Paper Tiger in 1985. His second collection, *Transluminal*, was published by Paper Tiger in June 1999.

❖ He lives in southwest England with his wife and two youngest children. Between commissions he explores the intricacies of computer-generated art – or, as he prefers to define it, "digitally-realized illustration."

to fall back on photographic reference sources for my main characters, although I can get away with tiny little background figures straight out of my head. All sorts of photographic material becomes a resource to me. I have vast archives of potentially useful material from myriad sources squirrelled away, including magazine images going back to the 1960s which are now getting very flimsy after countless 'reference hunts.'"

Burns has become adept over the years at distorting "found material" in subtle but convincing ways so that the original source becomes considerably altered but retains its essentially photographic quality. When the commission requires it, he will often assemble objects, pose the models and do his own photo-shoot.

From his viewpoint as a reader, Jim's preferences lie in the direction of what might loosely be termed "hard SF" – in other words, that branch of genre writing which tends to rely upon the artefacts of advanced technology, confrontations with alien races and believable extrapolations of science into a variety of future scenarios.

"I don't by choice read a great deal of fantasy. I prefer to see violence meted out by maser pulse weapons than by the sharp edge of a sword – particularly a sword with a name – and I tend to run a mile from words like "dragon". This reflects somewhat obviously in the work that comes my way.

"Having said that, there are exceptions. I have a special affection for Robert Silverberg's Majipoor series of novels, which I think many people would classify as fantasy rather than mainstream SF, though I'm inclined to group this style of future medievalism with its suggestion of technological stuff going on off-screen more with my favored genre. I can honestly say that I enjoyed painting the covers of the Majipoor books as much as any work I've ever done."

## IT'S A FAMILY AFFAIR

Each of Jim's three daughters has found herself following in their mother's role of unpaid model for Dad's latest "weird picture." With many of the pictures in the selection here there has been a fair bit of initial referencing with imaginative elements feeding in at different points in the completion. Sometimes paintings are very highly dependent on this photo-reference stage in order for the photo-real look to be attained.

Some paintings, however, use little or no photographic material. These are usually of the more far-out subject matter where the imagination has more freedom to roam, though Jim has large archives of reference material showing interesting textures, reflections or peculiar detailing which he will often consult in search of

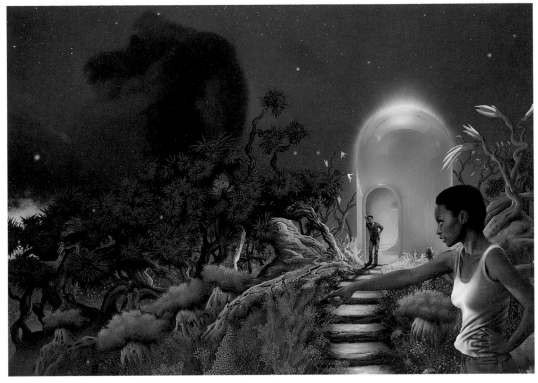

*Ancient Shores* by Jack McDevitt, Voyager, 1995
**Acrylics on gessoed hardboard, 52 × 70 cm (20½ × 27½ in)**

Once again, Jim's daughter Megan adopts the pose for a cover painting. The painting was an exercise in deliberately ditching self-restraint with regard to color. "'What if I painted the whole thing red and purple?' I thought. Seemed to come out OK!"

some kind of synergistic revelation. This is how he is often able to create such offbeat organic surfaces, superimposing references such as seaweed onto unlikely objects such as humanoids or machines which he has decided to include in the cover painting.

## MODUS OPERANDI

"The preliminary *modus operandi* remains more or less the same in virtually all my painted work. I work on ordinary hardboard – the smooth rather than the textured side. I cut the board to size, allowing extra for a good border, then sand the edges in order to round them off a little as the square-cut edge of hardboard is more vulnerable to damage. I also lightly abrade the surface with sandpaper to give more of a tooth for the gessoing stage which is to follow. I then wash all the dust off the board and after it has

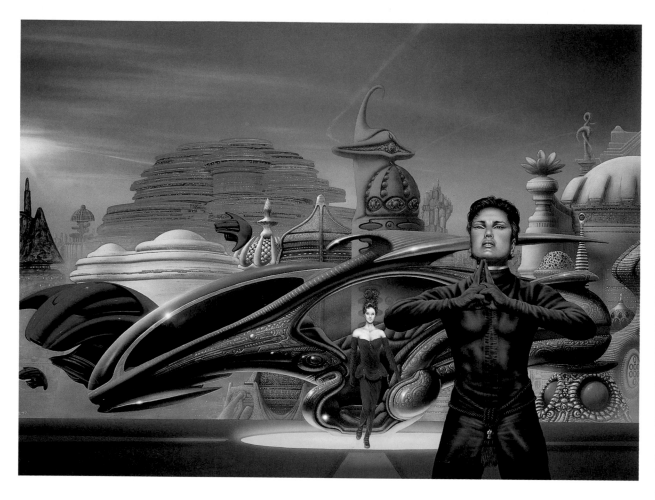

**To Hold Infinity by John Meaney, Transworld, 1997 Acrylics on gessoed hardboard, 50 × 70 cm (19¹/₂ × 27¹/₂ in), plus pencil sketch**

The photograph shows Jim's youngest daughter, Gwendolen, taking up one of the oriental finger-knitting, energy-channelling poses known as Kuji-Kiri which are adopted by Yoshiko Sunadomari, the central character of this excellent first novel.

"I enjoyed this painting immensely and got a terrific bonus out of seeing the writer's face light up when he saw it. That sense of satisfaction on my part was further buoyed up when he wanted to purchase it. I find it very rewarding when a writer likes the cover painting for one of his or her books enough to buy it."

completely dried I apply the first of five coats of a good-quality acrylic gesso.

"This first coat is usually quite highly thinned with water. The following four coats are less dilute – just enough water to allow the gesso to go on smoothly. Some artists sand between each coat of gesso and end up with a wonderfully glass-smooth surface on which to paint. Laziness more than anything else dictates that I leave all my sanding to the end, which seems to work fine for me. I then give the board a quick run under the tap and a gentle once-over with our pink-handled back-scrubbing brush to remove any traces of gesso dust!

"When it's absolutely bone-dry I draw in the edge of the picture and mask out all the outlying border areas so that the clean white border remains at the end. I run a little extra gesso around the edge of the mask and then just rub it off with a finger to smooth it so that paint doesn't leak under the masking tape edge and spoil the border. In the past I too often found myself trying desperately to clean up a tatty edge with time running later and later on a deadline I'd already missed, so I eventually decided it was worth avoiding the extra

stress at the end by putting in more preparatory work at the beginning.

"I'm now ready to start drawing out elements of the composition and adding the paint, which these days means a fairly crude underpainting over the whole surface with a watered-down tint of the shade that most closely approximates my anticipated shadow tones. Depending on how densely the later coats of paint are to be applied I sometimes put a glaze of color – often a yellow – across the whole board as well, which provides extra luminescence.

"The main process of painting is, for me, a fairly undisciplined business. I gravitate between various brushes, small or large, bristly or soft, quite randomly, and the airbrush sits in this arbitrary sequencing just like any other brush. Most of my more detailed brushwork is done with Dalon Series D77 synthetic brushes. I find that natural brushes simply don't last as long and can get very expensive. Most of the smaller brushes I use, say between sizes 00000 and 2, are only good for one painting or maybe two if I'm feeling gentle, so I get through a lot of brushes.

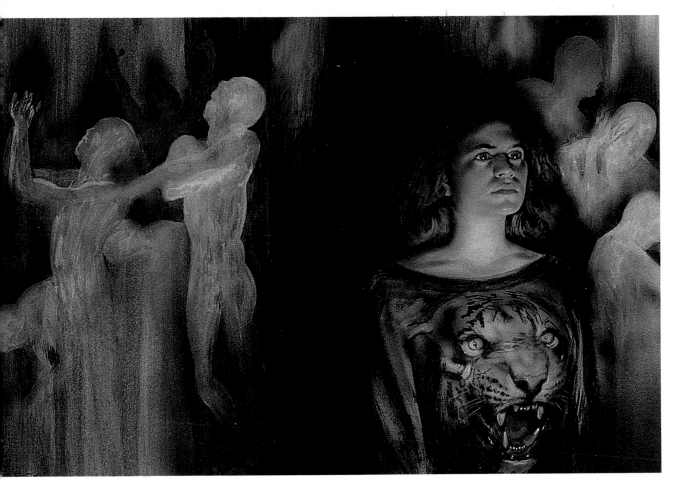

*Kaeti on Tour*
**Photo-references and preparatory
sketch in acrylics on board**

"The airbrush I use is a Badger 150 — a simple and relatively inexpensive piece of equipment, but one which I'm used to and which has served me very well over the years. Nozzles and needles wear out very quickly though and are frequently replaced. I use a compressor to power the airbrush. Anyone seriously considering using the airbrush a lot for their art would be well-advised to purchase one. They last a long time, and my big old Simair has only finally turned up its toes quite recently after more than 15 years of almost daily heavy use. Compressed air cans, conversely, last for a depressingly short time and the cost adds up, severely inhibiting one's use of them.

"I use a variety of acrylic paints from different manufacturers, both British and American. Each range has its own qualities and colors. You're not supposed to intermix colors from different companies, but I do it all the time with no ill effect that I'm aware of.

"I sometimes draw over the paint with water-soluble pencils and use a wet finger quite a lot to push the pencil around and 'harden up' compositional elements into their final locations. One shouldn't overdo this sort

of thing, though, as the acrylics do not always sit too happily on top of dense pencil. I sometimes apply airbrushed ink glazes over the final acrylic coats to add a little more vibrancy to the acrylic finish, which is occasionally slightly dead. I use a lot of masking fluid to isolate areas for airbrushing rather than frisket film, which I know is preferred by some artists.

"When the whole thing is finished I give it a coat of Liquitex acrylic matte medium usually mixed with a little gloss medium just to lift the flatness a touch, and then the painting is packaged up and sent to my agency for forwarding on to the client."

## KAETI ON TOUR

"I knew Keith Roberts as the writer of *Pavane*, probably the best alternative history of them all, which I'd read many years before with huge enjoyment. I'd never met him so it was with great delight and not a little humility that I found myself talking to him on the phone one day. Apparently he'd followed my own progress with some interest — Keith is a talented artist in his own right — and thought that I might be the right choice of

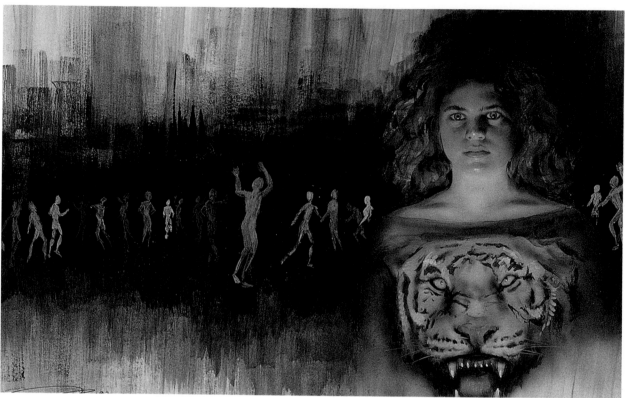

*Kaeti on Tour*
**Preparatory sketch, acrylics on board**

*Kaeti on Tour*
**Final book jacket**

cover artist for his new book. We very speedily came to an agreement over the brief, fees and so on, and I started work on a couple of preliminary sketches for Keith's perusal.

"We decided to base the cover on the short story entitled 'The Tiger Sweater.' An obvious choice of model sprang to mind, more by name association than anything. A local girl named Katy Courage who had done babysitting for us in the past seemed to me an ideal subject. She was more or less the right age and was blessed with a terrific face – huge eyes, wonderful bone structure and suitably disorganized dark wavy hair. Better still, she overcame her shyness at being asked to pose for the photos and found the whole thing a bit of a hoot. Out of the session came a couple of color sketches completed in acrylic washes for Keith's approval. Fortunately he declared my choice of model to be 'perfect,' and chose one of the two sketches (it now resides on his wall).

"I decided to limit the palette to variations of browns and yellows – essentially the colors of the tiger in 'The Tiger Sweater,' I suppose, though I don't recall this fact being obvious to me at the time. Such decision-making is sometimes almost unconscious; a nearly monochromatic approach just felt appropriate on this

occasion. As a consequence a lot of subtly spooky atmosphere is generated on the canvas.

"Kaeti's face is almost purely airbrush work. A base flesh tone was laid down and the details of facial features were drawn over this lightly in pencil. Then, with glazes of raw umber and burnt umber and a little Payne's gray, the face was slowly almost sculpted up into a three-dimensional reality. A tracing overlay was occasionally dropped down to check that the features were remaining in their correct places – eyes in particular have a habit of wandering off into new locations as the original pencil marks slowly vanish beneath the multilayered assault of paint glazes.

"A very transparent Indian yellow ink wash was then airbrushed over this along with a little acrylic Acra red, highly diluted and very transparent to add a hint of rosiness to the cheeks. I always use this invaluable and expensive red to bring life to a face. It's almost as if the blood flow is suddenly switched on, so dramatic is the improvement. I used to get much the same effect when I worked in oils with rose dore – but both colors need to be used very judiciously.

"To finish the face a little darkening of shadow areas was added to compensate for the tendency of the most transparent glazes to even out the tones somewhat, and

a few highlights were added to the nose tip and eyes. The rest of the cover design was handled in a much looser fashion, which helps to draw the eye to the detail 'hot spot' of Kaeti's face.

"The 'woodlike' backdrop is simply broad vertical washes of burnt umber, much diluted and airbrushed over with more burnt umber and burnt sienna, while the ghostly figures looming out of the background are the most simplified and cipherlike indications imaginable, a combination of brush and airbrush work."

## STEPPING OFF THE PAGE

A vigorous postal communication took place between Jim and Keith Roberts over the course of this piece of work. Keith's enthusiasm for the project was most infectious and Jim is on record as saying that the process is rarely as enjoyable for him as it was on this occasion. In a letter to Jim, Keith referred to a conversation he had had with a colleague involved in the production stage of the book.

"'What the hell's she looking at?' was a question he asked a number of times; but when I put the same point to Katy Courage, her answer was inimitable. She said it was the door of your studio, and it couldn't half use a lick of paint. As I recall, you told her not to give away trade secrets. I was delighted, of course; it

**Above:** *Kaeti on Tour* **by Keith Roberts, the Sirius Book Co. Ltd, 1992 Acrylics on gessoed hardboard, 44 × 96 cm (17½ × 38 in)**

**Left:** *Kaeti on Tour* **Preparatory sketches, acrylics on board**

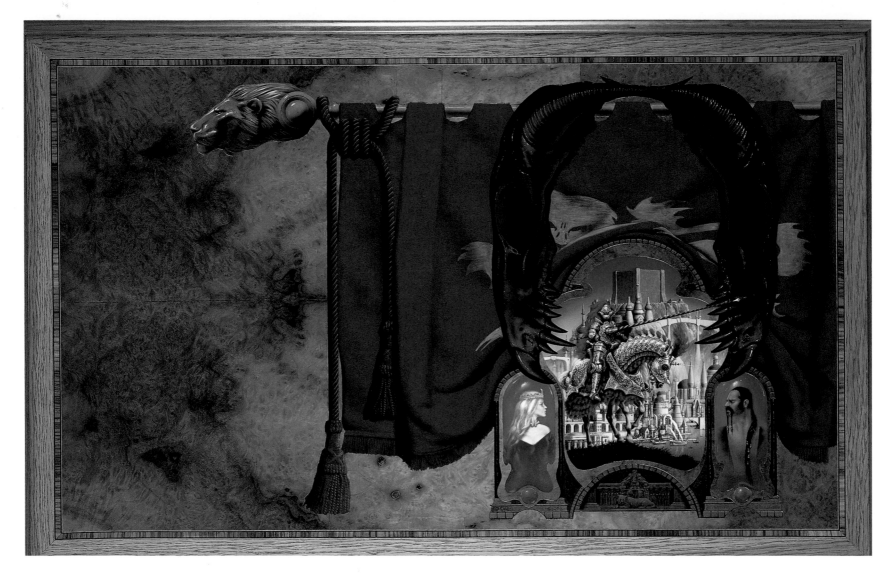

was exactly the sort of thing Kaeti herself would have come out with. But of course it was Kaeti I was talking to; or her beautiful avatar. A magic circle seemed to have completed itself, with no conscious intervention from me."

Keith's single brief conversation with Katy Courage had occurred on the occasion when she and Jim drove down to the hospital near Salisbury, in Wiltshire, where Keith was recovering from an operation. Jim was keen to present the painting to Keith in person and invited Katy along as a very proactive member of the whole enterprise.

Jim says, "In another letter to me, Keith wrote, 'A shy thank-you should be extended to Katy as well; the whole visit was a bright episode in what had been a dreary, seemingly endless time. The memory will certainly stay with me; as I have already observed,

perhaps ad nauseam, there are or can be few writers whose main character has stepped off the page and kissed them. I'm unsure what conclusion should be drawn from that, except that Kaeti/Katy is even more magic than I allowed for.' For me, that was a most rewarding moment."

## A GAME OF THRONES

"The brief here was pretty straightforward. An approach often taken with fantasy novel covers is to require a selection of elements from the tale to be tastefully arranged within the design, usually symmetrically and with the lush use of frames, borders and other decorative motifs, giving the whole thing something of the quality of a rich tapestry or an exotic wall-hanging. This was very much the requirement here, so I decided to go at it with a vengeance. It so happened I'd been browsing

*A Game of Thrones* **by George R. R. Martin, Voyager, 1995**
**Acrylics on gessoed hardboard with decorative veneer elements, 54 × 88 cm (21 × 34¹/₂ in)**

*A Game of Thrones*
**Book jacket, detail**

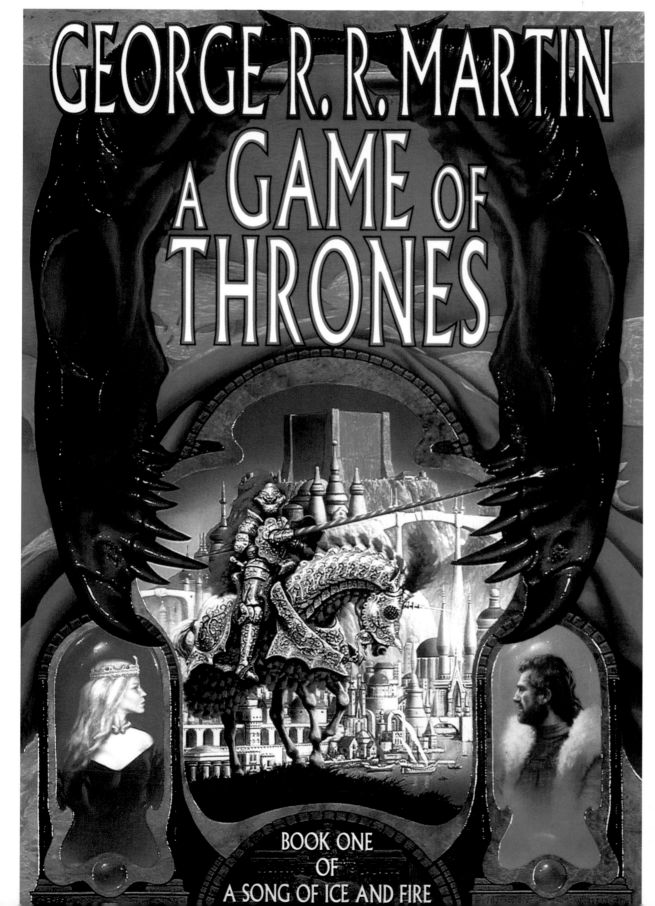

**A Game of Thrones**
**Pencil sketch**

**A Game of Thrones**

Photo-reference for the folds that appear in the banner draped over the image of the charging knight.

**A Game of Thrones**
**Final book jacket**

Hidden within the reproduction is a highly complex set of veneers which, although apparent in the original painting, completely vanish in the jacket art. Note the last-minute change of character in the bottom right-hand panel, an image added in Photoshop just prior to publication.

69

around a local timber merchant's premises and was taken with the beautiful selection of exotic hardwood veneers on sale there. I decided, somewhat rashly it transpired, that what was needed to lift these paintings out of the ordinary was a generous application of these veneers acting as framing elements for the various narrative motifs to be featured on the front cover.

"How I ever convinced myself that the whole process of veneering was bound to be as easy as falling off a log I'll never know. I love to set myself little artistic challenges, but this one almost defeated me. The combination of delicate, wafer-thin, expensive wood, water to make it malleable and crack-resistant, hot irons to dissolve the glue, the shrinkage and cracking along convoluted burr lines as the veneer dried, the complex cutting of border shapes, the oversanding of the veneer and its subsequent removal and let's-start-all-over-again was enough to drive me to distraction. But it was a question of 'I've started, so I'll finish.'

"The knowledge that by completing the first book of the *Song of Ice and Fire* series in this fashion I was pretty much committed to doing the second, third and fourth books in exactly the same way was enough to seriously test my sanity! In fact I did quite enjoy the whole process, dogged, stubborn persistence with unyielding obstacles being one of my iffier virtues. But, boy, did it play hell with my schedules and in particular the deadline on this job — and strict adherence to deadlines is not one of my strong points.

"In *A Game of Thrones* the main body of veneer is maple burr. The outer border, which doesn't appear on the printed cover, is American red oak and the banding which separates these two is tulipwood."

## ALL THE COLORS OF THE SEASONS

"It was suggested to me at the outset that it would be an attractive aesthetic notion to convey a sense of the seasons in each of the four covers, this first being a 'summery' sort of design painted appropriately in the colors of summer, so I went for bright reds and blues here. The cover for the second volume has been completed in yellows, golds and autumnal reds.

"The large background banner is that of one of the noble houses described in the story — a theme I'm carrying through the series, with a different-colored banner in each. A sun-bleached goat skull that I found while I was roaming around some ancient ruined fortifications on the south coast of Crete served as the model for the dragon skulls which frame the upper half of the picture.

"All the various elements found within the elaborate frames on the front cover are based on characters and

incidents described in the text, the idea being to try to convey a sense of this narrative to the potential reader. When the brief allows me to I try very hard to get some sort of truthful visual analogue to the story. It is often the case too that I get passionately caught up in some element of the design and proceed to push deeper and deeper into the detail. This was the case with the knight and his elaborately armored war-horse — a detailed section of the painting with which I was particularly pleased.

"I was asked to replace the character in the bottom right-hand corner of the painting with one of the more mainstream characters, which I did as a separate little painting. The varnish that I used on the main painting — a wood varnish to bring out the grain in the veneer — was carried across the acrylic painted areas also. This varnish would not provide a good base for corrective acrylic work, hence the need for the little character study you see on the printed cover to be done separately and digitally scanned in at the art director's end. At this point the color matching seemed to go a bit wonky — I don't think it was at the painting stage."

## SLANT

"I love Greg Bear's particular brand of hard, convincingly extrapolative science fiction. The combination of this with a tense crime thriller and an exploration of themes revolving around the nature of human relationships produces in *Slant* a hugely readable book and suggests a writer who enjoys pushing a boat out into uncharted territory. It's all done so convincingly.

"I had completed a cover for a Greg Bear book many years before — the Gollancz edition of *Eon*. That required a hardware-orientated approach in which humanity was reduced to dots — or less than that, really. The dots were the tiny road vehicles traversing the interior of the vast habitat which provides the location for the unwinding tale. Humanity was the supposedly even more minuscule dots being carried within them.

"In *Slant* the characters are not overwhelmed by the high-tech location in quite the same way, though Greg manages as usual to convey a pretty awe-inspiring near-future scenario. This time we follow the fortunes of his heroine, Mary Choy, and it was the assumption from the start that she would provide the main focal interest on the front cover.

"Occasional reference is made in the story to a Swanjet — some kind of flying machine. In view of the evocative name I assumed Greg had a mental image of some sort of graceful-looking aircraft, but his actual description in the book is a bit cursory and I'm a stickler for this kind of detail. So, as is often my way,

*Slant* by Greg Bear, Legend, 1997
Acrylics on gessoed hardboard,
46 × 75 cm (18 × 29½ in)

The majority of the preparation for this painting centered on the finely realized Swanjet destined to end up discreetly placed on the back cover of the book. This attention to detail is what defines Jim Burns's work.

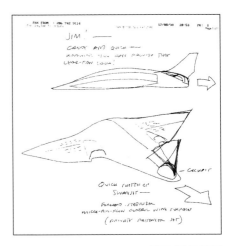

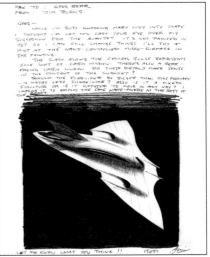

**Slant**
**Pencil sketches**

From top: The author's sketch, Burns's sketch and notes, and the final line visualization.

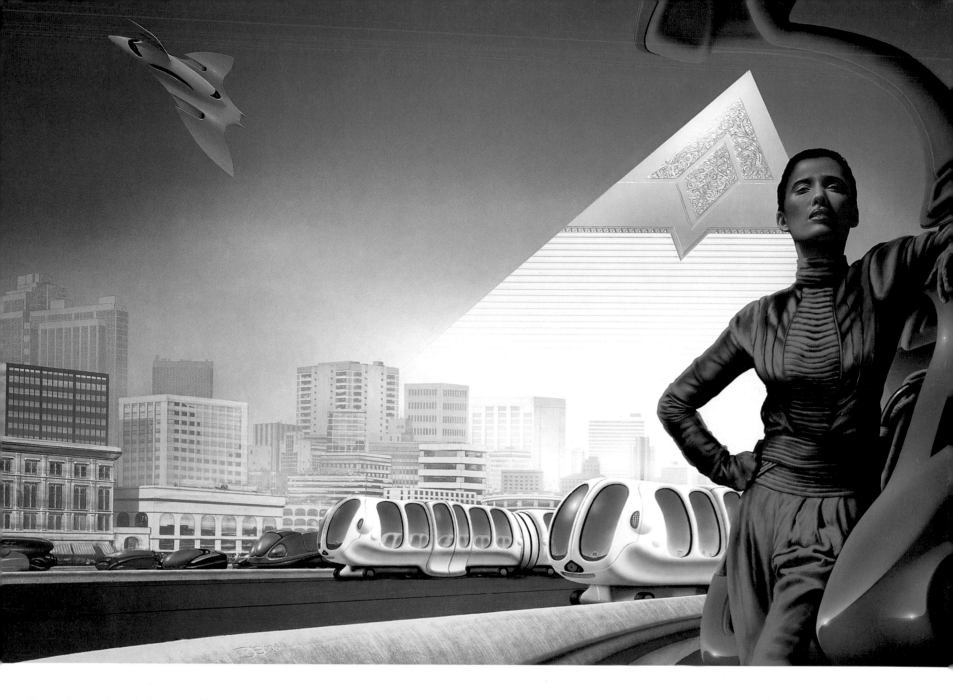

I complicated the whole essentially simple process by getting in touch with Greg over in the States in order to fill in the information gaps. Such conversations invariably throw an extra curve or two in my direction and this one was no exception.

"I suspect Greg may have had a longstanding crush on the actress Deborah Kerr, as he was keen that I should model Mary Choy on her. It was one of the odder requests to come my way and one which in the end I have to admit I kind of ignored – though I did look at some old publicity shots of Ms. Kerr. The costume seems to have come more from *The King and I* than *From Here to Eternity*!

"The point of the call though was really to sort out the appearance of the Swanjet, and rather gratifyingly

*Slant*
**British cover (left) and pencil sketch (far left)**

**Strafer, unpublished**
**Digitally created**

Jim created this piece while he was exploring the parameters and potential of his new digital art software. A photograph of his garden wall served as the background for this SF dogfight. An earlier project's pencil sketch of a dolphin craft was then scanned in to be reshaped in a more aggressive avian form and airbrushed in Photoshop.

The painted wreck of an enemy plane was ignited by cloning photographs of a burning oil rig and the background layers were given a speed blur. A cloned image of the first Strafer plane breaks the smear of smoke and provides a triangular balance to Jim's first-ever completed piece of work on his Mac. He was sufficiently pleased with the result to display prints at the 1998 British Science Fiction Convention.

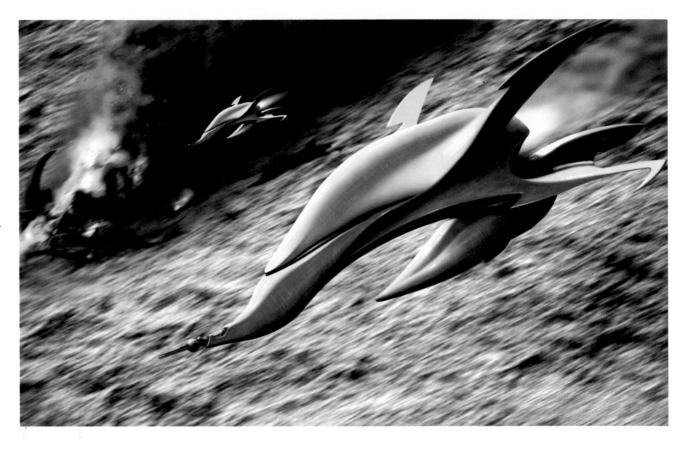

"The first appearance of this vehicle was as the dolphin ship on the cover of *Analog* (left). The pencil sketch for this (above) was scanned into a computer and changed into the avian shape featured in *Strafer.*"

"A 35mm slide I took of a section of garden wall was scanned into the computer. Motion Blur was added in Photoshop to give the impression of moving at high speed over the terrain below."

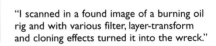

"I scanned in a found image of a burning oil rig and with various filter, layer-transform and cloning effects turned it into the wreck."

Greg suggested that he fax me his idea of how the craft might look. I hadn't known until then that Greg is himself something of an artist and is more interested than most authors in the processes involved in the cover artist's work.

"The final version of the Swanjet that appears on the back cover of the book is based quite closely on Greg's own sketch but with some extra curves and little refinements added. The figure is an amalgam of found facial reference material, much altered and tweaked, while the body pose and the jacket are taken from some snaps I took of my long-suffering wife, Sue, who over the years has modelled for me as space heroines, queens, strumpets, the lesbian Greek poetess Sappho, the cowering victim of monstrous creatures and the Bride of Frankenstein."

## LORD PRESTIMION

"By July of 1998, after 18 months of sometimes very frustrating attempts to get to grips with digitally realized art, I finally felt confident enough to tackle a proper commission with the equipment. I've had a growing conviction over the last few years that the way forward in commercial illustration is definitely digital – particularly in the realm of science fiction and fantasy art.

"Painting in the traditional manner is obviously not going to disappear – I'm certainly not going to stop and I'd like to think that I'll be producing more personal, more adventurous work in paint which in turn will help to inform the routes I'll follow with the digital output. I see the computer as a fabulous, enabling new tool coming into the studio environment and not some ghastly, impersonal gadget which takes all the soul out of art, which is how a lot of people regard it. It gives me precisely the same kind of thrill that mastering the airbrush gave me 25 years ago – only more so.

"I think most people have an idea in their mind's eye of 'computer art' which is, frankly, quite erroneous in the context of current output. The fact is that there are all sorts of spurious 'realities' being created in print, on TV and on film and video by masters of the new art form – and most of us don't realize the artifice going on right before our eyes. The same tools and the same software, more or less, is available out there to anyone who wishes to explore its creative potential. It doesn't produce work that 'all looks the same' – as long as one goes about the process in the right way – and it seems to me to offer an infinity of possibilities.

"After the time-consuming business of learning the new processes involved, that time spent is quickly recouped when one starts on an actual digital painting. The process is incredibly pure – almost all of it is simple creation. No mixing of paint or cleaning of brushes. No mess. No interminable airbrush cleaning (how well I know my airbrush!). No inhaling of noxious paint components (you still get an aching back and your eyes start to bug out, but you can't have everything). Infinite ability to edit and correct work without having the trauma sometimes associated with attempts to do the same with a painted surface.

"And, of course, no painting. Yes, this is a bit of a problem – there is no actual painting at the end of the process. The potential sale of an original to a collector adds a not-insignificant chunk of income to the family's meager coffers and there will never be the same interest in acquiring a print, no matter how high the quality. I'm still getting my head round that one, but as I'm not

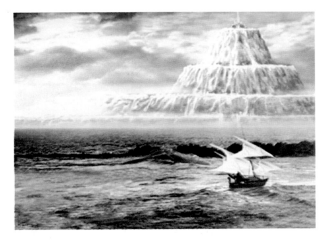

going to stop painting I'll still have originals to sell. It's a question of some kind of balance, but at the moment it's definitely the case for me that the excitement of the new technique outweighs all other considerations."

## WORKING IN PHOTOSHOP

"What particularly appeals to me about working in Photoshop is that it provides me with an almost exact digital analogue to the way I've always worked in the past. I use the software in perhaps not precisely the way it was originally designed to be used – but then the airbrush was originally designed as a photo-retouching tool, not the means by which SF artists create vast space panoramas or complex machines of the future.

"It seemed immensely important to me at the outset that the work I produced for my clients on the Mac should look like the work I'd always created in paint. Whether or not I've succeeded with *Lord Prestimion* I'll leave others to judge, but I'm happy with the result – or as happy as I ever am with one of my paintings. I've done so much work for Robert Silverberg's books over the years that it seemed most apposite that this first commissioned digital attempt should be for the latest in the epic Majipoor cycle – and I hope I've managed to capture some of that same Majipoor ambience I created in the earlier paintings.

"The sketch stage consisted of two alternative and quite different representations of the Isle of Sleep from the novel. They were created at a low resolution of 72 dots per inch and submitted to the client on a Zip disc. The chosen design then formed the basis for the finished artwork, which was created at a higher resolution of 300 dpi with an image size the same as the final printed output. This meant a file size of 37.7 megabytes.

"One of the great attributes of Photoshop is the ability to work in layers. Each element of the picture

can inhabit its own discrete layer which can be moved nearer or further away than other elements and worked on quite separately. I love this capability! On completion of the picture, all the layers can be finally merged together on to a single layer. At times I was working in 15 or 16 layers – which may not sound a lot to a seasoned user but seemed to me like a pretty dense visual arena in which to play. The sea, the various reflections off it, the sky, the moon, the rocks, the Isle itself with its harbor entrance, the ships and the separate reflections of all these elements plus the various buildings and even the tiny crewmen on the larger vessel all inhabited their own layers at different times.

"Maybe it was because there is still a large novelty value in the technique for me that at times I felt strangely drawn into the hyper-real but completely invented world within the screen.

"One very small but interesting bit of rock reference served as the basis for all the rocks and the line of cliffs receding into the distance. The 'rubber stamp' or 'clone' tool provides the artist with a fascinating new way of putting down a mark, with no real historical precedence in art except the potato print.

"I found myself using the 'traditional' painting and drawing tools and of course the airbrush tool a lot, and in fact it's surprising how one finds oneself working in much the same pattern as before, albeit digitally. However, one of the dangers in using this fantastically competent and well-thought-out program is the inclination to use preset effects – in particular filters – too much and I think this is what sometimes gives computer art a boring predictability. Such time-saving and very clever effects have to be used in moderation and with restraint. The same was always true of the airbrush. Is there anything more boring than an over-airbrushed painting? I did use the 'ocean ripple' filter in Photoshop to help give convincing reflections to the rocks and boats and quite a lot of 'Gaussian blur' to try to get a sense of depth of field to the image.

"Most of the last three or four days I spent on the image were occupied by attempts to distress it some-what to knock back that perhaps slightly overperfect computer rendering. This could be an interesting area for those clever programmers to work on: software to dirty up the scene a bit, polluting filters, grim ambience overlays, grime gradients. There's a program called Piranesi which humanizes those rather cold 3D architectural constructs in what looks like a most interesting way.

"On the last day of working on the image I dropped in the yellow tint to the nearer sea surface, which made a huge difference to the atmosphere generated. It was precisely the sort of thing I would do in paint, where

quite often at the last moment I spray in a transparent ink glaze to bring the thing to life – and even though the drying time of such sprays is very short it's not as short as the digital variant!

"By the time I'd finished *Lord Prestimion* it had moved quite a long way on from the original sketch version. Of course, one of the pleasing things about this kind of art is the fact that you can go on working on a copy whenever you like. I anticipate the larger part of my output over the next year being digital."

**Lord Prestimion
Artwork detail**

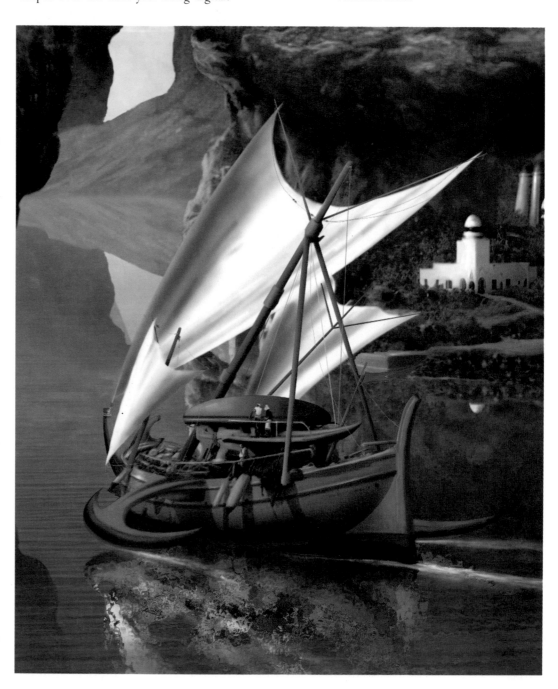

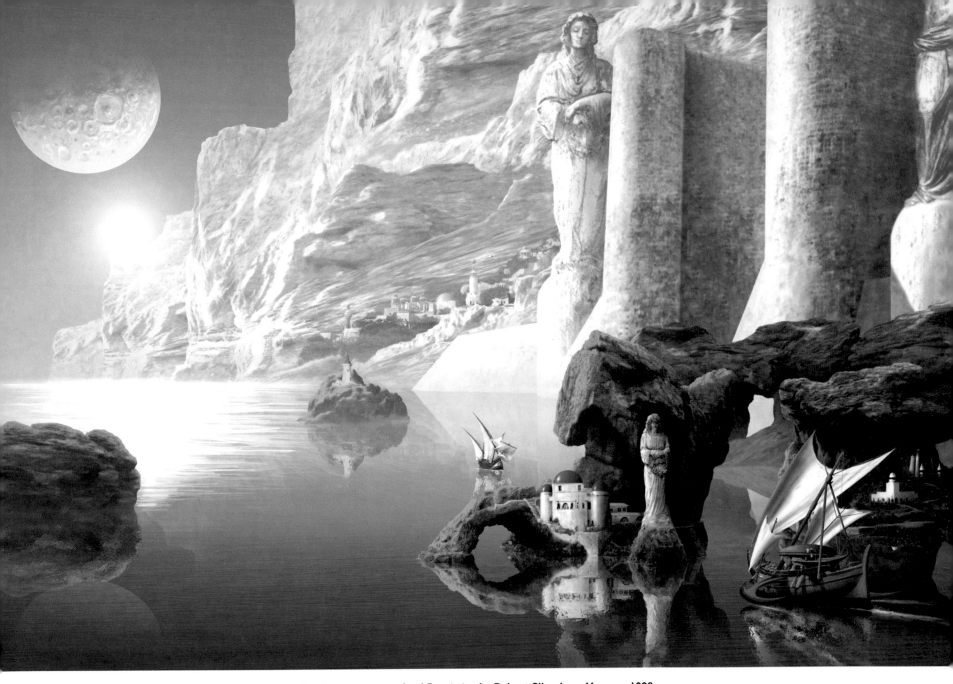

*Lord Prestimion* **by Robert Silverberg, Voyager, 1998**
**High-res digitally created painting**

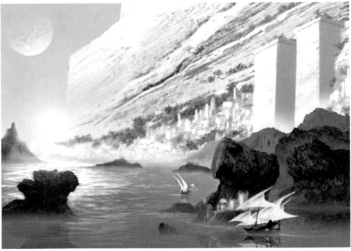

*Lord Prestimion*
**Low-res digital color rough**

 # Rick Berry

*"I see with the medium. Concept hardly ever hardens before the art begins to happen. The art is not done as an execution of a preexisting idea, the art is done to discover the idea. The sketch is just the finished piece part-way done, part-way conceived."*

Picture-making, for Rick Berry, has always been a wildly unpredictable process — by design. While this has produced anxiety in some art directors, there have been other bold hearts who seem to have understood what the risk-taking is about and the potential rewards inherent in this approach.

"Picturing things is rarely about what I've already seen, sketched out or planned; rather, it's about what can be discovered or otherwise made to be the last thing you expected to see. Hiring me can be a test of an art director's character. Still, there are those who do it and I can only guess that they see some sort of connecting thread through the work — a lifeline promising a coherent completion of the brief, something that says I'll deliver the goods."

## THE LUST TO DISCOVER

"In terms of education, I'm sort of a garbage man of 'how-to.' Having no formal training, I learned art wherever I could find it. However, I consider myself a far cry from being self-taught, a term for which I've a fair amount of contempt. On the contrary, I feel extraordinarily lucky to have worked with some remarkable people. Beginning with my mother, I've always been in the company of someone doing art.

"I became conscious of art as a way of life with the advent of Robert Crumb's ZAP Comix in the late 1960s/early 1970s. Seventeen years old and in the era of the Vietnam war, I took the rapid growth of underground publishing as the sign I'd been waiting for. I promptly dropped out of high school, bid farewell to the Colorado Rockies and hit the road. I wasn't alone. In those days midgets roamed the earth, and I was happy to be among them.

"The comix gypsies took as their paradigm something natural to the medium — collaboration. Studios were formed, dissolved and re-formed. Often one artist did a pencil, another did the ink and the both of them wondered who had done this new picture. Painting

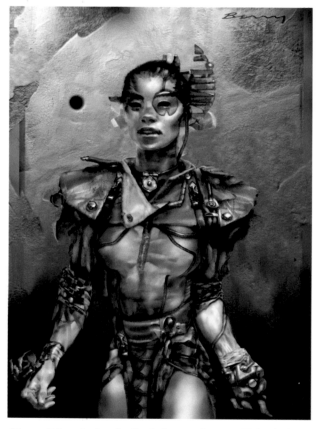

**Above:** *Cybertrix*, **for the Dark Age card game, FPG, 1996**
**India ink, china white and digital**

"This started life as an India ink/china white partial sketch on cardboard that was then scanned. Once it was in the computer I expanded the format and built her some hips and hands."

**Opposite:** *Red Prophet: Animal Man #84*, **comic cover, DC/Vertigo, 1995**
**Digitally created**

"This is 100 per cent digital paint, with no external sourcing or referencing. It was finished in Photoshop but was started years ago in Degas and Spectrum on the Atari ST. Photoshop is such a wonderful paint program."

### BIOGRAPHY

❖ Rick Berry was born in California in 1953. After repeated moves which caused him to attend 10 or so different schools, his first ambition was to leave school altogether.

❖ After a Kerouac-like life on the road, hay-making, silversmithing between the Navaho and Ute reservations and surveying miners' claims, Rick hitched east to Boston with the hope of pursuing a career in illustration. Finally, one step from living on the street, he got his toe in the publishing door by giving a hardback facelift to *20,000 Leagues Under the Sea* (Grosset & Dunlap, 1978).

❖ Rick embraced the digital realm in 1984 with the cover for *Neuromancer*, and has since evolved a style elegantly combining traditional oil paint techniques with the ever-growing potential of cyber-imaging.

❖ His work has been exhibited throughout the USA and he has won many awards and distinctions from both the SF and digital communities. He has produced concept art for television and with Darrel Anderson and Gene Bodio he created a 3D Computer Aided Design (CAD) cyberspace climax for the 1995 movie *Johnny Mnemonic*. He also created the 3D CAD Human Design Disc, an anatomical software model published by Antic Software.

❖ Rick has taught at the University of Tennessee, Adams State University and Tufts University in Boston.

❖ A book of his collaborative work with Phil Hale, *Double Memory: Art and Collaboration*, was published in 1993. His current project is a collection of digital images with Darrel Anderson entitled *Braid*.

❖ He lives in Arlington, Massachusetts with his wife Sheila and their three children.

❖ Website: www.braid.com

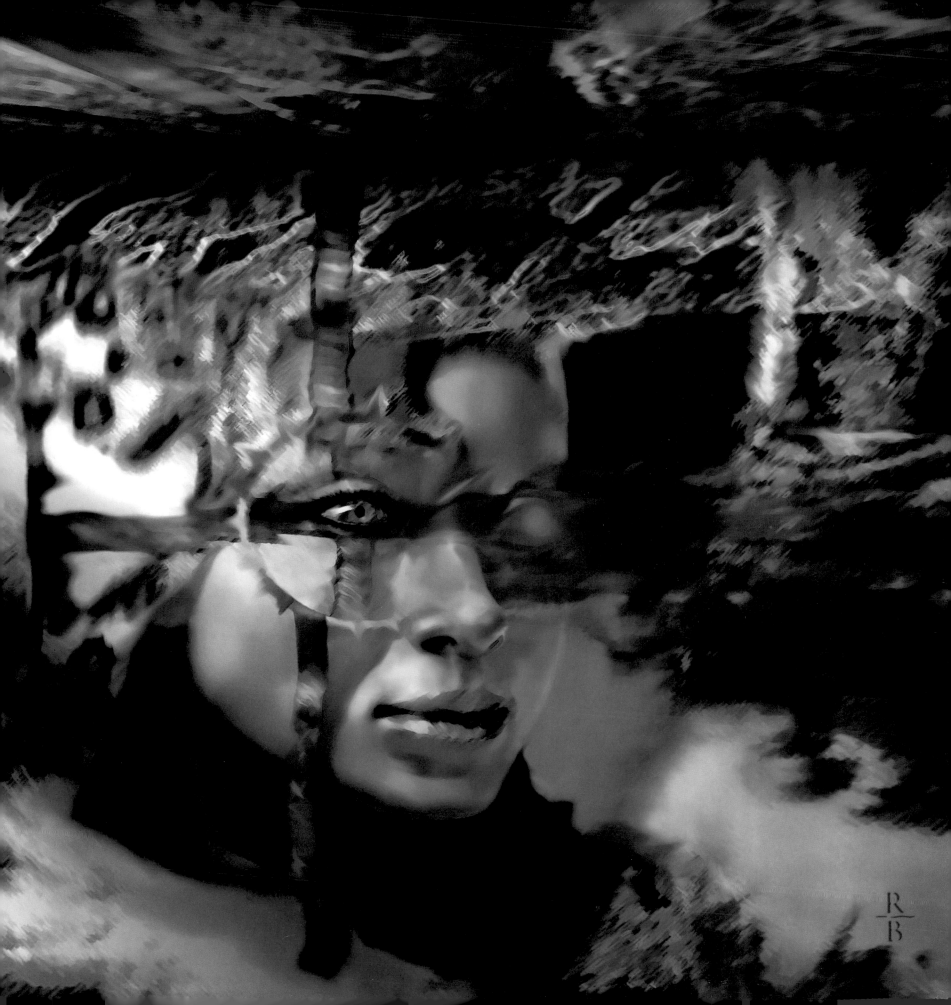

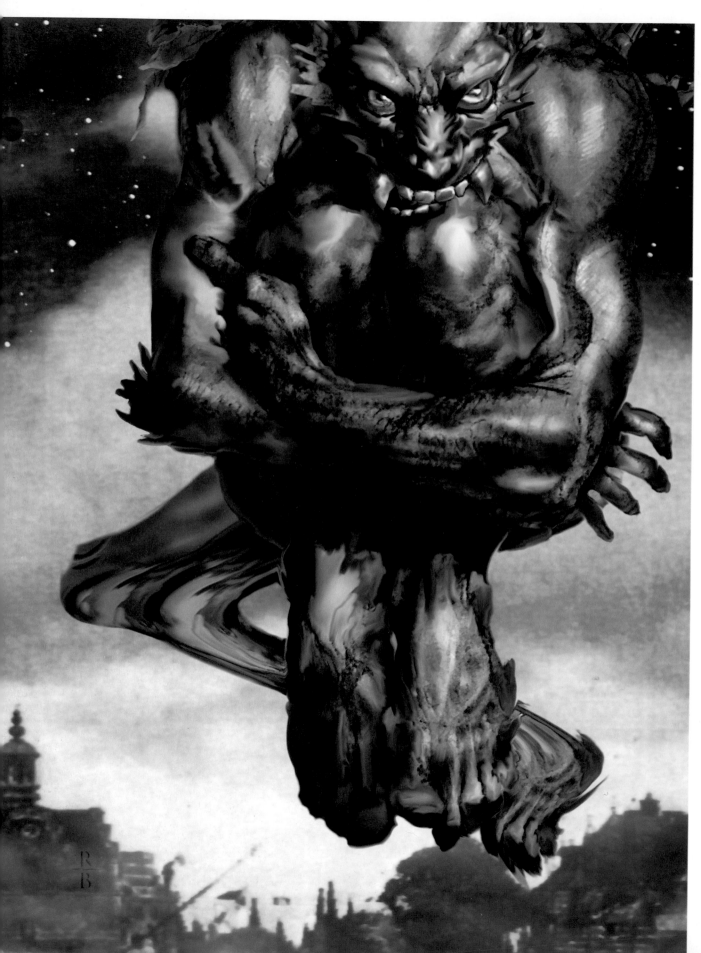

**Demon**, personal
work, 1998
**Digitally created**

"This work is a
slightly different
rendering of a book
promotion poster
that was created for
*Daemons, Inc.,* by
Camille Bacon-Smith
(Doubleday Books).
The grayscale image
[right] is the scan,
somewhat digitally
enhanced, of a little
black and white
charcoal starting
sketch. The
background of the
color image is a chunk
of Vermeer's *View of
the Delft* [above]."

**Opposite:** *The Ice Mother,* personal work,
1996
**Oil, photography and digital**

"This is a further development of a cover I did
for Michael Moorcock's *Sailing to Utopia* (White
Wolf Publishing). It has got abstract oil paint
sampling, photography and file swipes from
the digital artist Darrel Anderson in it.
A favorite piece."

went the same road, jamming in oil, markers, pastels on any available surface, barely satisfying the lust to discover what could be seen. Spending money on art materials rather than food kept these hippy freaks stylishly thin and their choices ironclad."

## GOOD COMPANY

"I account myself wealthy in the collaborators fate has foisted on me. There have been many, but chief among them would have to be the brilliant digital artist Darrel Anderson, the jaw-dropping painter Phil Hale and the superb watercolorist Sheila Vaughan Berry. I prefer the company of those who constantly make me feel like catching up. It is difficult at times to accept feeling dwarfed by the work of others – but by the same token it may be taken as an index of how large your world has become.

"If you stay worthy of good company you grow. If you fail to keep good company it gets lonely. Lonely at the top, lonely at the bottom, it doesn't matter; lonely is lonely. This is the red part of the meter and the red part can be very blue. If you can make the leap to just believing in at least a few good people, you can flank most of your worst blindnesses by seeing through their eyes. I've got people who are so smart, poking holes into my conceits, that I really have to work extra hard to achieve even my more embarrassing work and this way originality remains unavoidable."

## CREATION MYSTERIES

"The mystery of how one picture could belong so completely to itself when there wasn't one single artist behind it became a central question for me. I began to view all art as collaborative, whether there was more than one active participant or not. I did not see myself as the original artist, drawing on a beach somewhere with a stick in the sand, primordially beyond the influence of anyone else. Reasoning that I thought in a language I hadn't invented, I came to the conclusion that perhaps this ability to see had similar debts to social structure. If the construction of the mind appeared to have a basis in social structure, then art, as a product of the mind, could slip the constraints of being explained in terms of the merely individual.

"After holding forth on this at an international symposium on Artificial Intelligence, I was asked to teach a course of my own at the Experimental College at Tufts University in Boston. Mitch Rosenbaum and I designed a Trojan horse called Digital Imaging: A Collaborative Approach. This course posed as something the kids could get a job with but was really something else. We used art as a tool of evidence for exploring

how we think and see, both solo and collaborative vision. What emerged from these explorations was a model of creativity. Aspects of the model posited that original work arose from participation in an ongoing original act, one that was already in progress and as old as the universe; that artists didn't possess ideas so much as that ideas possessed artists; that beginnings and endings were illusory notions forced on the practitioners of art by their own mortality, perhaps causing them to combat their sense of finiteness with conceits about being self-importantly original; and that such egoistic difficulties abound in the arts. I suspect these conceits to be one of the chief difficulties in maintaining inspiration; an artist as his own source is too tiny."

## THE ETERNAL IMPROVISATION

"Perhaps an artist is more aptly considered as someone who is 'sitting in' on an improvisation already in progress, catching the drift of the piece, and coming back with a short lifetime of long-lived 'original' works. They are original because the artist opened up his or her perceptions and the ongoing Creation used the person of that artist to do a bit more creating. For a moment the artist touched the big Original.

"Hence two artists could be working on aspects of the same idea, an idea forming in harmony before their eyes on the same canvas, something so big that it absorbed both their contributions. Instruction without an instructor; idea as its own author with the artist as its implement. This is how I learned and am learning art. Working with live contemporaries is a high-octane experience. The learning curve is vastly sharper than studying artists either distant in time (dead and can't shoot back) or space. This, plus other interesting cognitive tricks for driving vision, is the subject of *Braid*, a book Darrel Anderson and I are writing."

## TECHNIQUE

"I'll use anything: oil, watercolor, graphite, pastels, spray cans with found objects as stencils or direct scans

**Death/Redux, trading card and limited edition postcard, DC/Vertigo, 1994**
**Photography and digital**

"This is 85 per cent photography-based with images from two different shoots – one of my wife, Sheila, on the roof of our Boston studio, combined with one of various cemetery shots. A portrait of Neil Gaiman's character Death."

of cogs and junk. As diverse as the materials may sound, the approach is internally consistent – I scribble, and tend to lay down a visually often chaotic ground. On go the Rolling Stones or Chopin to guide the mood of the piece, and then I just get physical for a while, moving forward as mindlessly as possible.

"As the language part of my mind begins to go away and the visual brain begins to kick in, certain cognitive functions begin to shift as well and I begin to see. It's rather like the way in which one is able to see a zillion things inside a Jackson Pollock or the suggestive geometries of a Franz Kline after relaxing with the image for a while. Quite a number of my paintings could simply finish in this phase while they are still potentiating vision, 'anythingness.' This is part of the appeal of sketches; it is less their unfinished quality than it is the question pressed upon the imagination."

## THINKING AND SEEING

"The trick here is 'kinded' vision – scribbling in the 'kind' of way you wish to see. 'Anythingness' by degrees of skilled 'kinded' scribbling becomes 'architecturalness' where I'll need buildings in the composition; 'anatomicalness' is where an arm, hip or face will become necessary. The point is that I see with the medium. The concept hardly ever hardens before the art begins to happen; the art is not done as an execution of a preexisting idea, it is done to discover the idea. The sketch is just the finished piece part-way done, part-way conceived. A rough from me is usually just a painting in progress.

"Typically, I don't work from external models, photo references or sitters. It's not that I don't study – I do, obsessively. It's just that when it's time to draw and paint, I put the books away because I find them distracting. I want to look at what's happening on the surface. I will use photography from time to time, but only as photography, directly in the imaging process. I prefer to do very little thinking and mostly do seeing. Most of the thinking that does get done is in deciding what I'll visually refuse. This is because I usually wind up seeing too many things to be useful. Thinking is very good for not seeing.

"Having said all this, Phil Hale and Brom both advise me that I ought draw more from life and they're probably right!"

## ICONS

"Beyond all this cognitive technique is what and why – content, subject and meaning. The best art has a

quality of longevity; it continues to mean something well past the moment of its initial use. It often seems to gain depth as time goes by, to the point where it passes into the social consciousness, and can become almost a symbolic icon, for example the Mona Lisa, or Michelango's David.

"I'm most drawn to invented portraits as a subject. Beyond the simple narrative moment, caught and fixed in time, I prefer the deeper dimensions of history and psychology written and/or discovered in a person's countenance or demeanor.

"I can with equal facility paint urbanscapes, landscapes, plants and animals, thingies and widgets . . . if I've ever seen it, I can scribble it back up. Some landscapes do achieve icon value, although this is often dependent on biblical or mythical substrate. More often, though, it's a powerful depiction of a person, a portrait, that achieves this long reach. When you've got a short attention span, something mesmeric to contemplate helps keep you on the job."

**Above left:** *Khimera,* **for the card game Dark Age, FPG, 1996**
**Oil and digital**

"Here a little 10-inch [25.5-centimeter] oil abstract has been flipped over onto the scanning plate and pushed hard."

**Above:** *Pulpit,* **cover of** *Scenting Hallowed Blood* **by Storm Constantine, Meisha Merlin, 1999**
**Oil and digital**

"An oil figurine combined with a bit of Gloucester Cathedral and a blast furnace. It became digital thereafter."

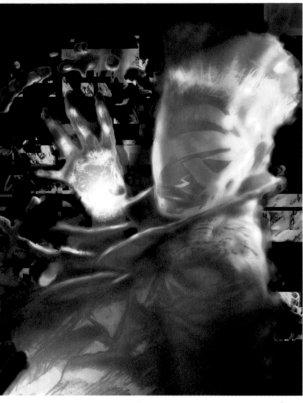

**Far left:** *Neuromancer: AI Redchalk*, 1984
**Digitally created**

"The redchalk is the substrate of an Apple IIE 16 color scan that was then popped through a Polaroid electronic palette – a very primitive process. The big blocky low-res results were then printed onto Ciba paper and prepared for oil paint. After the oil painting was done, it went off to the publisher to become the cover of *Neuromancer* and the rest is hysteria."

**Left:** *Neuromancer: AI Good-Bye*, 1994
**Digitally created**

"This is the result of going all the way back to the original redchalk drawing and scanning it anew, literally creating a new branch from the old rootstock but this time within a much more evolved imaging platform, the PowerMac, and a suite of associated imaging software."

## NEUROMANCER

Rick created the first-ever digital cover for trade fiction, and the story behind this is instructive. In 1984 William Gibson was on the verge of changing the world of speculative fiction with the novel *Neuromancer*, published earlier that year with a rather modest cover as part of a series of novels by brand new SF authors. Terms such as cyberspace, cyberpunk and digital gaming as well as much of the nomenclature of the Internet can all claim their origin with this book. The huge surge of media interest had waked up the publishers to the fact that the novel was going to sweep the major literary awards of the genre and they were looking to repackage the book quickly with a new cover image. Enter Rick Berry . . .

"Well, not exactly – hardly an entrance at all, in fact. Ungallantly seated on the only chair in the editor's office and somewhat spiffed on champagne, I am doing my best to understand what people are talking about. My condition is not entirely my own fault – the science fiction/fantasy editorial division has the charming custom of ordering up magnums of bubbly when a particularly rough day could use a round send-off. Having dropped off an assignment, I happen to be sitting in the chair of the editor whose office has been selected for the occasion.

"Various staffers, editors and the vice-president of the division file in to take their places around the room, standing against the wall; I'm reminded of good old days around the campfire while working as a ranch hand in the Rockies. Such reminiscences combine lethally with champagne. No doubt recognizing this, the vice-president moves to halt a string of spellbinding tales from me. She does this by mentioning the upcoming business with Gibson's book."

## LIES, LIES AND MORE DAMNED LIES

"Still the yippee-yi-yo-ki-yay of my happy disposition propels me forward. I ask what they have in mind and I'm told they aren't quite sure. At this point, I am absolutely clear on the value of unclearness. Certain that if they don't know what they want, I can find it for them. It only gets better when they say they hope to do something with computer art. I don't have a computer. I don't know anybody who does. I offer to do the job.

"The VP in charge then says, good, we need to get on this right away, talk to the art director tomorrow. The next day brings with it unwanted clarity and the pain of returning sobriety; have I been lying to my biggest client? Part of my 'sell' had been that my home

**Opposite:** *Neuromancer* by William Gibson, Berkley, 1984
**Oil and digital**

"With the fee from this job I went out and bought my first computer. I was amused to discover that William Gibson had done exactly the same."

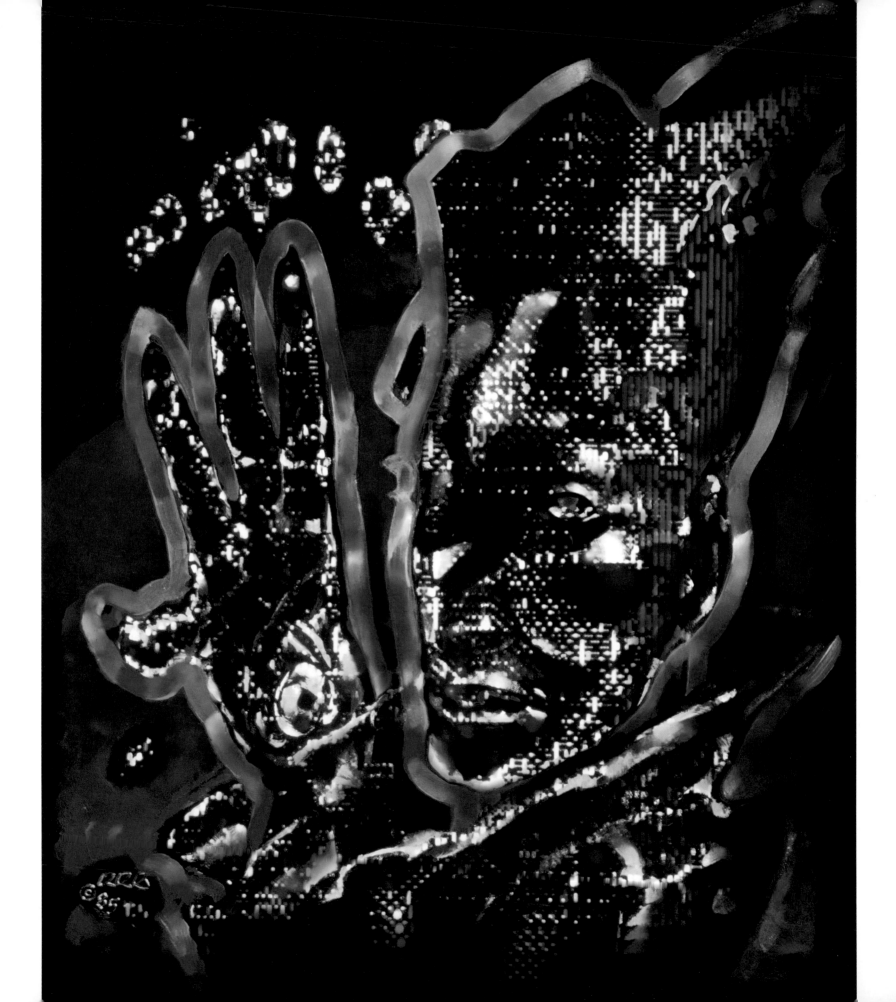

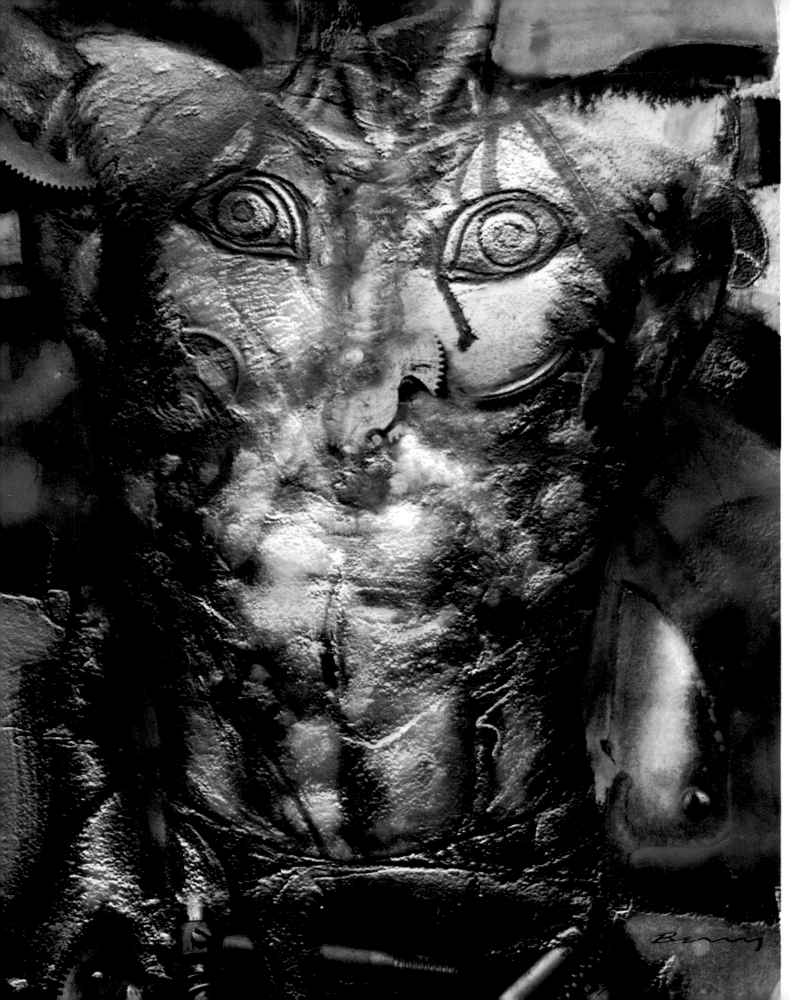

**Warchest, from the card game Dark Age, FPG, 1996**
**India ink, China white and digital**

"This began as India ink and China white on a 5-inch-tall [12.5 centimeters] board and was then combined with some direct scan of metal bits, bump-mapped onto the image. Brom asked me to produce anything, dark in feel, that he could use for his card game Dark Age. Brom puts his money where his mouth is when it comes to art direction; he picks people he thinks are good, believes they'll do their best if allowed to, and he allows them."

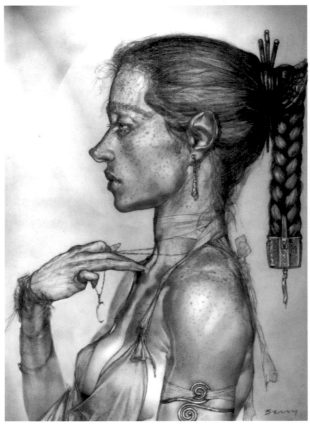

**Above:** *Boudicca,* from *Double Memory: Art and Collaborations of Phil Hale and Rick Berry,* Donald M. Grant, 1992
**Graphite on paper, digitally colored, 38 × 28 cm (15 × 11 in)**

"A pencil drawing colorized digitally. I've always had an interest in portraying strong women from history and mythology."

**Right:** *Nemesis,* cover for *Mrs God* by Peter Straub, Donald M. Grant, 1990
**Oil on board, 76 × 51 cm (30 × 20 in)**

"This painting was done in a yet more abbreviated technique than *Belling the Moon.* So often simpler is better. It was one of four accepted by Communication Arts in their 1991 illustration annual as among the year's best book illustrations."

base, Boston, is one of the computer capitals of the world. I had always been fascinated by the self-fulfilling prophecy of falsehood. The problem then was to tell the right lie. Had I? Only further lying could tell.

"Later that night, dressed to the nines and armed with glossy photos of my work, I find myself lying to the saintly face of the M.I.T. Media Arts building janitor. Convincing the gentleman that I've legitimate business with the Visual Language Workshop, I persuade him to work the crypto-lock and he promptly lets me onto the wrong floor. After a quick scan for traps, I surmise I've wandered into the area of a far

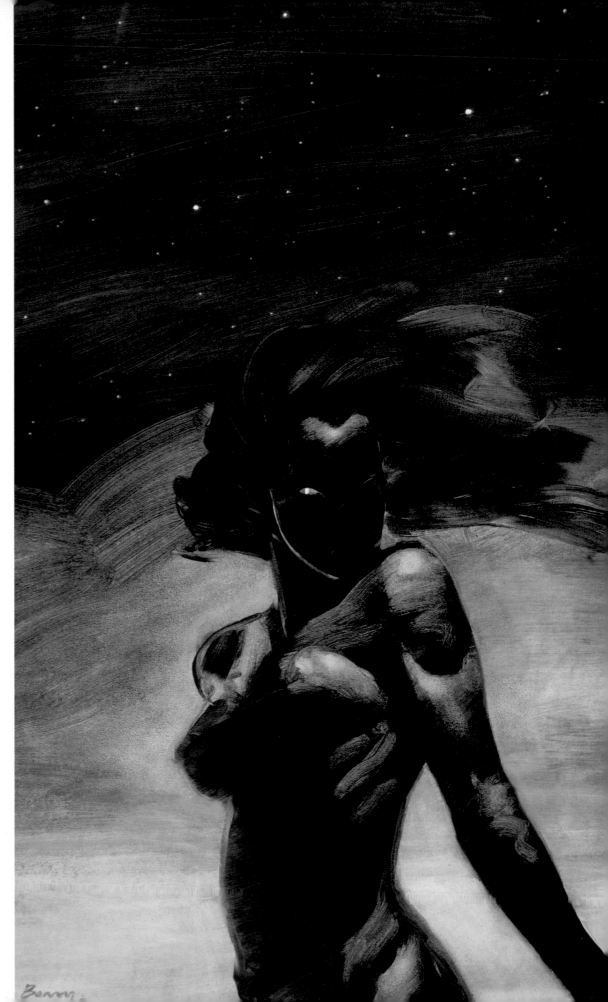

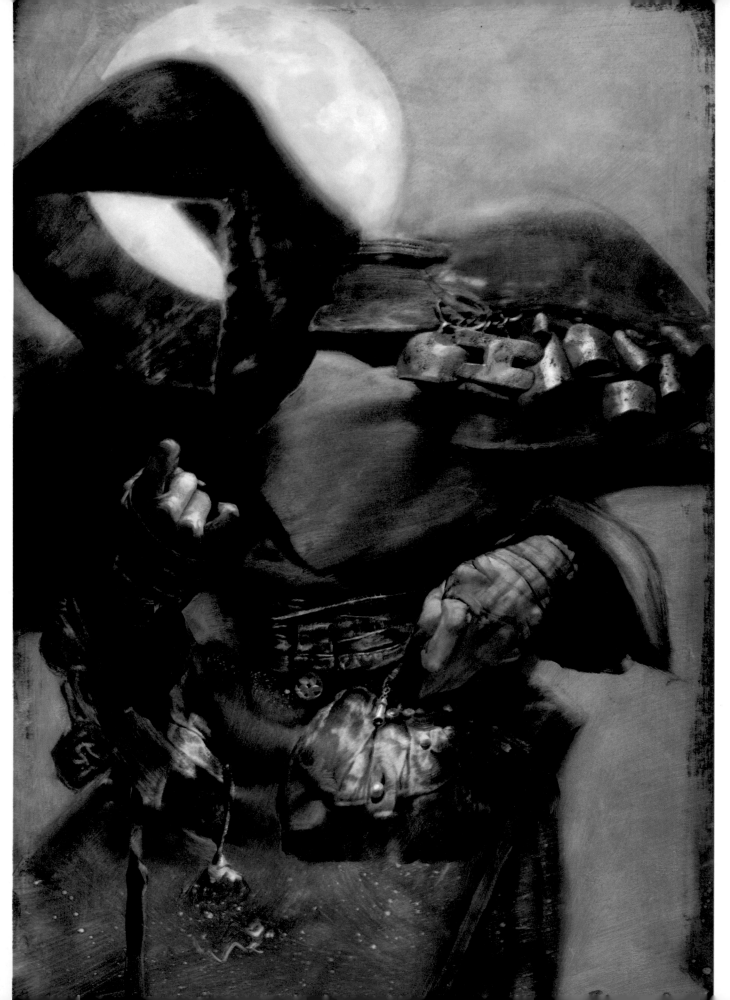

**Belling the Moon,
personal work, 1992
Oil on board, 76 × 51 cm
(30 × 20 in)**

"A very rapid piece, done
for fun. Kent Williams did
something that proved
inspirationally evocative in a
fine graphic novel called
*Blood*. It reminded me of
how in medieval times the
lepers would be belled like a
cat so as to keep the general
populace aware of their
movements . . . strange
beings of some unguessed
subculture moving through
the woods at night."

more powerful outfit called the Architecture Machine Group. Winking in the dimly lit peripheries of the poshly upholstered, uniformly gray interior can be seen lovely little miracles of high-tech imaging. There are tanks crawling over peasant landscapes and peasants alike in bucolic little war simulations (a Swiss program called Trillium) and glowing molecular models shifting valences and reconfiguring themselves. Fib time is over – there in the palace of illusion it is time to get real.

"I manage to strike up a conversation with a young hacker named Mike Halle. I'm very frank with him, I tell him I've been lying and would like to somehow make all my lies come true. This appeals to Mike and soon we are happily scanning the photos of artwork. The computer on my desktop today would eat alive the one Halle and I were working on then, but in 1984, a mainframe Ramtek running Sun workstations was such stuff as dreams were made of. After a bout of false color mapping, I had a bunch of very bizarre digital versions of my art on 35mm slides – including the red chalk drawing that became the *Neuromancer* cover."

## BUT WHERE ARE THE BIG BLOCKY THINGS?

"The publishing industry being what it is, the images produced at M.I.T. were deemed too slick to be recognized as 'computery' enough. I was asked where the big blocky things were – they meant large pixels, low res. Fortunately, I had made precisely the same raid at the Massachusetts College of Art – thanks to the lab technician Victor Salvucci – where a more primitive lab gave rise to more obviously computer-generated images.

"Ironically, to make the final image sophisticated enough for print, I had to apply oil paint to the final computer output. As such, the cover of *Neuromancer* is a transitional work, sitting between worlds. Perhaps this is appropriate, since this visionary novel of computer nets and so on was written on a typewriter in the first place. With the money from this job, I tried to make an honest man of myself and bought a computer to do the next two Gibson books and many others thereafter."

***Partners*, FASA Games, 1994**
**Oil on panel, 122 × 107 cm (48 × 42 in)**

"Phil Hale and I worked on this painting together in my studio in Boston. Phil and I have shared at least five studios in the past, besides just painting in each other's studios at various times. He is much more of a planner than I am and is always trying to make me work harder."

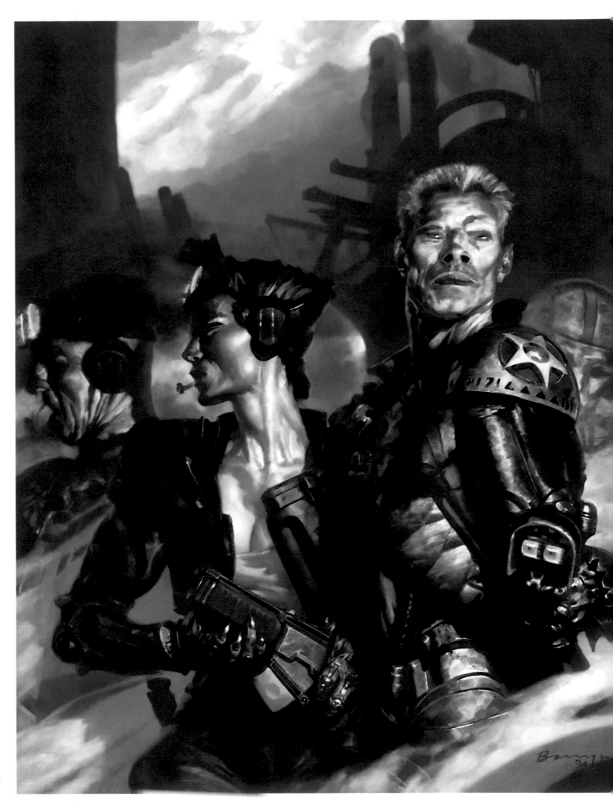

# Chris Moore

*"Most commissions have their own particular problems, but that is part of the fun of working in this profession — solving the problems in the best way I can in the time available and within the restraints laid down by the brief."*

Chris Moore already had much experience as a jobbing illustrator when in 1974 Peter Bennett at Methuen asked him to provide his first SF paintings as covers for two novels by Philip K. Dick and one by Alfred Bester. The task was a pleasure for someone who had been greatly inspired by the SF movies of the time, particularly *2001, A Space Odyssey* and *Silent Running*. It was made even more fun by the fact that the marketing wisdom of the day only required from the illustrator a generic image that gave the book an SF feel — there was no obligation to know what was going on inside the covers. This allowed Chris a purely imaginative approach and one that did not demand photo-realistic representations of everyday objects. Although today's editors and art directors have quite specific briefs or particular sections of the novel they want illustrated, it is still the sheer imaginative freedom the genre allows that has kept Chris working for 25 years with one foot firmly in SF illustration.

A recent talk he gave at his daughter's primary school, accompanied by slides of his work, reminded him of this. "We started at the launch pad, then, bursting free from the gravity of the planet, I took the children on an excursion around the galaxy, skimming stars and black holes, making the occasional stop on an alien planet, meeting exotic life forms and robots, even visiting a futuristic theme park and returning finally to the classroom when the lights came back on. The audience reaction to this was fabulous. There's nothing quite like a child's sense of wonder to remind me why I do this and what is so fascinating about working in this field."

On days when Chris is not lured out of his studio by excursions, be they either mundane or one-offs such as the above, he tries to keep to a routine. 'I usually start the day enthusiastically enough. I walk into my studio at around 8 a.m. and check my e-mail, turn on Radio 4, make myself a cup of tea, clean my brushes and plan what I have to do. This sounds really efficient, but then our two springer spaniels start barking because they want to go into the garden, so I let them out. This is

**The Stars My Destination by Alfred Bester, Millennium, 1999**
**Acrylics on board, 56 × 40.5 cm (22 × 16 in)**

One of the few true classics of the SF genre, deservedly reprinted many times since its initial publication as *Tiger, Tiger* in 1956. There could be only one image for the cover of this book — the transformed face of the novel's revenge-driven protagonist, Gully Foyle.

## BIOGRAPHY

❖ Chris Moore was born in Rotherham, South Yorkshire, in 1947. He always wanted to be a commercial artist, even before he knew exactly what that meant.

❖ He was educated at Mexborough Grammar School, after which he went to Doncaster Art School for a foundation year. Between 1966 and 1969 he studied graphic design at Maidstone College of Art and then spent a further three years at the Royal College of Art in London on a postgraduate course in illustration, gaining his MA in 1972.

❖ Together with fellow RCA graduate Michael Morris, Chris formed Moore Morris Ltd in 1972. The company was based in Covent Garden and from day one began producing covers for books, magazines and records. This relationship lasted until 1978, when Chris joined Spectron. In the early 1980s, he changed agents and signed up with Artist Partners.

❖ His first trip to the USA in the mid-1980s generated work for Dell and Random House and in the late 1980s he acquired an agent in the USA, Bernstein and Andriulli Inc., a relationship that continues very successfully.

❖ Chris lives in Lancashire with his wife Katie and their two children, Georgia and Harrison. He also has two children from a previous marriage, Robert and William. He spends the majority of his time working but finds space for playing guitar in a local R&B band, walking and taking photographs.

❖ Website: www.illust.demon.co.uk

**Ubik** by Philip K. Dick, Voyager, 1994
**Acrylics on board, 25.5 × 40.5 cm (10 × 16 in)**

"As with many of these covers, I built the image around the element of the girl. Here I depicted her looking a bit furtive, almost hunted, in keeping with the air of paranoia prevalent in the book. I introduced the volcano-like towers of frozen ammonia to add drama to the background design and the strange rain clouds allowed the piece to have a most individual lighting."

where the problems start; if it's a nice day I take a stroll around the garden with the dogs and don't get back to the studio until around 8.45. There are usually a few e-mails to reply to and this takes a further 30 minutes, and so on. . . .

"The gist of this is that I am very easily distracted and in order to produce work on time I need to pace the job. This involves splitting it up into various sections and allocating each section a period of time within which it has to be completed. For instance, the background can take four to five hours, the main figure, given good reference, about three hours, and the clothes a further three hours, leaving a period at the end for tightening up the entire image – maybe half a

**Now Wait for Last Year** by **Philip K. Dick**,
**Voyager, 1995**
**Acrylics on board, 40.5 x 56 cm**
**(16 x 22 in)**

"This image is three Philip K. Dick covers in one – it started life as the proposed cover for *The World Jones Made*, evolved into the proposed cover for *A Scanner Darkly* (left) and with modifications finally made it as the jacket for *Now Wait For Last Year*. I never throw away drawings of space ships or robots – they all go into box files and periodically I go through them to see if anything can be reworked. I eventually found a use for this one."

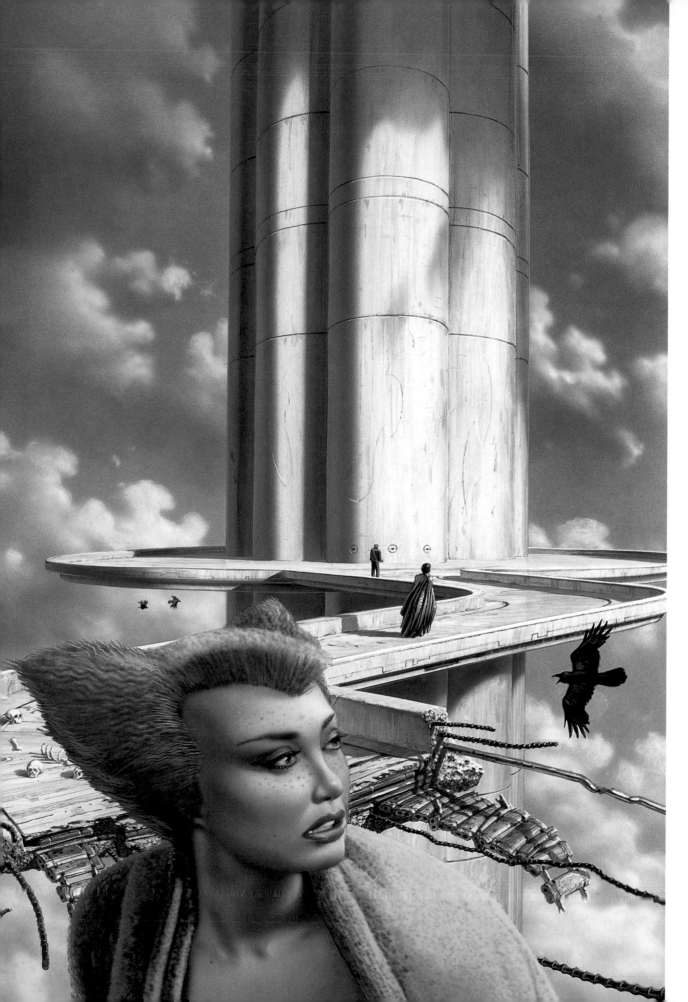

**The Rediscovery of Man by
Cordwainer Smith, Millennium, 1998
Acrylics on board, 56 × 40.5 cm
(22 × 16 in), plus pencil sketches**

"The section of the book I was asked to
illustrate featured this huge 12-mile-high
[19 kilometers] tower called Earthport,
and a road that ran through the sky. Our
heroine, the cat woman in the foreground,
plays a pivotal role at the story's climax
and provides the almost obligatory
babe-in-space element. My wife, Katie,
modelled for the uppermost of the two
sketches above."

day, depending upon the complexity of the piece. This, of course, is on a good day; with distractions it can take twice as long.

"I do try to read the book when I'm asked to illustrate the cover. Deadlines often make it difficult so I may skim read or consult a friend who has read the book. Sometimes the publishers will give me a synopsis, since in some cases the book is not even finished when I am commissioned. I occasionally get a manuscript that has only just been delivered. This can be quite a thrill, as it means I am one of only a few people who have read the book and I get a feeling of discovering something new."

## INSPIRATION

"My inspiration comes from the story itself, or from the author's previous titles if the book is part of a series. Sometimes I look through my collection of box files containing masses of drawings and ideas that I like, or stuff that's been rejected for one reason or another. I keep all that kind of material – nothing gets wasted.

"As far as reference material goes I usually build up the picture with bits of reference – not too much, just the key areas such as faces or recognizable machinery such as cars or planes. I often make models and photograph them.

"I tend to work out the composition first and then make things fit around it, but this isn't always the case – I am sometimes taken with a particular image in my reference and it will send me off in a completely different direction. It's very difficult to put down rules about this sort of thing, but I get a feel for the atmosphere and conditions that I want to create and fill in the gaps between my reference pictures, often changing the reference as I go, redrawing things to fit my background. As long as I have a basic color scheme to work toward, I kind of follow my nose a bit and see what takes my fancy. It's a bit like baking a cake – you assemble all the ingredients and then try to amalgamate them to produce something interesting.

"I always produce my roughs to the same size as the finished cover, since this gives me a feel for whether the image will work at that size or not. I often ask the publishers for a type layout so I can manipulate my image to fit the type. It's very important that the whole thing should work as a cover as well as a picture in its own right."

## APPLICATION

"When I have decided what I am going to try to achieve, I will enlarge my drawing twice up onto tracing paper on my A3 photocopier, or slightly smaller

*Blindfold* by **Kevin J. Anderson, Voyager, 1999**
**Acrylics on board, 40.5 x 56 cm (16 x 22 in)**

"With this image, I liked the way the light fell across the girl's face. I simply constructed an alien landscape around her. The pencil sketch [left] shows explanatory notes and the proposed color scheme of the painting."

if the art director wants more bleed, and then trace down the drawing on to my prepared board. I use Crescent Hi-Line board with no surface preparation whatsoever, just a line outline and trim marks. I then redraw the image in fine pencil to give me the main areas of work. This part is absolutely crucial to the final design because it's quite difficult to change the main areas afterward, so I have to make sure that the basic drawing is accurate by using vanishing points and construction lines.

"I use a frisket to mask out the main areas to keep them clean, then employ a variety of techniques to apply the paint to the exposed area. I can have several attempts at it but I can't scrub out and mess about too much or the board surface begins to disintegrate. I may use an airbrush to apply flat color or glaze-type effects, or employ watercolor techniques such as washes in acrylics – whatever comes to hand. For rocks, I quite like using a stipple effect with modelling applied later by airbrush. It is simply a matter of using any of a whole range of methods and techniques in order to achieve as much variety as possible.

"Once I have covered the entire area of the picture I will work back over the image to tighten it up and rectify any gaps or areas that don't fit together in terms of tone, structure or color. I find that the airbrush is a wonderful tool for this process, giving me precise control over the depth of color to merge areas into each other. I will constantly keep a weather eye on the tonality of the entire image to make sure that it contains sufficient contrast and that any subtlety is not lost or obscured."

## VARIATION

"It would be as difficult to choose my most favorite piece as it would my least favorite, but I think the best

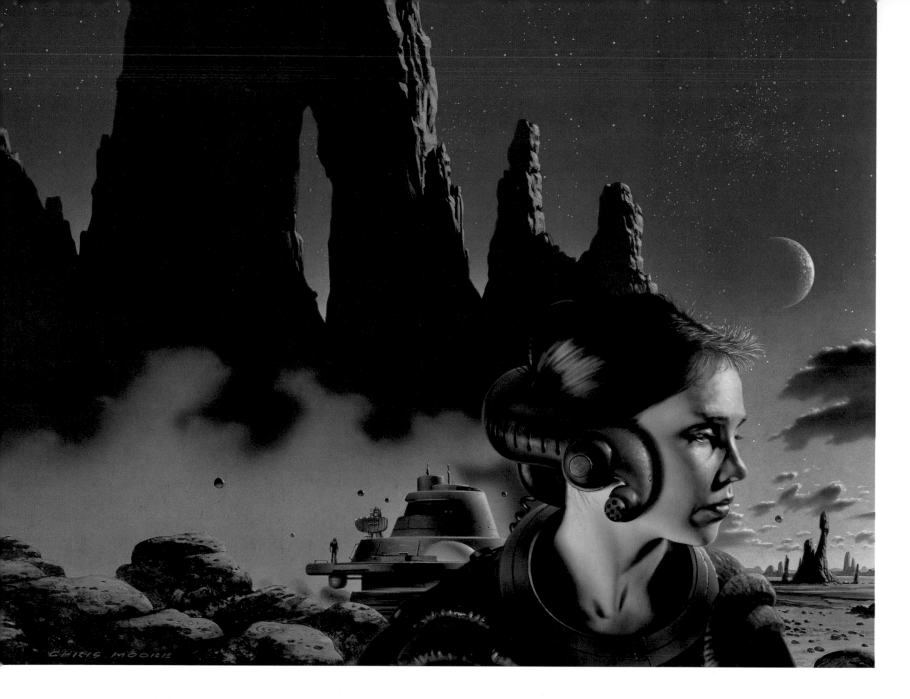

ones come when I am feeling on top and good about what I'm doing, and the opposite is also true.
I do feel, however, that as long as I keep the standard above a certain level, certain fluctuations in my own standards are just part of being human.

"Most commissions have their own particular problems, but that is part of the fun of working in this profession – solving the problems in the best way I can in the time available and within the restraints laid down by the brief. Briefs vary hugely in type and complexity. Some are open-ended and allow you to produce pretty much what you want while others are very tight and require you to steer a precise course, but I am lucky in that I am offered a vast range of projects and can usually see some merit in even the most mundane assignment. The

main part about being largely a jobbing illustrator is that I have to tackle whatever is thrown at me, just like I did all those years ago at the Royal College of Art when I produced illustrations to order for the graphic design students. I've done wallpaper designs, advertising work and hundreds of book, record and magazine covers.

"I have always tried to avoid being typecast in my book covers. One way of keeping the elements of my working life fresh is by illustrating more than just science fiction. Techno thrillers provide an opportunity to render high-end machines in a less fantastic context and since the readers of these know what an F1-11 looks like, they also offer a challenge of delivering something recognizably realistic. Other than historical

romances I have produced covers for almost every type of book that has been written, including detective stories, workshop manuals, humor, thrillers, mainstream novels, horror, sociology books, music books and nonhistorical romances! However, I always return to science fiction illustration for the sheer freedom it gives me."

## INTERPRETING THE IMAGE

Chris's book covers are created by a consideration of several things. First, an analysis of the story, either by reading the book, manuscript or synopsis or from a verbal description by his agent or the art director. Secondly, there may be a series style or previous cover that will dictate a specific approach, or a very simple graphic device may be required to give a little extra something to a large bold typographic cover, as in some mass-market paperbacks.

The third element of the creative process is Chris's collaboration with Dom Rodi of Artists Partners. Dom was formerly the art director at Sphere Books, where he and Chris worked on many projects together. This relationship has now developed into a singular service that AP can offer clients. Concepts are worked out over the phone with the art director, then faxes and e-mails are used in brainstorming sessions to provide highly original solutions to mass-market paperback and hardcover designs which are then executed in Chris's studio.

"I start with a few thumbnail sketches. Art directors don't normally see these nowadays; since the introduction of computers they are accustomed to seeing more sophisticated images as roughs. For a number of years the color roughs I produced were small paintings the same size as the book. I resisted buying a computer for a long time, mainly because I could paint the image in less time than it would take on a Mac, and also because I liked the feel of paint. However, since the introduction of e-mail as the communication medium *par excellence*, I've used a computer to produce rough color images which I can then send instantly to the client, who is in some cases many thousands of miles away."

## EVERYTHING HAS ITS PLACE

"I feel that as the use of computers is becoming more widespread it is leading to a mentality in the publishing field that things are now easy to change: all you need to do is scan in your image and change it in Photoshop. This is not a bad development, it's just different, and you have to adapt to survive in a business where you're generally only as good as your last job. Computers

open up a whole new range of possibilities; I recently secured another fee on a job which required an old image to be doctored and the colors changed to produce a new cover for a book. It was a very simple exercise on the computer but would have taken days to modify in paint.

"Some people are under the impression that computers do it all for you and that ultimately they will replace the creative mind. I feel sure that this is not the case. There is no substitute for the creative spark — the computer is just another tool, just as the airbrush was when it was rediscovered back in the early 1970s. The computer is infinitely more flexible, versatile and clean, but it is still just a tool and as such can only do what it is told to do.

"I see it more as an aid to photographic reference at the moment. It gives you more options regarding aspects such as scaling, blending and checking color balances, and many of the decisions you must make while doing a painting can be investigated by trying them out on the computer at the rough stage before committing them to the finished picture. I do the odd finished job on the computer, but I can't see me turning to it completely. It's supposed to be much quicker than conventional techniques, but I find that it just devours time — and besides, I still like slopping paint around."

**Babel-17 by Samuel R. Delany, Millennium, 1999**
**Acrylics on board, 40.5 × 25.5 cm (16 × 10 in), plus pencil sketch**

Only the skills of the novel's poet heroine have a chance of revealing the meaning in the seemingly alien broadcasts so concerning her society. Another girl and cityscape but with an enclosing vertical design and color scheme to emphasize the brooding air of uncertainty that grows as attempts to understand the unfamiliar linguistic nuances slowly move toward resolution.

## THE WORLD OUTSIDE THE STUDIO

In 1995, encouraged by Jim Burns, Chris attended a World Science Fiction Convention in Glasgow, where he showed some original artwork for the first time. He sold several pieces and met Jane Frank from Worlds of Wonder, an American agency that sells science fiction art worldwide. She expressed great interest in selling his work and Chris began to realize that there was a market for his paintings outside their function as book jackets. At the same convention Chris also met Fred Gambino, who was instrumental in persuading him to begin incorporating computers into his work and has been very generous with his help.

Chris discovered a further advantage to attending SF conventions, "They're the only time that I really meet authors. I have found that I really enjoy the convention scene. It's very reassuring to be complimented on my work, because for the most part I work in comparative isolation and I don't get much in the way of feedback."

## THE COSMIC PUPPETS

"Pressure of work prevented me from even starting to think about this piece until the night before the deadline expired, when I sat down at the drawing board and searched desperately for inspiration. Since the story

*The Cosmic Puppets* by **Philip K. Dick, Voyager, 1995**
**Acrylics on board, 40.5 x 56 cm (16 x 22 in)**

95

*Flow My Tears, The Policeman Said* by
**Philip K. Dick, Voyager, 1997**
**Acrylics on board, 40.5 x 56 cm**
**(16 x 22 in)**

concerns miniature people carried around by others, I began to wonder what the view would be like for a tiny person walking across the palm of my hand, with the canyons and valleys of creases and the monolithic inclines of the fingers. I held my hand up to my face and looked down the palm towards my fingers, then, lighting my hand in a suitably dramatic manner, I set to work on a sketch which delivered what was needed in terms of the preliminary study.

"Once this was approved I photographed my hand, taking quite a few varied shots, and then, having selected the best, I found the job comparatively simple to execute in paint. There is something coincidental about all these elements coming together to provide the flash of inspiration that all creative endeavors hinge on. That explosive instant that provides the starting point is at the core of this process; after that, the decisions of composition and lighting are just other hurdles which you overcome in your race toward the deadline.

"Things often have to happen like this in my creative process. Ideas will germinate slowly in my back brain – my wife often accuses me of being 'off on another planet somewhere' or 'away with the faeries.' I'm aware of the necessary visuals beginning to take shape, but there are so many elements that affect this: the previous covers in the series, the pressure of the deadline (always good for focusing the mind), the type of cover required, whether it be figurative or cityscape or, increasingly with the Philip K. Dick series, a combination of the two."

## FLOW MY TEARS, THE POLICEMAN SAID

"I approached this commission from a photojournalist's point of view, my intention being to create an image with obvious tension between the three characters destined for the front cover. The woman in the foreground is supposed to be waiting with growing impatience for the man, who has his attention firmly on

the woman in the middle distance. I felt I captured that look of bored resignation such a situation would engender and was generally pleased with the results, particularly the balance between the three figures and the Jim Burns–style car.

"Before this image reached the dust jacket certain changes were made which in my view detracted from it. I felt that placing sunglasses on the foreground figure diluted the interaction of the characters and her face was also cropped substantially, no doubt to allow sufficient space for the rather long title."

## WE CAN BUILD YOU

"I sometimes like to produce images for this genre that do not immediately scream 'Science Fiction'! I like to be as subtle as possible, which can cause concern on the part of art editors, who sometimes want precisely the opposite effect. This image is a case in point. It consists of a figure in a landscape which at first glance could be

a photograph. The sky is one you could see anywhere on earth and the figure looks like an ordinary human being, but there are ingredients which give a hint as to the nature of the genre.

"Crudely put, the bottom line is that we're all in the business of selling books. We need to give the prospective purchaser a clue as to what the book's about, so there's no point in producing images that suggest the book is something that it isn't. That said, I do try to introduce elements that ameliorate the meat and two veg approach to producing covers for these books.

"This image contains those elements. I photographed the church and palm tree while I was on holiday in Florida. The painting really started with the church, purely because I liked the feeling caught in the photograph. Having repositioned the trees to make best use of them within the proportions of a front jacket, I had the ideal background upon which to introduce the

*We Can Build You* by Philip K. Dick, Voyager, 1997
**Acrylics on board, 40.5 x 56 cm (16 x 22 in)**

97

individual, an android, easily identifiable as such because of the plug socket and serial number on her back between her shoulder blades.

"However, the principal exercise when I was creating this image was to capture the effect of the beautiful post-rainstorm light which first prompted me to take the photograph. The detail in the sky and the glare off the church's roof silhouetting the palm trees and highlighting the focal character are to me the substance of this painting."

## NEW LEGENDS

"The proportions of this painting were determined by the intended usage. A hardback dust jacket was required with the illustration bleeding onto the end flaps. The only specification in the brief was to produce one of my futuristic cityscapes, as the book was an anthology and therefore a cover was required that was not specific to any story.

"There are certain characteristics that I sneak into many of my pieces. One is the crescent planet or moon

which can be found floating in the skyscapes of most of my works in one form or another. Although other artists often use this motif, it is a kind of signature for me and I like to get at least one in if at all possible. Another is the placement of part of an object or shape in the foreground that draws the viewer into the painting by the tonal graduation and accentuates the fact that only a portion of the vista is being seen. I always try to convey that the image on the cover is just the view from a window and, as with all such

views, there is a world out there beyond the confines of the frame.

"The yellow hover car was the part of this painting that caused the most deliberation. The painting was based entirely in blue/purple/magenta but I felt there was a need for another color element to lead the eye into the landscape. This was further accentuated by the converging lines of the building on the right.

"To echo the formal complexity of the city, I opted for some unusually symmetrical cloud formations."

*New Legends*, **edited by Greg Bear,**
**Legend, 1995**
**Acrylics on board, 35.5 x 91.5 cm**
**(14 x 36 in)**

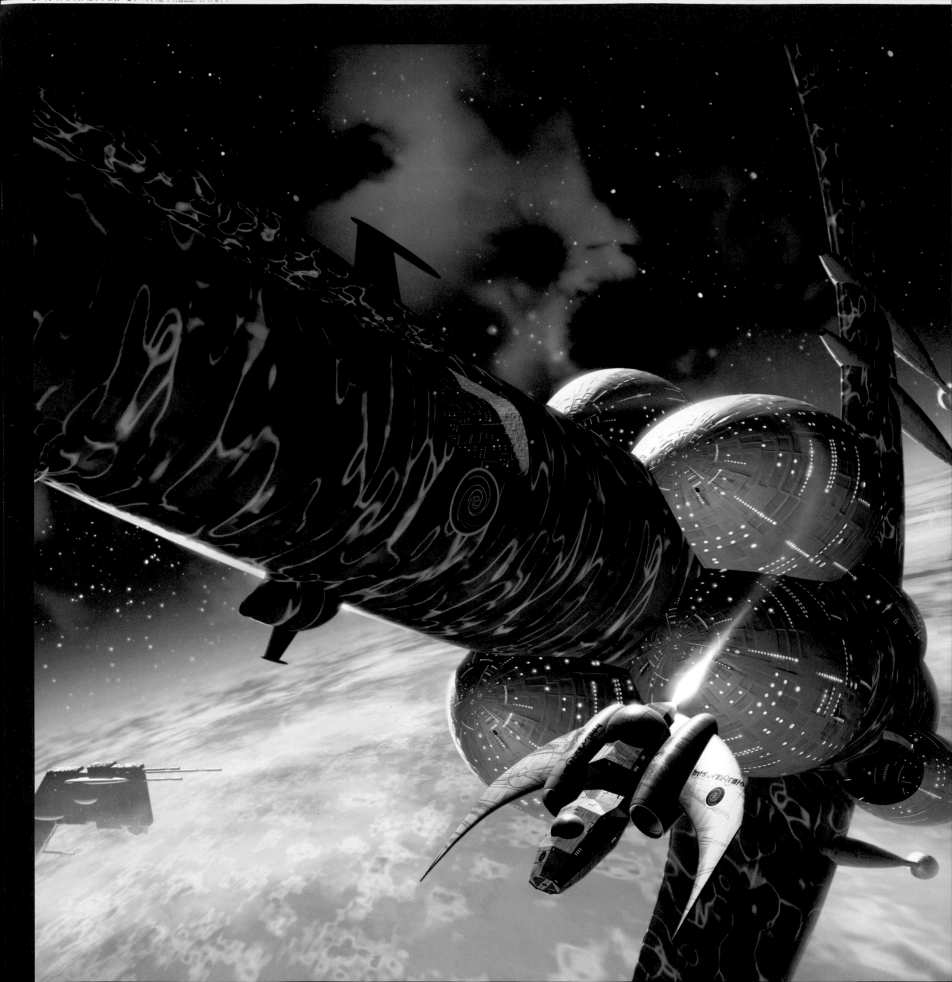

# THE DIGITAL REALM

The three artists in this section work almost entirely with digitally manipulated imagery. This does not mean that they never paint, but that their work is all assembled and finally processed in a machine. Steve Stone tells us of his move from using computers in the rave scene to employing them as a tool for producing fantastic images; Fred Gambino discusses the joys of three-dimensional model-making within the computer; and Dave McKean discourses on life as a fantasy illustrator at the end of the millennium and on the camera as the true art form of the 20th century.

Opposite: Fred Gambino, *Heaven's Reach* (detail); Left: Dave McKean, *Dust Covers* (detail); Above: Steve Stone, *Wasp Queen* (detail)

# Steve Stone

*"I am part of a generation of artists that has healthily shed its early awe of computers and, as in my case, has returned to the basic rules of picture-making: idea — composition — light."*

Steve Stone's earliest inspirations were Disney characters and the superheroes in his large collection of Marvel Comics. During his schooldays the copies he drew of these gave him confidence as a draftsman and his reputation as such spread quickly among the adults in his life – in fact he was often asked to illustrate a subject on the blackboard that was too difficult for his teachers. However, he kept his "girly" interest in art strictly away from his mates in the playground, concentrating instead upon honing his soccer skills.

This all changed when a bereavement in his family caused Steve to withdraw from playground society and concentrate on his art. Already steeped in the wealth of talent within fantastic illustration – Jim Burns, Chris Foss and Bruce Pennington were painting covers for almost every major SF book at the time – Steve found particular resonance in the work of the Swiss illustrator H.R. Giger. He achieved the necessary academic results for art school and at the age of 17 embarked upon a foundation course. At the end of this year he was accepted by Trent Polytechnic School of Art, where he began to realize an interest in film-making, built his own small animation studio and produced five short films. He graduated in June 1985 with an honors degree in Fine Art, but instead of pursuing his early ambition to be a painter he now wanted to become a film director.

Instead of attempting to enter film school, Steve decided to finance and shoot a script of his own, *Where Is She Babe*, a dark chiller set in Manchester. With his determination overcoming all difficulties, it was shot within a year and was being edited when it gained the attention of David Loughlin, head of Tense Productions.

## THE RAVE SCENE

Tense Productions organized major raves, the ultimate multimedia dance events of that period, providing their audiences with an intense fusion of sampled music played through powerful, state-of-the-art sound equipment, augmented by computer-generated light shows and sympathetic, highly complex montage video projections. Steve was offered the job of art director.

Ten years later he staggered away from the experience, slightly disillusioned at the way in which the rave lifestyle, as powerful as the hippy movement of the 1960s, had become corrupted and controlled by businessmen and how, mired in the excesses of drug abuse on the dance floor, the "us" movement had been broken into a fragmentation of fear and paranoia.

During his time on the road Steve had seen the initial film loop projection replaced by intelligent video mixers that spontaneously mixed visuals from sound on huge electronic screens, while the standard rock band light setup had been superseded by far more evolved intelligent lasers and Intella beams. He knew from this that his future lay with computers. Just as the bands that Steve had worked with used myriad sampled sounds, holding them in the computers to be remixed and distorted, so could he montage sampled images and in doing so return to his first love of painting.

## STARTING FROM SCRATCH

Steve left the dwindling rave scene in 1995 and, with only a sketchy idea of what he wanted to do, bought his own computer system and a piece of software called Adobe Photoshop. From what little he knew of it, he felt this software would provide him with the basic two-dimensional environment needed to produce sketches and make notes where necessary. After 10 years in the rave business he wanted to rediscover his artistic soul in a relatively private and limited creative space, harnessing his computer experience into a more personal expression.

"The process was not an easy one. At the start, my work looked like everything else done with Photoshop at the time, just a photomontage – photographs that had been cut and pasted together. There was no one else pushing the boat out and as a consequence there was no one to look to for inspiration. It was as if the machine was in charge.

## BIOGRAPHY

❖ Steve Stone was born in Manchester on 19 March 1964. At the age of 17 he entered a foundation course and was accepted by Trent Polytechnic School of Art, where he began to develop an interest in film-making and produced five short films. He graduated in June 1985 with an honors degree in Fine Art.

❖ His film *Where Is She Babe* was noticed by Tense Productions, a Sheffield-based company that put major rave events together, and he was offered the position of art director. This provided him with the opportunity not only to work extensively in the United States but also to work with highly complex computer systems running light shows and montage video projections. For 10 years he remained in this business, working at the cutting edge in computer technology.

❖ Upon his return to society Steve decided to put this experience to good use and, after buying the necessary computers and software, he launched the highly individual graphics company Nexus DNA in March 1996.

❖ Steve's first collection of digital art, *Nexus DNA*, was published by Archangel in June 1998.

❖ Steve lives outside Wakefield in West Yorkshire with his partner, Sian.

❖ E-mail: stone@nexus-dna.demon.co.uk
Website: www.nexus-dna.demon.co.uk

***Cyberkillers*, GB Posters, 1996**
**Digitally created**

This is a simple exercise in terms of technique, but the power is in the idea. It was Steve's first indication that he had found the direction he wanted to take with the computer. "You never forget your first, simply because it is your first . . ."

"Then, slowly, my training as a traditional artist came back. I had been taught in terms of composition, light and texture, all elements that I could now use. I began to have strong ideas of where I wanted to go and then forced the machine to go that way, with no arguments. The results began to look more satisfying, more like me, and although I was still using the machine at the most basic level, I was harnessing stronger ideas."

Steve's digital creativity really flowered when he started grafting superficially unsuitable or uncomfortable images together, an approach pioneered with pen, ink and paint by H.R. Giger, Steve's early source of influence, in his "BioMechanics" sequence – a collection of images that fuse elements of human biology and machinery. This rather disturbing imagery found a huge and devoted audience and brought Giger's work to the attention of Hollywood, leading directly to him being invited to contribute similar designs for the Ridley Scott movie *Alien*.

Computers can hold each scanned or sampled component visual separately, allowing each to be recoloured, resurfaced, repositioned, distorted or combined with other images as the overall image is being built. In effect all are in a constant state of flux or incubation. This core realization had such a pronounced effect on Steve that he named his company Nexus DNA. This is as much a design ethos as a company, consisting effectively of Steve, two dual Pentium computers and an awful lot of RAM. It is represented to the world at large by Dom Rodi and Christine Isteed of Artists Partners.

## A SERIES OF CREATIVE COLLISIONS

"I think that what we choose to do in life, if we are allowed a choice, is usually shaped by a powerful early experience, something that we never quite manage to shake off. That experience for me was sitting down in Manchester's Odeon cinema in late 1979 and being confronted by the film *Alien* on its opening night.

"Nothing had prepared me for what I saw. It was one of the most terrifying and overwhelming experiences I had ever had. It was intoxicating. I walked out of that cinema onto Oxford Road late that evening wanting to be an artist. I knew that the film had been based around the work of a single artist, H.R. Giger, so I set out to discover more about him and his vision. Within a week I had managed to track down a copy of *Necronomicon*, Giger's first book, in a backstreet bookshop in Manchester. The journey had begun. . . ."

The film broke new ground in every department and the idea was so simple: to mix elements not normally so intimately associated with each other – science fiction, a haunted house story and a state-of-the-art monster movie. The collision of such disparate elements in the capable hands of director Ridley Scott and H.R. Giger gave *Alien* its longevity and spawned numerous uninspired copycat SF/horror movies.

Much of Steve Stone's creative process can also be deftly encapsulated by the term "collision." Rather as the horror of a highway collision produces dramatic transmogrification for both the vehicles and passengers involved, so Steve's process of sampling, mixing, formatting and combining images, textures and forms provides unanticipated and sometimes disturbing results.

Perhaps the most marked collision in Steve's visual process is the way in which, after 10 years in the multimedia world of the large-scale raves of the 1980s and 1990s, he eventually returned to art – a collision of the freeform, machine-led, digital revolution that took place in music during the mid-1980s and the almost contradictory force of Steve having been formally trained as a traditional painter and sculptor. Although the training as a painter came first chronologically, it has in some ways been arrived at second in Steve's artistic development because its disciplines only really affected him after he had got a creative grip on the digital process in his own right outside the needs and constraints of a larger team. "I felt as if I needed a grounding, something to root my experiments in. That grounding for me was my training as a painter," he says.

A further extension of the collision metaphor would be that of tectonic collision, the process whereby the edges of the massive plates of the planet's surface slowly grind against one another, eventually causing geological features such as mountain ranges across millennia. Not all of Steve's artistic decisions are arrived at with the speed of a car crash; many lie awaiting a revisit in the digital labyrinths of his computers, image files to be opened and tweaked when inspiration takes him.

## A QUESTION OF DYNAMICS

Often a piece that has been carefully composed still lacks the dynamic that Steve requires; the shapes all fit together, the lighting has been recomposed, but what is missing is the "hook" that will draw a viewer into the picture again and again.

Steve battles daily to produce images that do not merely serve to illustrate the power of the computer as a labyrinth of tricks and effects. "Again the influence of the musicians I was around earlier in my career is very strong here. I would see them playing with endless digital layers of sound – the options open to them were mind-blowing. But then it would all have to boil down to a good tune, a simple hook that would lift a dance

**Opposite:** *Silverborg*, **GB Posters, 1996 Digitally created**

*Silverborg* was Steve's first step at bullying the machine toward his desired effect. "I began to feel I could let the machine have more rein and throw ideas into the pot as long as I had a strong enough conception of where I wanted to go."

audience and then take them on a journey. This is the dynamic that I work in, like any artist."

## DEVELOPING A RELATIONSHIP

During his early experimentations with Photoshop, *Cyberkillers* was the first image Steve created where he knew he was on to something compelling and individual; the simple collision of rubber-clad girls with gun barrels instead of heads produced an image of surprising potency. Within just a few days of his completing the *Cyberkillers* image, *Silverborg* emerged.

"With these two images I had developed the taste of where I wanted to go and what I could achieve with the computer. They were the stylistic basis for most of the work I was to undertake in the following year or so. They also provided me with my first professional artistic engagement, as a poster company decided to sign both images for worldwide distribution.

"The creation of these two images had helped me to overcome my crisis of confidence in my relationship with the computer and I began to feel that the machine could contribute ideas toward the development of the image as long as I felt that I was onto the scent of a strong idea in the first place. It was a matter of gaining enough experience to start making the machine slave to the ideas that I wanted to see, rather than constantly regurgitating what the machine knew it was good at. I had begun to find 'my' process of working with the machine."

The key elements of *Silverborg* were texture samples Steve had collected photographically from a variety of places. To these were added samples of chrome and other metals that were twisted and recombined until they began to take shape. The textures were conceived as a vast baroque panel that would soon have a central occupant – the mighty *Silverborg* itself.

Steve's archive of texture samples has grown to an enormous library of images with more than 10,000 scans and maps of different textures which have become the basic palette in the effects he strives to create. The textures used often allow him to evolve one image into another. *Techno-Mermaid* is a good example of the progression of the *Silverborg* textures. Over a year after he had created the original artwork, Wizard Press in New York asked Steve for a cover for their magazine *Inquest*. The *Techno-Mermaid* brief caused Steve to resurrect the textures used in *Silverborg* and tie them into a new presketched composition.

## IT'S SKETCHING, BUT NOT AS WE KNOW IT

The term "sketching," although appropriate, is used in an entirely new context when working with computers.

The image is composed in grayscale – graduated black and white – which allows each of the elements to be positioned and manipulated before the colors required for the image are added.

"I usually work in grayscale to start with to provide a quick way of producing the composition and forms that I want to see. Subtleties of light and color slow me down in the early stages of an image's development. At the very early stages I want to move as quickly as I can through the idea without becoming overloaded with the technical problems that I may be creating for myself. Those can be solved later."

The process of monochrome sketching not only allows the prioritization of the composition but also regularly reminds Steve that the unlimited range of colors offered by the computer can sometimes detract from the power of an image. *Braveheart* and *Horn Queen*, although also existing in numerous colored variations, are both preferred by Steve as black and white pieces.

"Inevitably some images stay at the grayscale version because color would always take away from them. Black and white has always fascinated me in terms of how it makes an image seem timeless and perhaps more surreal. This is true throughout photography and cinema for me. I think *Eraserhead* would have been a very different film if David Lynch had chosen color stock for filming."

## DIGITAL JAMMING

As Steve's experience with using the computer has grown he has felt increasingly confident in allowing the machine to start spinning ideas away in front of him, but only when the pictorial elements have been firmly established in a picture which he has tightly controlled until that point. The plates *Black Widow 1* (1996), *Black Widow 2* (1997) and *Wasp Queen* (1998) neatly illustrate this process of evolution, each relating to the other just as musical elements would in a jamming session, one rhythm or harmony inspiring another until something quite new and unexpected is produced. This is a process which requires not only discipline and practiced technique but also the ability to let go of an overriding desire to control every element within the whole, to trust your instincts but not to abdicate all creative responsibility: hardly a process associated with something as apparently cold and formalized as a computer.

"I never felt that I had pursued the original *Black Widow* image or the textures within it to the bitter end. A combination of wet wood and tarantula spider textures had produced an environment for my squatting demon and an arresting composition, but that was all.

"When I returned to this image in late 1997, I allowed the machine to throw repeated mutations of the basic

*Techno-Mermaid, Inquest* **magazine, 1998**
**Digitally created**

Reconfigured and resurfaced over the course of a year, the *Silverborg* textures were here dropped into a presketched seascape.

texture at me which directed the image as a whole away from the widow figure and focused the attention on the alien terrain. At this point I felt the contrast of the brilliant blue sky, the brooding figure and the foreboding organic landscape were incompatible elements. The mood of the piece was enhanced by the substitution of a sulfur-drenched storm sky photographed in Sheffield, where such skyscapes are not rare.

"The *Wasp Queen* is one of many other variations that came from the *Widow* textures and, for me, is one of the most successful. The same textures were manipulated into a new portrait format, twisting the shapes to frame the photographic study of my girlfriend Sian's face. The progression of these three images shows the way in which I attempt to balance my vision and the contribution of the machine. The first image was very much what I wanted to see. The second is partly the result of letting the machine run wild in the landscape and the third is a combination of the two, but this time driven by the portrait of the model which has resulted in the symmetry lacking in the first two."

## ACCOMPANYING TOYS

"The procedure of starting from a very preconceived image and running it through the wide range of evolutionary potentials that the machine allows is the fundamental way in which I have worked throughout the Nexus DNA concept. Sometimes, as happens with pen and paint, I have struggled for days to get the first true concept out; only after that can I allow the thing to develop a life of its own. I have occasionally tried to jump past this part of the process by allowing the machine to "jam" from the scraps I've provided but it always looks hollow to me — the idea is just not there.

"This is the shortcut that is the downfall of much computer art, in my opinion. The machine and all its accompanying toys are available but unless there is an artist involved and a struggle to make something that was not there before, there seems no point. I do not believe that flicking a switch is the root to creating a powerful image. All effects currently in existence can only add a surface finish — they cannot create the bones of that image and without a skeleton or framework everything collapses. A computer can bring out the best in an artist and vice versa, but both have to be present at the encounter.

"I am part of a generation of artists that has healthily shed its early awe of computers and, as in my case, has returned to the basic rules of picture-making: idea — composition — light. I repeatedly advise people that they should learn to draw before they even go near a computer in order to have tools of their own to

bring to the creative process and to avoid the beast pushing them around the minute they start attempting to create with it."

## INTO THE THIRD DIMENSION

Having struggled to find his own style within the 2D environments of software such as Photoshop, in the summer of 1997 Steve started to wrestle with the real challenge of 3D with software such as 3D Studio Max

*Braveheart* (above) and *Horn Queen* (right), from *Nexus DNA*, Archangel Press, 1998
**Digitally created**

The term "sketch" refers to grayscale images such as these. Free from the concerns of the subtleties that color brings to the process, Steve can put the basic composition together and remind himself of the power that a black and white image can convey.

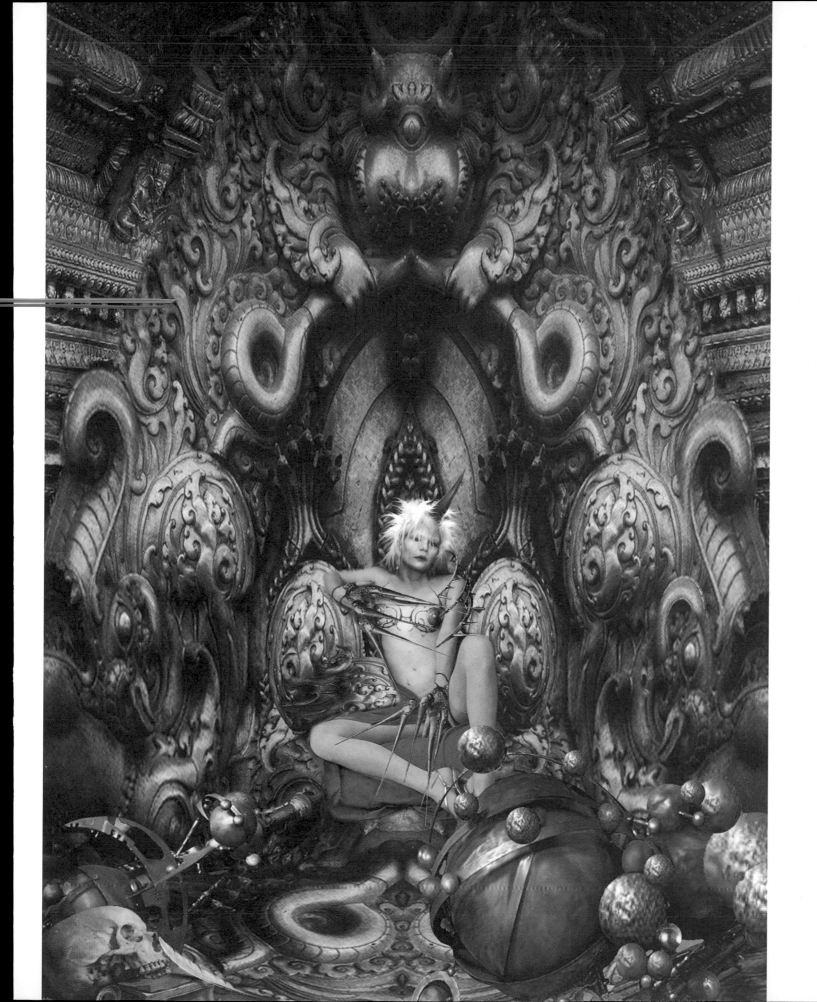

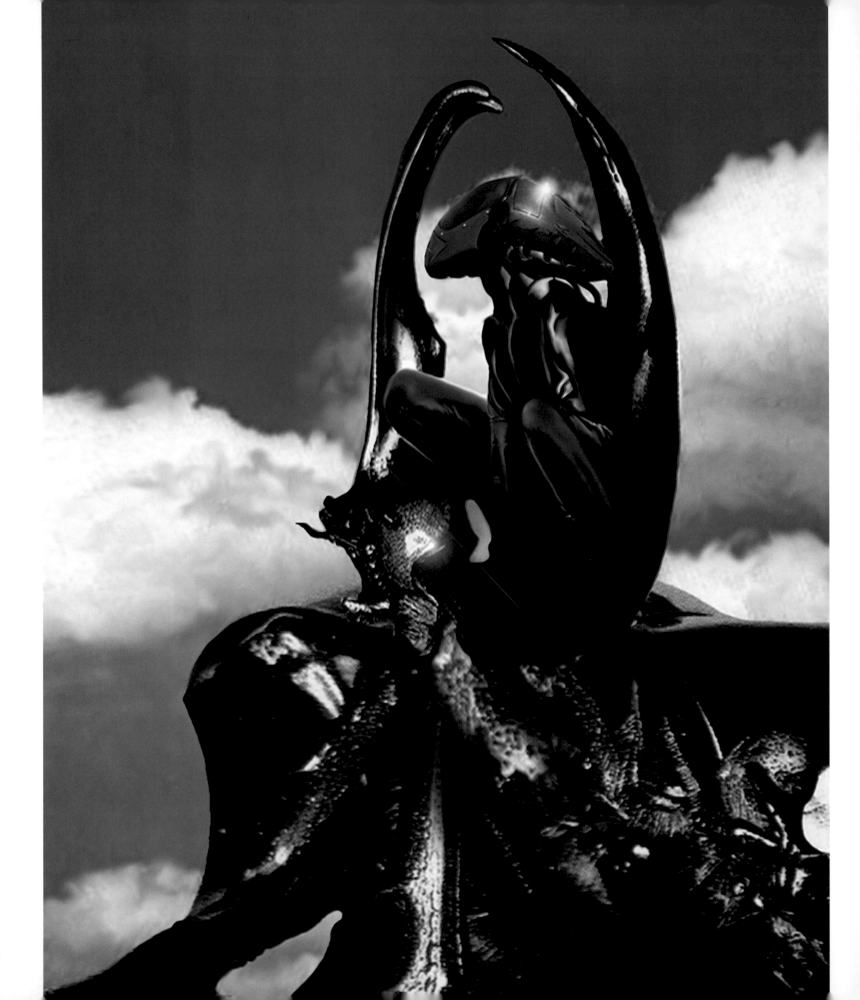

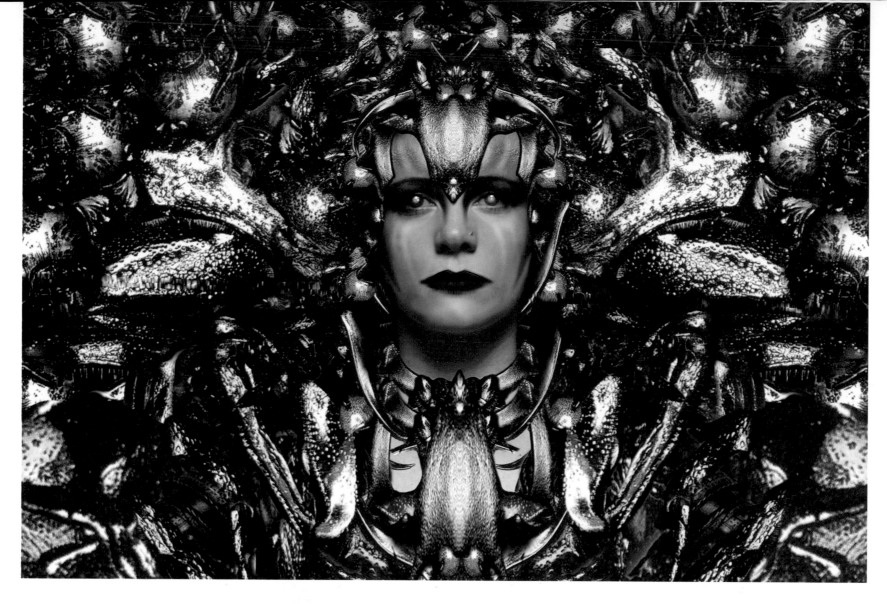

and Lightwave. In this area the ability to remain distinctive seemed almost impossible to achieve. It has proved a even longer slog to start to breathe life into the 3D experiments with the Nexus imagery.

Three-dimensional objects can exist within a computer as well as in the outside world of reality. An object can be built using a wire frame and then, with a process called rendering, a skin or texture can be wrapped around the object to give it realism.

"The modelling of three-dimensional objects always seemed very important to me if I were ever to be able to realize my ideas fully. Not only would I have access to a digital model that could be posed in any manner required until I had exactly what I wanted, but it would also give me the facility of animation I desired, one of my early influences being Disney animations.

"There are, however, major problems for me when working in three dimensions, the first being the time it takes. Building and rendering a single model can still take me weeks, and many of the jobs in advertising and publications have deadlines for completion of work that

**Opposite and left:** *Black Widow* 1 & 2, **developed from a core image created for the Zero role-playing game, Archangel Entertainment, 1997**
**Above:** *Wasp Queen* from *Nexus DNA*, **Archangel Press, 1998**
**All three images digitally created**

Once again the image progresses across three years. Initially, the biomech widow sits on a organic hillock watching the clouds sweep by (opposite). A year later, after the computer has repeatedly mutated the landscape, a change of focus and a new direction is indicated, requiring a more fitting storm-filled sky to be added (left). Finally, a new approach (above), using the same textures but this time dictated by the more formal constraints of a portrait. Aren't tarantula spider samples the most flexible little things?

*Gold*, unpublished, 1998
**Digitally created**

Here a central three-dimensional rendered figure has been given a new look within Photoshop and drawn into the overall design. The satisfaction of having such a pliant model is almost always weighed against the inordinate length of time and therefore cost such 3D models take to create.

*Hivetank*, Zero role-playing game, Archangel Entertainment, 1997
**Digitally created**

"This has to be one of my favorite creations, as I tend to like the environmental pieces – they suggest a whole world to me. It was created for the US-produced roleplaying game Zero, for which I designed the color plates for the manual as well as the entire look and feel of the game world. The game was ideal for my particular visual fascinations, with the players cast in the role of outcasts from a hive of cybernetically enhanced far-future human beings. The building that is featured here and places such as the badlands of Dakota both served as powerful inspirations in this project. I love to find places where I feel as if I am in another world."

would never allow such indulgence. The time element involved in 3D modelling also makes the whole process very expensive and many art directors aren't interested in the manner in which an image is created as long as it has the effect they require. If I can produce the commission in 2D to the required level there seems to them to be no need to spend five times as long working up a complete creation in three dimensions.

"Despite the limitations of some of my current briefs, however, I have devoted all my research and development time to 3D imagery, some of which has started to become the basis of my more recent work. Certain elements in the pictures begin life as three-dimensional models which are then transported into Photoshop to be given a photo-real surface as opposed to a computer-real look. I think this 3D approach will become more and more important as time goes on."

## CLOSING THE CIRCLE
In the summer of 1998 this 3D research came to the attention of another of Stone's early influences. Frank Frazetta Fantasy Illustrated in New York approached him to produce a comic strip from a storyline of his

own. The story, "Strange Cargo," required almost every aspect of design to be rendered in 3D.

"With this project there was a new discipline to be adhered to. The visuals had to be slave to the needs of the narrative, although I obviously developed a storyline that would allow for a lot of visual treats – it felt like a return to film-making. I think many people will just think this strip is clips from a film, which is a mistake many have already made with my pictures in general."

As film-making took Steve from his first love of drawing, painting and sculpture into computers and the rave scene, so computers have taken him back to painting, sculpture and film-making which he has unravelled to use in a new artistic endeavour, the comic strip, which ironically was his earliest visual influence.

"I feel as if I am travelling through the same circle over and over again in my life, but each time it is a different ride. Now I feel as if I am living somewhere between all the disciplines I have been involved with over the last 15 years or so. My art exists somewhere between painting, cinema and computer artwork. However, I think my ideas from now on will always begin life as an empty screen rather than a blank canvas."

*Strange Cargo*, **Frank Frazetta Fantasy Illustrated, 1998**
**Digitally created**

"The story described the struggle of a cyber superpower to obtain a box that contains the ultimate weapon capable of ending the war they have been fighting for thousands of years. They believe the contents of the box will give them the ability to extend the war forever. Their whole culture is based on war – they have no desire to see it end. The box contains the last traces of a force that could take the people of the galaxy beyond war into peace. It is 'love' – that is the Strange Cargo.

"The strip was achieved with perhaps the most ambitious combination of photographic and 3D elements I have yet attempted. The environments and figures were achieved using a combination of physical models and 3D 'film sets.' The whole thing was turned into the finished pictures in Photoshop."

# Fred Gambino

*"I have had people ask me what I use, expecting to hear of exotic software and hardware. The truth is that it is what you do with it that counts and there is still no substitute for good ideas and traditional drawing skills."*

Fred Gambino's interest in SF was prompted at a young age by the TV shows of Gerry Anderson, his earliest memories being of *Supercar*. Because of the limitations of the puppet characters Anderson was forced to concentrate on the machines in his shows, so it was the hardware that became the hero. The programs always seemed far too short to the young Fred so he spent hours drawing all of them, from there progressing to Dr Who. Eventually he started to design his own hardware.

The *TV21* comic, which featured all of his favorite Anderson characters drawn by some very good artists, formed another part of his childhood inspirations. "Some of the influence of those artists can still be seen in my compositions today, particularly the way I like to slant my horizons for dramatic effect," he says. It's ironic that the original impetus for his sophisticated computer modelling and digital painting should come from wobbly puppet shows and the equally unstable sets of the BBC's only science fiction show of the 1960s!

Today, Fred works at home but tries hard to keep to office hours. However, the pressure of deadlines means that it is not unusual for him still to be bathed in the light of a VDT well past the midnight hour.

"My nine to six routine is left over from the days when I rented a room from a photographer. I preferred working in a busy professional environment like that, which I found much more conducive to concentration. I miss the input from other people; one person there, Nigel Gibson, an extremely talented photographer who is probably an SF illustrator himself in an alternate universe, was very useful for bouncing ideas off, so much so that the concept stage almost became a team effort. Now I work from home I miss the company during the day, but at night and at weekends it is much better to be at home rather than in a deserted studio."

## OUT WITH PAINT, IN WITH PIXELS

For nearly 20 years Fred worked in acrylics, but about four years ago he felt he had seen the writing on the

***Brightness Reef* by David Brin, Little, Brown, 1996
Acrylics on board, 40.5 × 51 cm (16 × 20 in)**

This was created in Fred's pre-Mac days. Even though much of his output is now generated on the computer he continues to paint because each approach has its own satisfactions.

wall and bought a computer. For some years he had often worked long hours seven days a week, and whenever he finished a particularly gruelling job during which he might barely leave the studio for a fortnight he would feel as if he had been released from prison. He felt the computer might free him from this, but more importantly it seemed that this digital approach was the future and he should be at the forefront of it.

He found this new direction quite a leap in the dark. He knew no one who was engaged in the kind of work he wanted to do, but he did know that an AppleMac was the platform of choice for creative folk. At that time the first PowerMacs had only just been released, and Bryce, a landscape-generating program now installed on nearly every aspiring illustrator's hard drive, was in its first incarnation – the local Apple dealer had never even heard of it. A move into digital

## BIOGRAPHY

❖ Fred Gambino was born in Derby in the late 1950s. He studied graphic design at the Kedleston Road School of Art and Technology (now Derby University). While there he saw an exhibition of Chris Foss's work and this persuaded him that science fiction illustration was the career he wanted to pursue.

❖ Upon leaving college he earned a living delivering groceries in the morning and worked on his painting in the afternoons. During this period he was introduced to David Larkin at Pan Books, who liked his work and offered much useful advice.

❖ His first commissioned cover was *Beneath the Shattered Moons* in the mid-1970s.

❖ In 1984 he was awarded a contract with Orbit Books (then the SF and Fantasy list of Macdonald Futura, now that of Little, Brown UK). This allowed him to work not only with science fiction but also with historical romance, crime and children's books. However, science fiction remains his favorite genre to illustrate.

❖ Like many artists today, Fred has recently added computer-generated illustration to his accomplished techniques with acrylics and airbrushing.

❖ He lives with his partner Jenny in Belper, Derbyshire.

❖ Website:
www.users.globalnet.co.uk/~fredgamb

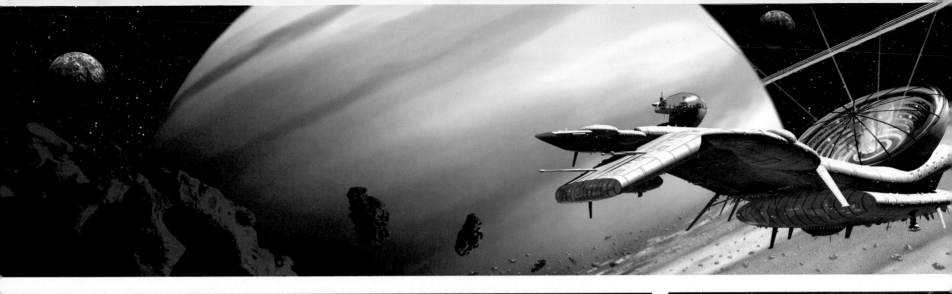

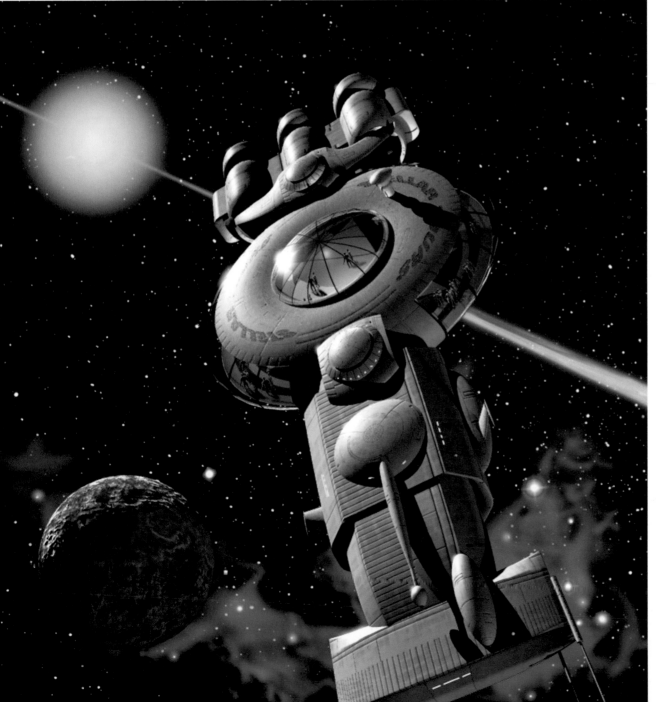

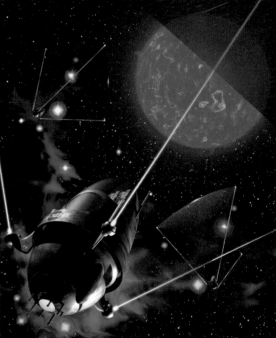

**Top:** *The Memory of Whiteness* by Kim
Stanley Robinson, Voyager, 1998
**Digitally created**

**Above:** *Lightsail*, United States Postal
Service, 1998
**Digitally created**

In 1998 the U.S. postal service commemorated
the space program. To make stamps attractive
to children, a booklet was produced containing
a short story about teenagers travelling to real
destinations in space. On the way they try out
lightsailing and pass a pulsar.

**Left:** *Pulsar*, United States Postal Service,
1998
**Digitally created**

If you look carefully you will see that the
observation deck is the same as the *Gravity
Failure* image (see page 120). It is in fact the
same model, viewed from within.

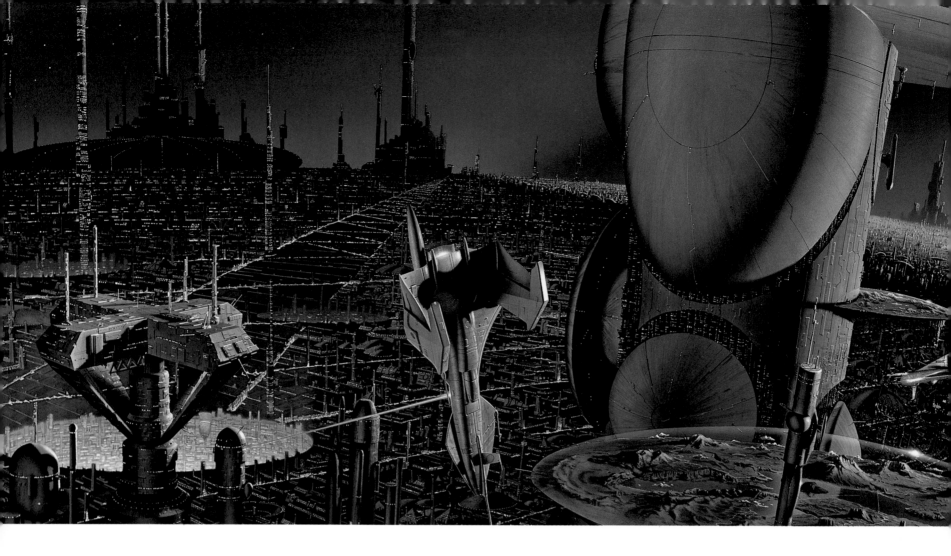

work represented a large financial investment and Fred could only justify it if it was going to pay for itself. Add to this the fact that he was almost totally computer-illiterate and it is easy to understand why he thought long and hard about it. He needn't have worried, however, as from the outset he was fascinated by the machine and the logic of the applications. He found all his older skills applicable to these new techniques and took to working with them like a duck to water.

## IS IT A PACKET? IS IT A BOTTLE? NO, IT'S A SPACESHIP

"The creative process always followed similar lines for me. First, I would read the manuscript, book or synopsis, then do rough pen or pencil sketches followed by a color rough that went to the client.

"Upon approval, I would seek out the necessary reference, photograph any figures that were needed and, in the case of hardware pictures, make model spacecraft out of whatever came to hand, light them in the studio and then photograph them. I would often wander the local supermarkets looking for unusually shaped bottles that might form the basis of a spacecraft or futuristic building. The spacecraft in the middle of

one of the *Foundation* series paintings began life as a bath salts bottle, for example.

"I acquired a huge collection of bottles, model kit parts and bits and pieces of all kinds that could be recycled into futuristic modes of transport or habitation. Imagine my delight, then, when I found that working on the computer turned out to be very similar."

The concept stage still begins with paper and a pen. Sometimes Fred will fax the pen drawing, but nowadays he may scan it into the computer and color it in using Photoshop. This image-manipulation program has been designed with airbrush artists in mind and most find it very natural to use after a short time. However, it also has a wealth of other color and image correction tools that rapidly become invaluable.

"These days I invariably send color roughs by e-mail, something that makes the price of the computer worth it in itself. It still amazes me that I can send stuff to clients in the USA and discuss it as we both look at the image almost as if we were in the same room."

## THE OLD ONES ARE THE BEST

"Once the rough is approved I still photograph any figures that are needed, but now I can build my

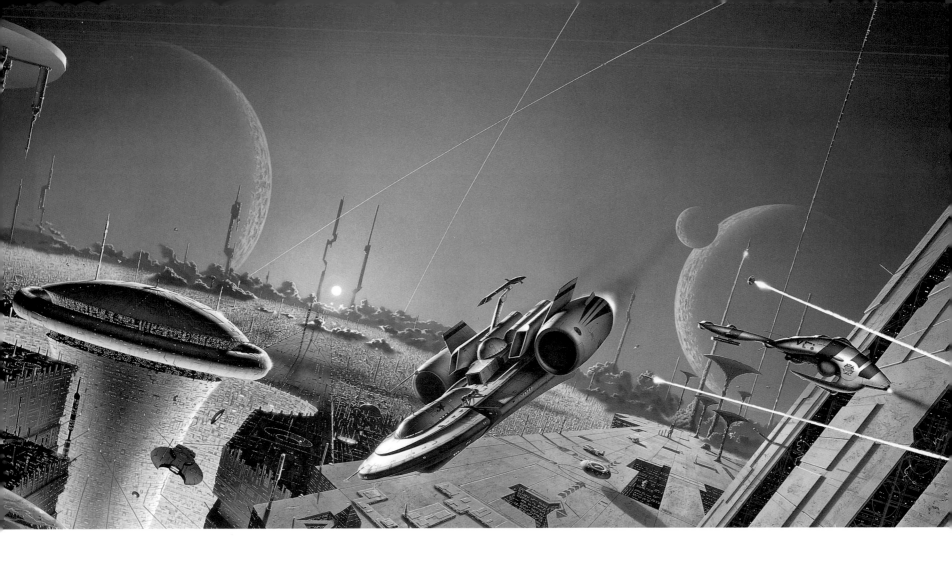

Opposite and above: *Foundation* series by
Isaac Asimov, Voyager, 1995–6
Acrylics on board, each painting
30.5 × 66 cm (12 × 26 in)

Two pieces were painted to create a future
vista of night and day. The publisher then split
them into six sections to use as jackets on
Asimov's six *Foundation* books.

### *Foundation* series

Fred's childhood interest in the Supermarionation
techniques of Gerry and Sylvia Anderson initially
resulted in him drawing his own fantasy hardware for
those shows. In later life it surfaced again in his habit of
building models from a wide variety of found objects to
use as reference material for paintings. Spot the heavily
augmented bottle of bath salts.

spacecraft in 3D modelling programmes. My preferred software is Alias Sketch, a program that was deleted about three years ago. I have looked for a replacement and have spent hundreds of pounds on software packages but none of them fit my needs as completely as Sketch.

"Anyone familiar with Photoshop or Illustrator could probably use Sketch immediately without a manual and the quality of the render, albeit a bit slow by today's standards, is still second to none in my opinion. Although the modelling is also limited by comparison with late-1990s standards I am so familiar with it that I doubt there's much I couldn't build in it."

## IT AIN'T WHAT YOU'VE GOT, IT'S THE WAY THAT YOU USE IT

"This brings me to an interesting point. There seems to be a search out there for a digital Holy Grail, that

elusive bit of software that will do it all for you. It's disappointing for some to find that it doesn't yet exist – nor will it ever. I have had people ask me what I use, expecting to hear descriptions of all manner of exotic software and hardware. The truth is that it is what you do with it that counts and there is still no substitute for good ideas and traditional drawing skills. An analogy I sometimes draw is that of the modern camera. These days cameras can deal with all the technical aspects of calculating exposure and focus and it is very difficult to take a technically bad photo with them, yet people still take bad photographs."

## THE VIRTUAL STUDIO

"Once I have designed and built the spaceships in the computer, I texture-map them and then light them in what is in effect a virtual photographic studio. Again

*Ringing the Changes* **by Robert Silverberg, Voyager, 1996**
**Digitally created**

"The techno wizard is my friend Nigel (below), aged by about 40 years. The texture on the wall came from a piece of slate scanned straight in."

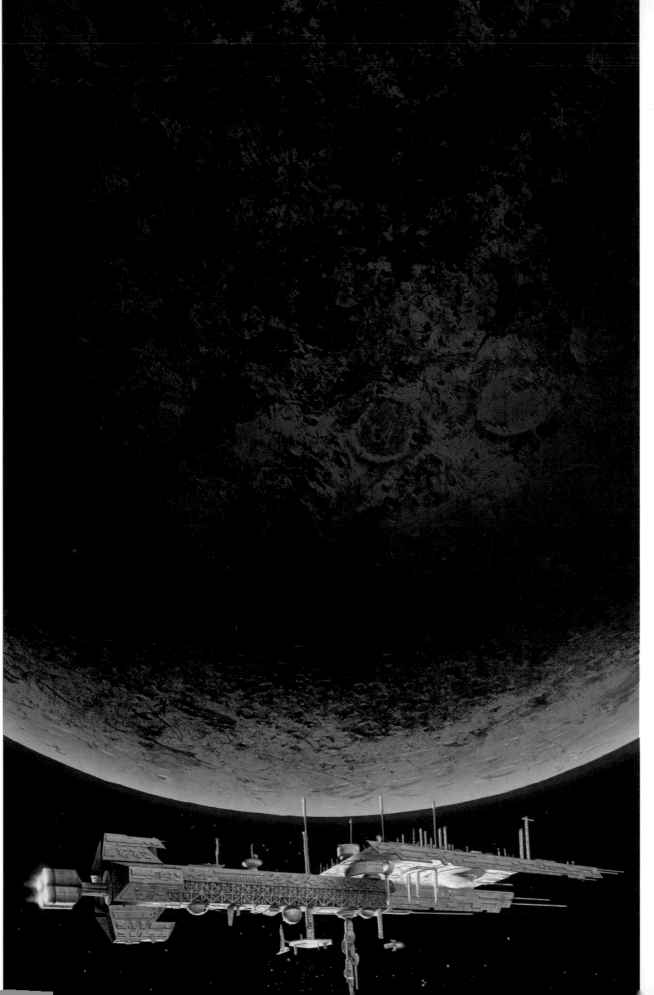

***The Vor Game* by Lois McMaster
Bujold, Pan, 1994
Acrylics on board, 40.5 × 30.5 cm
(16 × 12 in)**

The face that launched a thousand Gambino
moons. The moon's surface was initially
created by dipping tissues in paint and
literally throwing them at the board. The
resultant mess was worked upon to become
one of the most convincing cratered effects
Fred has ever created. So satisfied was he
with the result that this texture has now
become the standard starting point for the
texture of all his moons.

119

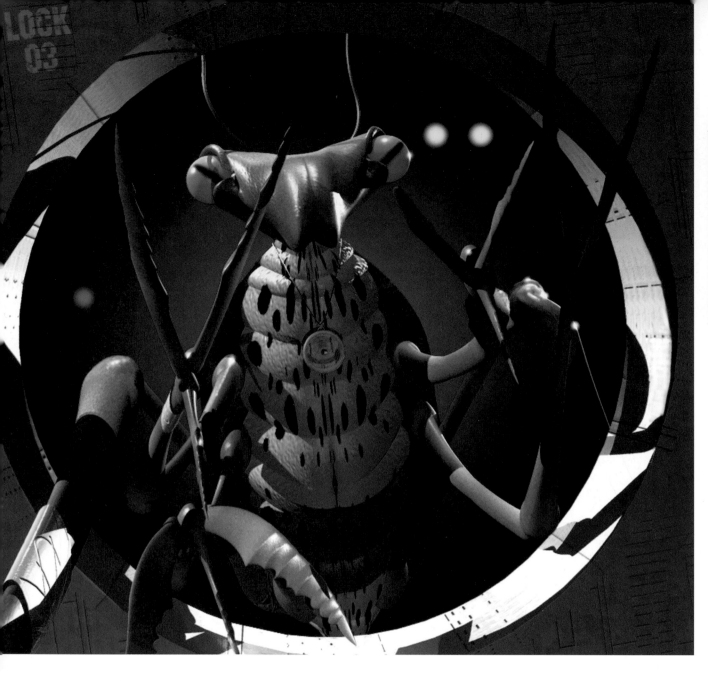

***Gravity Failure*, United States Postal Service, 1998**
**Digitally created**

Another in the series for the US postal service.
This one went through many incarnations as
e-mails went back and forth to Washington.
Because of the tight deadline some elements
had to be recycled from previous jobs and the
android can also be seen piloting the air car on
the Silverberg cover *Ringing the Changes*.

***Bug*, United States Postal Service, 1998**
**Digitally created**

The whole image is modelled in Sketch except
for the fuzzy lights in the background, which
were dropped in using Photoshop.

the process is very similar to the real world and I
immediately felt at home here.

"After all these parameters have been set, the
software paints the piece or, to carry the photography
analogy further, takes the picture. This can take several
minutes or several days, depending on the complexity
of the image. When all this is done, all the elements –
the photography and 3D models – are taken into
Photoshop, where I composite the elements and paint
all the atmospheric and special effects.

"The great thing about the computer is the ability it
gives you to make alterations and experiment with
different ideas ad infinitum, but this flexibility can be
a problem in itself. I sometimes find myself, at the
eleventh hour of a deadline, moving some element of a
picture half a millimeter to the right or left, unable to

decide which of these microscopic changes improves the
image most."

At the end of it all, Fred still enjoys the process of
painting and can see no reason why the two methods
shouldn't coexist. Recently, having worked solely on
the computer for six months, he collaborated with his
good friend Chris Moore on a project for Mattel Toys
which required paint and brushes.

"Chris reminded me what a pleasure it is to move
paint about on a board and I left the project with a
resolution to paint more covers, though some very tight
deadlines have made this difficult to do. However, I
still see myself painting into the foreseeable future.
Apart from the fact that each approach satisfies me in
different ways, some subjects lend themselves more to
painting than to digital rendering and vice versa."

***Boarding*, United States Postal Service, 1998**
**Digitally created**

"My agent in the states, Francine Rosenfeld at Bernstein and Andriulli, was due to come to England and we would have met for the first time had it not been for the fact that I was going to the Worldcon in Baltimore the same week. She suggested that I should send her a photograph instead, so I sent her this – I'm the one on the right."

## BUT IS IT ART?

"I'm slowly going full circle at the moment and painting rather than modelling the landscapes. I prefer the more painterly look achieved this way. The advent of faster computers makes this process more natural and I suppose with the approach of the gigahertz computer and more sensitive digitizing pads, painting on the computer will be as near to the real thing as dammit. For me this will be a great advance – all the flexibility and uniqueness of a painting but with none of the associated hang-ups.

"As long as the image does the job required of it I don't think it's important how it's created. If I were producing landscapes to hang on a wall, they would have to be painted; the clients in that area want something unique. But my clients' main concern is whether or not the art will sell the product. Once the thing is in print it's irrelevant how it was created as long as the end result is exciting and original and moves the product.

"I've had it said to me, 'Oh, now there's computer technology you don't need to be an artist.' Nothing could be further from the truth. All the old skills still apply. It's easy to see which images have been produced by people with artistic talent and which by those who have simply learnt how to use the software.

"I've been gratified by comments that there is little difference between my digital images and my earlier paintings. At a science fiction convention in Baltimore where I exhibited both acrylic paintings and digital prints, some people thought they were all digital. The computer is just another tool, and should sit alongside the airbrush and paintbrush to be used when necessary."

## ALIEN CITADEL

"The process involved in the creation of this piece can serve as a beginner's guide to the basic stages and programs involved in 3D rendering within a computer.

"I started by designing the basic shape of the citadel in a 3D modelling program called Amapi. This program contains basic shapes – cubes, squares, circles, globes – which can then be extruded into the shapes required by widening, narrowing, duplicating and overlapping. When I was satisfied with the basic wire frame skeleton of the object, this work was saved in DXF as an interim stage compatible for transfer into other art programs.

"A landscape in which the wire frame building could sit was the next stage, so it was then copied into Bryce, a program specifically for generating landscapes, in this case a desert and skies as well as other atmospheric parameters. It was at this stage that the wire frame had its surface applied.

"To create the foreground objects, I then used a more flexible modelling program, Alias Sketch. This not only modelled the ships as wire frame objects but also rendered them. Once I had designed the objects and chosen a light source this program decided what they would look like in the given conditions, effectively painting the picture. The images were combined, positioned correctly and checked to ensure the light and shade on the ships was compatible with the background details from the earlier programs.

"When the various images had been composed to my satisfaction they were transferred into Photoshop, a painting program, for special effects such as engine glow and lightning to be added. Using the digital paintbrush, airbrush and other painting effects, the image was given the final makeover and was then sent to the publisher on a hard disk for downloading."

**Left:** *Alien Citadel*
The basic shape of the citadel in a 3D modelling program called Amapi.

**Right:** *Alien Citadel* **by Douglas Hill, Pan, 1998**
**Digitally created**

The finished image, created by a combination of the programs Amapi, Bryce, Alias Sketch and Photoshop.

## TITAN'S SKY

"This was one of seven illustrations done for a children's booklet produced by the U.S. postal service to accompany stamps commemorating the space programme. All seven of them had to be produced in three weeks and at the time I had a lot of other tight deadlines to meet. Before I had the Mac I would have had to turn the commission down – and even with the Mac it took a good deal of working into the small hours to meet the delivery date.

"Because of this the artworks were virtually done as I went along, although I did have approval on very skimpy pen sketches. I would e-mail work in progress to the client and say 'What do you think of this?' or 'I'm not sure this is working.' He would then telephone me and as we both looked at the image we would sort out various solutions to any problems. It was as if he were in the same room rather than on the other side of the Atlantic, and this aspect of the computer revolution still amazes me.

"This was the first in the series to be completed. Because these were interior illustrations it was not necessary to leave space at the top for type as I need to do for covers – a refreshing change. The scene shows the father and son characters in the text looking at Saturn from Titan's surface. A colony outpost is visible on the plain below. Originally I depicted Saturn's rings edge-on, as they would be seen from Titan if it were possible to see Saturn through Titan's atmosphere, but the client felt that artistic license should be allowed in order to make the rings more apparent. I had a friend pose for the figures wearing gauntlets and then built the suits in Sketch to match. Both the clouds and foreground rocks are painted in Photoshop, although the distant plain was rendered in Bryce."

***Titan's Sky***, **United States Postal Service, 1998**
**Digitally created**

Because there was to be no type running across the image, Fred was able to make full use of the vertical space and fill it with a dramatic view of the planet Saturn. Each major element was modelled and test-rendered separately before being transferred into Photoshop (below).

## HEAVEN'S REACH

"I had already done several of David Brin's covers before I bought the Mac and just as I acquired the computer I received six more books to rejacket. At this stage of the game I hadn't the expertise to do finished work but it was very useful to have these jobs to design on the Mac. I then ran a printout and used that as reference to paint from, something I still do today when I paint with acrylics.

"I had submitted a rough for a previous Brin cover that was very similar to this. It wasn't deemed suitable for that particular novel, but it was suggested that it might be suitable for the upcoming *Heaven's Reach*. When the manuscript arrived, I realized that with a few alterations it would be. However, the manuscript proved such an enjoyable read and so full of brilliant imagery that I felt compelled to submit more roughs. It is a joy to have such a manuscript to illustrate – all too often one has to trawl desperately through novels to find something dramatic enough for the cover.

"Despite all this, the original rough was chosen. The rough in this case was almost as good as the finished image, as I chose to build all the models first to get the perspective right. Although this is time-consuming, especially if the rough doesn't get approval, if it works the artwork can sometimes be finished in a day. As it happens, this one took about a week to do because so much of it was painted freehand in Photoshop.

"The starscape is one that I have used often – indeed for all my starscapes since its inception. It started life as a speckled white pattern, produced using a toothbrush dipped in paint, on black card. This was my preferred method of rendering stars in the pre-Mac days and it produces a truly random pattern, something that no software can yet do. It was then scanned into Photoshop, where the stars were given a slight orange glow. The subsequent file was saved into my textures folder and used many times since. This is another advantage of the computer – you can endlessly recycle such material, and it can be made to look different every time.

"Likewise, the cratered texture on the moons was sampled from one of my paintings of a cratered planet. I created the texture by dipping tissues into paint and literally throwing them at the board. The resultant mess was worked upon and produced one of the most convincing cratered effects I have ever made. This texture has become my standard moon finish. Textures that have been produced in this way also have the advantage of being unique.

"The nebula was painted in Photoshop with the neutron star modelled in Bryce. It was heavily painted over using Photoshop's airbrush tool. Although the main

blue ship, which is the Streaker in the novel, was modelled for this job, the other two ships were previous models recycled for this image. By now I have dozens of models built in Sketch and these, or parts of these, can be used and edited endlessly. It's all very reminiscent of my precomputer days, but far less messy."

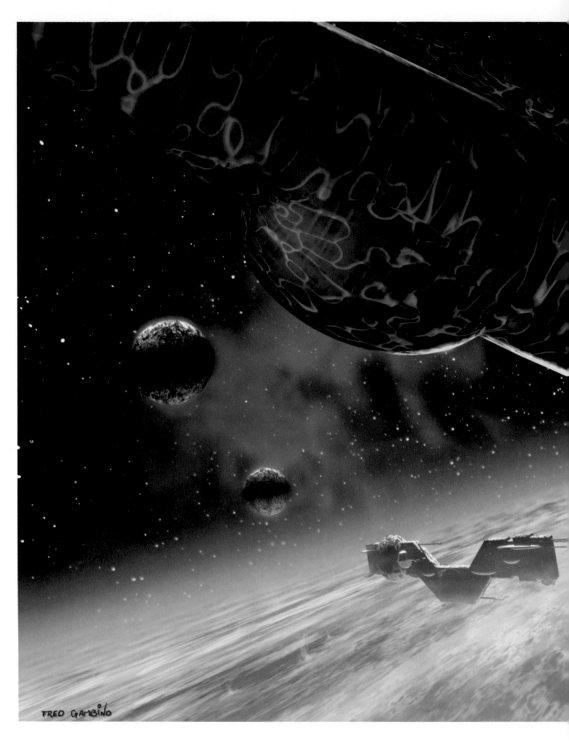

*Heaven's Reach* **by David Brin, Little, Brown, 1998**
**Digitally created**

More than half of this picture was to be hidden beneath text. It's the curse of book cover illustration.

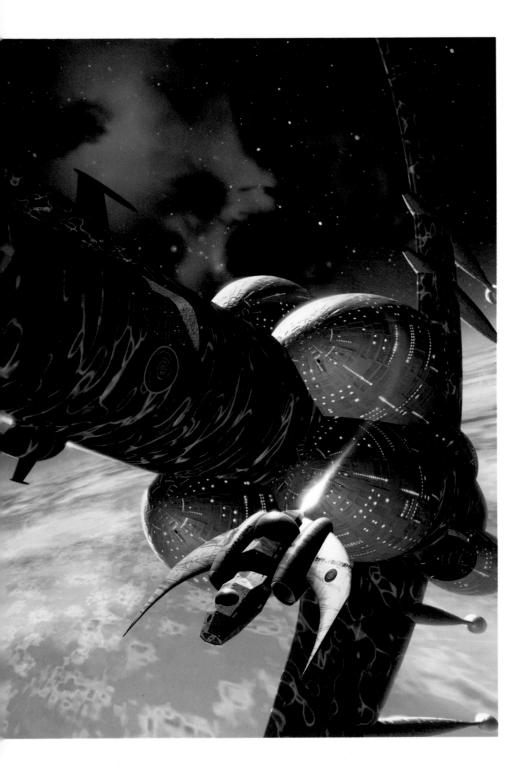

*Heaven's Reach*
*Screen grabs*

Working in Alias Sketch wire frames and test renders establishes the shape and basic coloring – the digital equivalent of drawing and color roughs – before the images are finally rendered in much greater resolution and dropped into Photoshop for composing and the final painting stage.

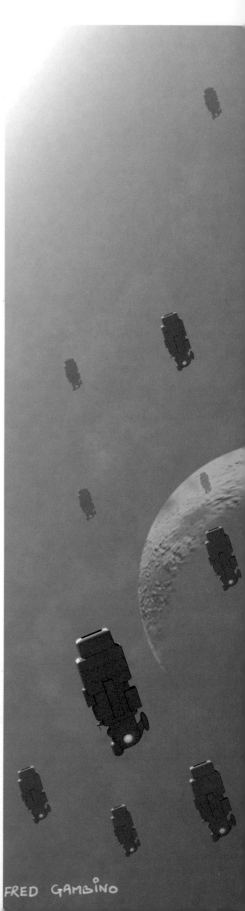

## NIGHTWINGS

"Again, this is part of a series begun before I had the Mac. I had already done several Robert Silverberg covers for HarperCollins, who were one of the publishers more receptive to the idea of digital images when I started. My first digital cover, *The Road To Nightfall* by Silverberg, was done for them. In fact I really cut my digital teeth, so to speak, on the Silverberg series.

"*Nightwings* is one of Silverberg's most famous novellas and it has had many covers done for it, some of which are hard acts to follow. I felt that the invading fleet thundering overhead with the vulnerable image of the girl throwing herself upward would make an intriguing cover. I did the initial rough using Poser, which is a program for generating human figures. Originally designed as an adjunct to Painter, it has now become a program in its own right, but although it is interesting it still has a long way to go before it can be used for finished images. I find it useful for visualization, particularly when such a dramatic perspective as this is required. However, while it is easy to get the Poser figure throwing itself into the air, it proved more difficult to achieve this using real people.

"My first attempt involved getting the model to lie on the floor with her back arched over cushions, thinking that shooting across her horizontal body would enable me to get the very low angle needed. I tried to do this in my dining room, which left me very strapped for space. The model had posed for many of my covers in the past and so was used to being asked to do some peculiar things. She did not pose topless, but I reasoned that I could remove her bikini top in Photoshop later."

## GRAVITATIONAL PULL

"When the photos came back, the first problem I saw was that because of my lack of space I had been too close and the perspective was too forced. Secondly, because she had been lying down, gravity had been pulling things in the wrong direction, and try as I might I could not get the breasts to look right in Photoshop. There was only one thing to do — reshoot the whole thing, in a large studio, with a topless model. As I had already paid for the model, I was anxious to save money and so I asked a male model I had used recently if he thought his girlfriend, also a model, would do it at a reduced rate. I had seen photos of her and thought she would be fine.

"Unfortunately, when she arrived it was evident that there had been a certain amount of overindulgence since the photos were taken, and that she was now a couple of stone overweight. I hadn't the heart to tell her, so I did the shoot anyway and paid her. At the back of my mind I thought I could perhaps salvage the situation in Photoshop, but when the photos came back one look told me I was in trouble. Then, running out of both time and money, I did what I should have done in the first place and hired a topless model through an agency. She was brilliant — she had a superb body and was also a dancer. I had her stand on a table and on a count of three she threw her head back and arched her back as much as possible.

"When the photos came back I composited the chosen one with the starships I had modelled, this time in Amapi, a 3D modeller that I really like for its intuitive interface. It is a modelling program only and so had to be rendered out in Sketch. I had been careful to match the lighting to the figure photography.

"Only two different ships were modelled — the remainder were duplicated using Photoshop. What would have taken days to paint I can now achieve in minutes. I had to do a fair amount of work on the figure, including adding the wings and bits of jewelry. I was a little ambiguous about scanning the photos straight in to begin with, even though they are my photographs. I feel that you can always see that it is a scanned photograph and in recent works I have taken to painting over the photograph, completely obliterating the original, using Photoshop's painting tools in much the same way as I would have painted it in acrylics. This results in a much more illustrated look and avoids me feeling I have cheated.

"Although this character flies naked in the book, I felt that W. H. Smith's [a UK bookstore chain] probably weren't ready for full-frontal nudity. In truth, I was surprised that the amount of nudity portrayed here was allowed, as SF covers have shied away from what some might consider politically incorrect images in recent years. Both the jewelry and the strip of cloth between the girl's legs were modelled in Sketch. Any shadows cast on the body by the jewelry and clothing were added by hand."

**Nightwings by Robert Silverberg, Voyager, 1997**
**Digitally created**

The finished picture (far right) and the photo reference (near right).

FRED GAMBINO

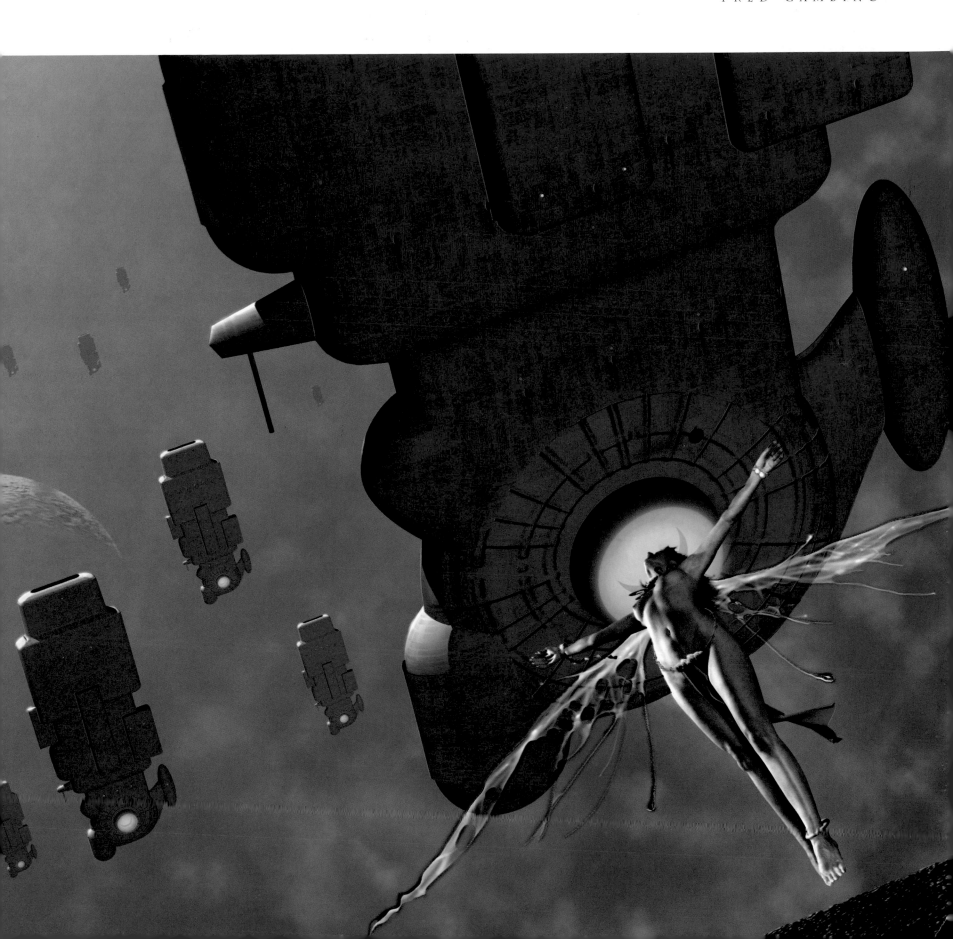

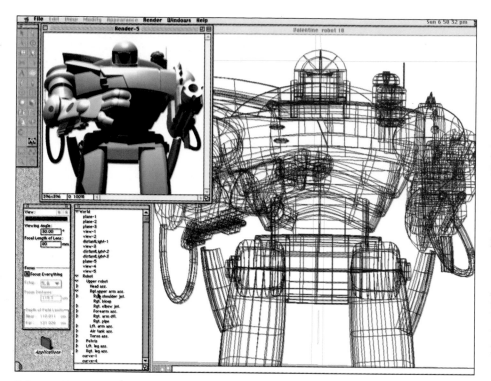

**Valentine Robot**

The wire frame and render develops pencil roughs into a 3D image ready for painting in Photoshop.

*Valentine Robot*

A variety of ideas trying to marry the concepts of science fiction and St. Valentine's Day. The rose held in the metal hand proved to be the pivotal idea.

## VALENTINE ROBOT

"The brief was to come up with an SF image with some kind of Valentine connection. I drew seven very quick black-and-white marker sketches and faxed them as a basis for discussion with a view to doing more finished roughs later. As it happened the client approved one of them and told me to go straight to finished artwork.

"I then did a slightly more finished drawing to establish the design of the robot before moving on to modelling. I had the idea that the robot should be based on an exaggerated bodybuilder, so I gave him huge shoulders, a small head and no neck. I tried to visualize how he would articulate with those large shoulder joints and came up with the idea of the flaps which would hinge as the arm moved. He was great fun to do.

"The first version had a smaller rose to emphasize the robot's scale, but this was to be printed in a small panel on the front cover, finished size about 4 inches [10 centimeters] square, and the art director felt that the rose would be unrecognizable at that size. Because this is a digital image, an alteration that would have taken a day using traditional methods was achieved in seconds.

"The bullet-sprayed wall was produced by applying acrylic gesso primer to a board and then airbrushing at an angle so that the texture was picked out by the spray. I hammered a screw into the board for the bullet holes. This background was then scanned in and further manipulated in Photoshop.

"Interestingly, my first attempt used the background the other way up, but I felt it was somehow not working. When I turned it round what had previously looked like raised plaster now looked like pits and hollows and worked much better. The bullet holes at the bottom also helped to improve the composition, running as they now do from one arm to the next. The rose was a black and white Polaroid shot by my photographer friend Nigel Gibson, colored in Photoshop.

"The success of this image depends largely on its contradictory content, with the huge, aggressive robot leaning forward to proffer a delicately held rose. I've had people working out different scenarios as to what's happening here and so I feel that it must be doing the job it was designed to do – namely to intrigue the viewers and persuade them to buy the book.

"I try to do this with all my images, with varying degrees of success, and hope that the medium does not get in the way of the message – the fact that it was done digitally is completely irrelevant. The flame and smoke coming out of the gun was suggested by Chris Moore and adds an extra bit of drama to the whole thing."

*Valentine Robot*, for the anthology *Asimov's Valentines*, Berkley, 1998
**Digitally created**

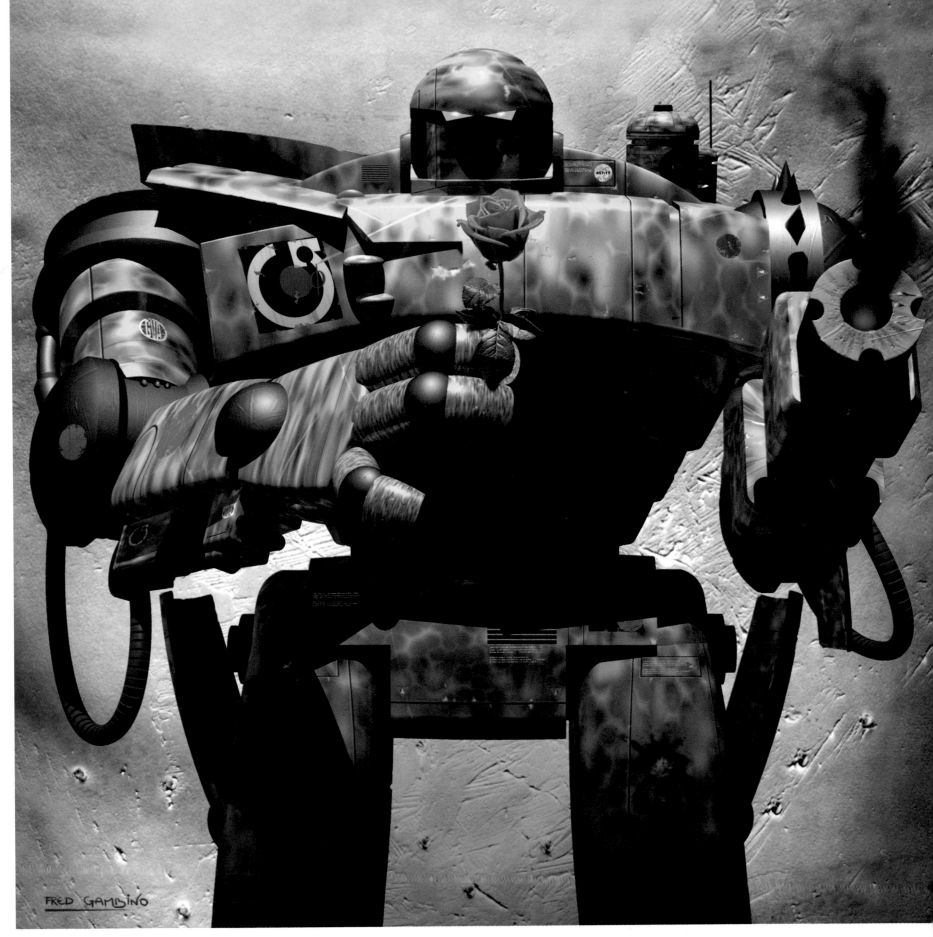

# Dave McKean

*"I've lost the will to paint literally. I don't see the point in worrying away with a paintbrush trying to reproduce a literal photographic texture like cloth or skin. Paint is best at being paint."*

It was immediately apparent upon the release of *Violent Cases* (Titan, 1987), the first collaboration between Dave McKean and writer Neil Gaiman, that two major new creators had announced their presence and outlined an agenda to contribute something new to the tired and predictable comic format. Here was a comic with no testosterone-drenched superfolk beating one another up in an ultra-violent ballet rendered with varying degrees of skill and printed in a simple three-color process. Instead the reader was presented with a near-monochrome sequence of subtle words and pictures relating the narrator's claim that as a child he met Al Capone's osteopath, hence the title – a twist upon machine guns in violin cases.

The images were particularly striking: careful, controlled and produced in a startling variety of techniques – collage, pencil, oil pastel and photocopy – a rather heady mix in comparison to the normal practice of the artist's pencils being inked by someone else to be then passed over to a third person for coloring. Here was an artist with a very personal vision who was prepared to use procedures rarely seen in comics at that time to bring these pictures to life.

## A DIARY OF DREAMS

The artistic collaboration of Dave McKean and Neil Gaiman continued with the graphic novels *Black Orchid* (DC/Vertigo, 1991), *Signal To Noise* (Victor Gollancz, 1992) and *Mr Punch* (Victor Gollancz, 1994). Dave also provided every cover in Neil's Sandman comic series over a period of nine years and the recently published collection of these pictures, *Dust Covers* (DC/Vertigo, 1997), allows the full range and development of this inquisitive and restlessly creative artist to be tracked. An extensive range of techniques and approaches is displayed in what is effectively a diary of Dave's growing dexterity, showing three-dimensional assemblages of everything from rodent skulls to watch components, model-making, painting, collage, drawing and typographic design all pulled together and further

**Panels from *Cages* by Dave McKean, Kitchen Sink Press, 1996
Pen and ink**

Just four panels from the 3850 drawings, paintings and photographs that form the graphic novel created initially as a series of 10 comics and finally published in its collected edition in 1998. Not only were the design and illustrations entirely the work of McKean but he also wrote all the words, a creative accomplishment which is still a comparatively rare event in the field of comics. This justly celebrated achievement was officially acknowledged when McKean's work won the Harvey Award for Best New Comic in 1992, two years into its creation, and the Alph Art award in 1999 after its publication in one volume.

*Empress – The Anthropomorphik Calendar*, **Off Beat/Alan Spiegel Fine Arts, 1996 Photography, acrylics, resin, copper dust and digital**

"This is one of a series of images that were created to reflect the seasons."

developed with photography. This work won the World Fantasy Award in 1991.

The addition of a computer to Dave's array of illustrative tools in 1994 meant that a visual makeover of some of his earlier work was inevitable. *Mr Punch* was the first work to be digitally revised and designed, the cover, which had already gone to the printers, being entirely reworked from scratch. Many of the Sandman covers were also processed and refined prior to the publication of *Dust Covers*.

The sheer range of technique and influences was far too great to be contained within the realm of the comics business and since 1990 Dave has designed, illustrated and photographed over 100 CD covers, including recent releases by Michael Nyman, Tori Amos, Real World, Altan, Toad the Wet Sprocket, Bill Laswell, Alice Cooper, Front Line Assembly and Bill Bruford. His work in this field was acknowledged in 1991 when he won the first International Amid Award for the best album cover of the year for Mícheál Ó Súilleabháin's *Casadh/Turning*, on Venture records.

As well as successful forays into the fields of comics, book and CD design, photography, writing and film and rock video direction, Dave has also pursued his interest in music. In 1996 he composed and performed, with saxophonist Iain Ballamy, the music for the BBC Radio adaptation of *Signal to Noise*, another collaboration with Gaiman. Dave and Iain Ballamy have now formed their own record label, Feral. Fortunately Dave works with his partner, Clare, and his studio is only a rickety bridge across a pond away from his home so he can occasionally find time for domestic and recreational pleasures.

## CREATION MYTHS

Irregularly and infrequently during the period 1990 to 1996 Dave wrote, illustrated, and designed the massive 496-page comic *Cages* (Kitchen Sink Press), a meditation upon the why and wherefore of existence and a reinvention of certain creation myths, a theme common to much of his self-penned work. The limited edition of *Cages* included a spoken word CD accompanied by improvised music from Dave and Iain Ballamy. A short film written and directed by Dave, *The Week Before*, pursues the theme of creation and toys with the premise that God created the world in seven days but only after he couldn't put it off any longer – after all, if God made us all in his image then he must have lackadaisical inclinations just like us.

"Throughout my twenties I constantly found myself trying new disciplines – photography, film, writing and computers. In each of these fields there was already an unimaginable wealth of creative work already out there and I needed to find a cohesive, unique voice of my own, partly to understand the world on my own terms and partly to be able to communicate those ideas clearly to others. This seems to me to be the basic reason for creating things – to look into other people's lives, to allow others to look into yours and for both to feel some sort of empathy. This is as close as I come to a religious belief, and it was the theme of *Cages*. I believe everybody creates their own god, that motivating force that gets you out of bed in the morning rather than that restrictive club that is all too often used as a tool of social control and a very effective means of closing down dialogue, the very lifeblood of creativity."

*A Part, And Yet Apart,* **Bill Bruford's Earthworks. CD cover, Discipline Global Mobile, 1998**
**Photography, acrylics and digital**

Three pages of the artist's sketchbook (below) show how the concept evolved. The key, locks and fruit ideas were all refined to take their proper relationships within the final picture.
  "The first ideas I had were rejected because they were too close to the previous cover I did for Bill, *Heavenly Bodies.* The idea for the image revolves around three members of the band who come from the jazz world, and Bill out there on his own."

## ON ILLUSTRATION

"There's a wonderful history of social activist art for today's artists to draw inspiration from. It is usually dismissed as wallpaper, but I think illustration can comment in a much more meaningful way upon a text than design, which is the current visual equivalent of pop music. In England there has always been a critical tradition in illustration, and the line between commercial and fine art is often straddled by artists like Hockney, Blake, Coe and Steadman with no self-consciousness whatsoever.

"I've lost the will to paint literally. I don't see the point in worrying away with a paintbrush trying to reproduce a literal photographic texture like cloth or skin. Paint is best at being paint. Paint can never be as perfect as nature when it is trying to imitate nature. It's a lost cause. Paint can only be as beautiful as nature when it *is* nature, when it is its own texture. Marks on paper have their own beauty, and it is this slipping from the literal world into the world of abstract qualities that I try to achieve in my work. If I need a shirt to look like a shirt, I'll scan it into my computer. If I want the shirt to feel like the wind, or like a constricting skin, or angry, or like a consoling embrace,

**Above and above left:** *Café des Amis*, postcards, Café des Amis, 1999
**Acrylics, pen and ink, photography and digital**

"Created for the best Mexican restaurant this side of Mexico – conveniently located in Canterbury – where I regularly write and work out projects over a Margarita. I offered to design their menus and since then have created many images as postcards and T-shirts. These images have much more of a handmade quality regardless of being finally processed through the Mac. They have a lighter feel in both the content and in terms of their creation in comparison to many of my digital images. Nevertheless, they also allude to the darker nature of much Mexican art, including Frida Kahlo's paintings and diaries."

then maybe it should be painted or drawn, as more of the emotion can be expressed that way.

"Photography is the definitive 20th-century art form. It's immediate and both technically complex while being happy-snapper accessible to all. It's the ultimate democratic media. I love the ambiguities of 'truth' and 'lies' that photography throws up, and the language that has developed that can be so easily distorted and manipulated to undercut expectations, and to, well, shock.

"I'm drawing a lot less now, so drawings have become quite precious to me. I used to comply with fans' requests to sketch their favorite character in copies of my books at conventions, but I have stopped doing this because I don't like the idea of all these meaningless, really rather bad drawings floating about with my name on them. When they were a tiny proportion of my output it didn't seem to matter, but now I want all the drawings I do to have some reason to exist."

## REVERTING TO PLASTIC

"I hated the idea of working on a computer, tapping away at a keyboard, not getting my hands dirty. In 1994 I finally gave in and signed in blood, buying a Mac. Now everything goes through the computer at some stage. Even if the image is originally drawn, painted or photographed, it will eventually be scanned. The control I get over the final composition, as well as technical things like ink density, make the computer an invaluable tool.

"I work in Photoshop almost exclusively, scanning everything rather than drawing directly in the machine. The odd thing I've found is that the more I work on a piece in paint or collage or anything physical, the more naturally beautiful it gets — that is, the more it mimics a natural process of ageing, staining, weathering, entropy. The layers of time are visible and give it life. However, the more you work on something just using

**The Citizen Shoe, 1998**
**Photography and digital**

"This is as close to a space ship as I get. It was commissioned by Nike but not used. The background is a fusion of three photographs on to which a 3D rendered foot was placed, with shadows painted in beneath it."

135

computer filters and drawing programs, the more it seems to revert to a state of plastic and loses its life. Suddenly you realize why it is that all modern cars look the same – they've all been computer wind-tunnelled to death.

"I hope my images work in the real world since they are anchored by the real world, not in some Daliesque dreamland. The important bit of the word surrealist is 'realist.' Surrealism for me is a filter through which I can look at, comment upon and try to make sense of the real world. Even though we know how a flower grows, I don't think that takes any of the mystery and strangeness out of the phenomenon – in fact I think it multiplies it. I don't see any reason to create airy-fairy spirity worlds to hide in when the one around us is so astounding, so totally open to infinite interpretations, so perfect."

## THE CONCEPT IS THE KEY

"No two images have the same beginnings. Sometimes the client has a specific brief which often needs to be clarified before it can work as a graphic image. Some images are entirely personal, inspired by places, people or overheard conversations. I always start by doodling on paper – basic shapes, abstracts, connections between things. Eventually I have what I hope is a clear and direct conceptual idea. This is always the key. If the idea is not accurate here, no amount of pretty picture-making can save it. It is also the focus that I always come back to if I start to doubt the value of the piece.

"I usually then elaborate on this central idea, trying to find the most succinct way of expressing it, and deciding how it should be made. This is normally very obvious. An image will obviously need a photographic approach or a drawn approach. Also the tone of voice should be apparent; a CD cover for an industrial noise band should feel completely different from a CD of Irish traditional music – and I'm not just referring to the content of the image. Every line and tone and color should abstractly feel like the music. This applies equally to use of type and other design elements. Commercial art is a fusion of the external requirements of the brief and my own internal bank of personal images that I continually revisit and develop. These images represent internal worlds for me. Masks, the body pierced by roots, keyholes and locks, wings and feathers, body markings/striations/textures – all express psychological states rather than literal situations.

"I try to keep a firm grip of a project all the way through, right from being involved in conceptualizing the work. I even write briefs for myself for my own

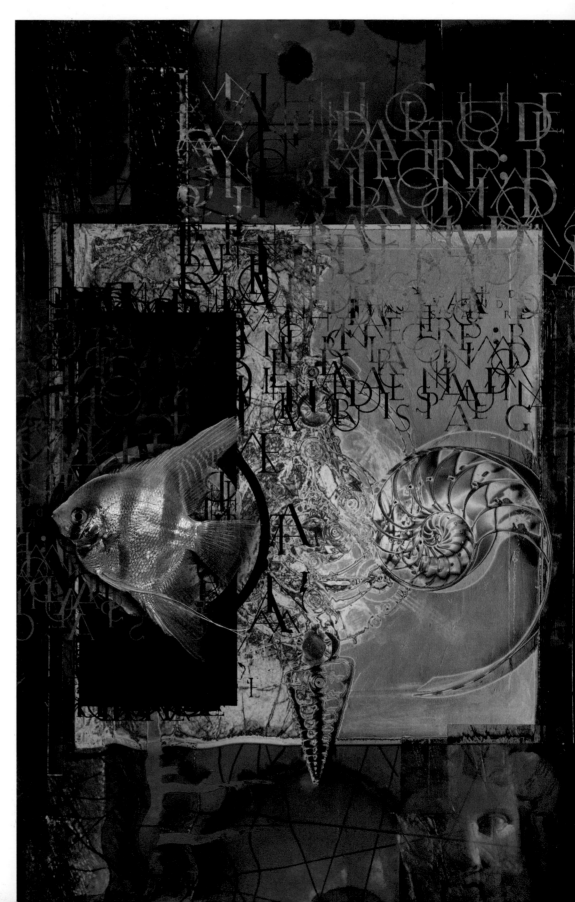

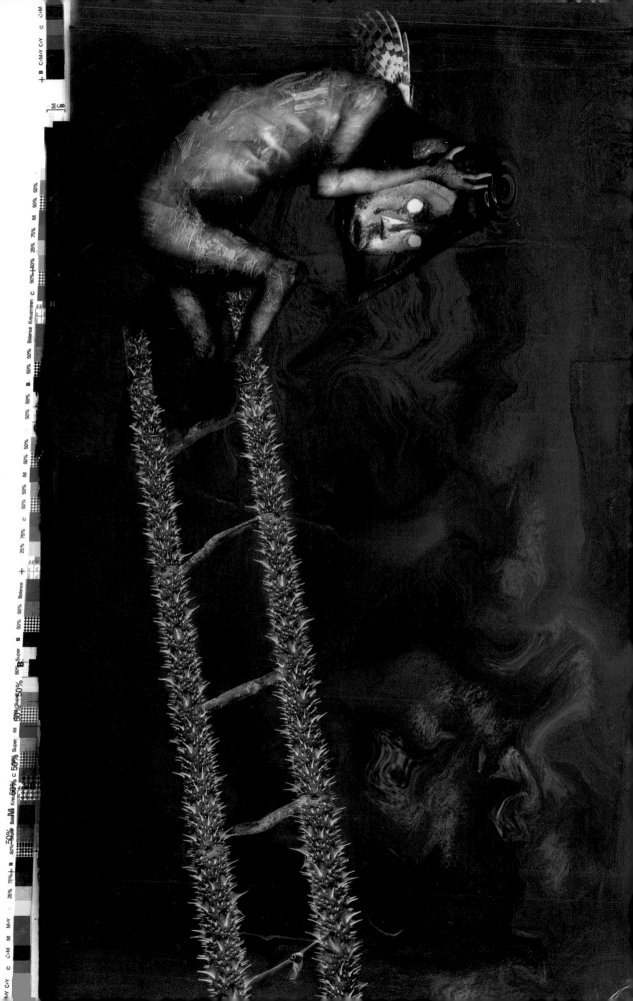

**Above:** *Dust Covers* **cover art, DC/Vertigo, 1997**
**Photography, sheet metal and digital**

The image is based on *The Librarian* by Arcimboldo (1565). The Sandman comic series created a fantasy soap opera from literature, myth, history and the dreams of its broad cast of characters. A library of dreams and unwritten novels is at the center of the Sandman's realm.

**Left:** *Season of Mists*, **from** *Dust Covers*, **DC/Vertigo, 1997**
**Paper collage, shells, photography, typography and digital**

"Originally *Sandman #26* (1990) and drastically reworked for the *Dust Covers* collection in 1997. The original version was just too awful to see print again so I made use of the fact that the computer can endlessly rework raw materials into anything desired – in this case revising a clumsy combination of photographic and print techniques with the fluidity and translucency available in the digital domain."

**Right:** *Vertigo Gallery*, **DC/Vertigo, 1995**
**Photography, rose stem, color bar, acrylics, ink and digital**

This image was the cover for a collection of DC/Vertigo cover art.

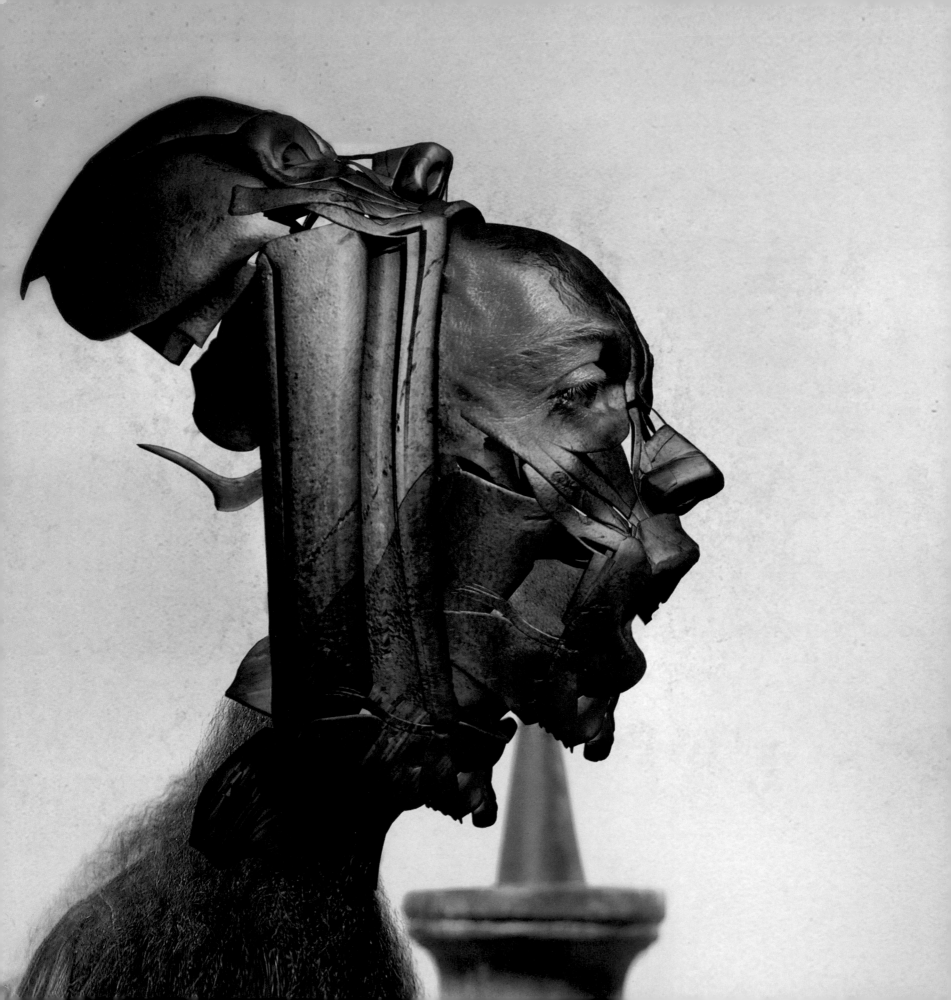

**FLAvour of the Weak, Front Line Assembly. CD cover, Offbeat Records, 1997 Photography and digital, plus pencil sketches**

"The band changed direction for this CD and the image reflected a move toward more organic textures as opposed to machine-created, hard-edged industrial music which had previously been the thrust of their CD cover design. I wanted to smooth hard edges and remove sharp corners, add more nature than factory. This echoes the current direction of industrial designs which are embracing natural forms and images inspired by insects' carapaces and chrysalises rather than the Bauhaus concrete formalities."

personal work in order to work out clearly what I want to say. Then comes the creation of the piece, taking my own photographs and reference and designing and integrating the imagery into the finished product, right through to the print stage. In the case of my self-published work, I handle the marketing and distribution too. I've found this holistic approach to be not only the best way of achieving the most consistent results, but also by far the easiest and most enjoyable way of working.

"Of course the final work only really has a life because of the creative tension between what the creator tries to communicate and what the audience interpret for themselves. The dialogue is the source of all the pleasure and pain. You can't really have one without the other."

## ON COLLABORATION

"At its best, collaboration is more akin to an ongoing dialogue. I've worked with Neil Gaiman for 14 years

**Opposite: *Feeding the Machine*, James Murphy. CD cover, Shrapnel Records, 1998 Photography and digital**

"A 3D computer model of a skinned face was texture-mapped with a sheet of rusted metal and combined with traditional photography."

***Nike Goat Boy,*
advertisement,
Nike, 1998
Photography and
digital**

"For this advert the
art director wanted a
simple portrait of a
Goatboy, which is
what he got, plain and
simple. I shot various
photos of a local goat
and blended elements
into the face of a
friend of mine, Tim
Hobday, who posed
as the boy."

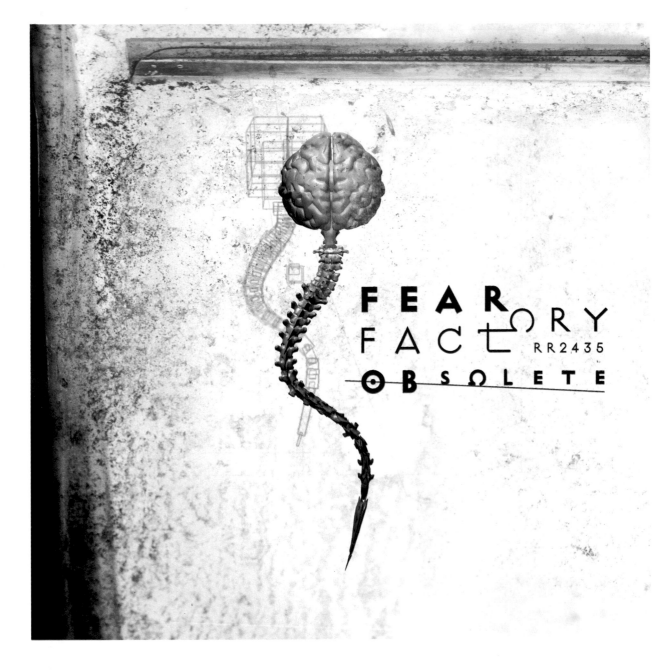

***Obsolete*, Fear Factory. CD cover, Roadrunner Records, 1998**
**Photography and digital**

"The lyrics on the CD were written from a hypothetical future – a computer's point of view trying to make sense of an extinct human race. I created several images [above and right] that looked like computer reconstructions of anthropological museum exhibits."

on Sandman and a variety of other projects and in the process it feels as if we've not only grown up together but found our own voices. Sandman, when read as a collection, feels like a lavishly illustrated diary since this work was produced on a monthly cycle across a period of eight years. By the end of the Sandman run there were no cover briefs and I wasn't reading the scripts because I was working well ahead of Neil's writing deadlines. Neil would phone me and talk about ideas for forthcoming issues and somewhere within the mulch of words I would find a picture. The relationship has developed across such a long time that where one of us

falters, the other can take the reins and drive the project forward. There is a shorthand style of communication between us and the kind of support one would more commonly find when collaborating with a fellow musician.

"I've worked with the writer Iain Sinclair on a book, *Slow Chocolate Autopsy* (Phoenix House, 1997), and a feature film, *The Falconer*. With him it's more as if I have been given a day pass to the city in Iain's head. Iain maps out this huge sprawling territory and I am the conduit that tries to find visual equivalents. Unlike working with Neil, where we mutually agree on the

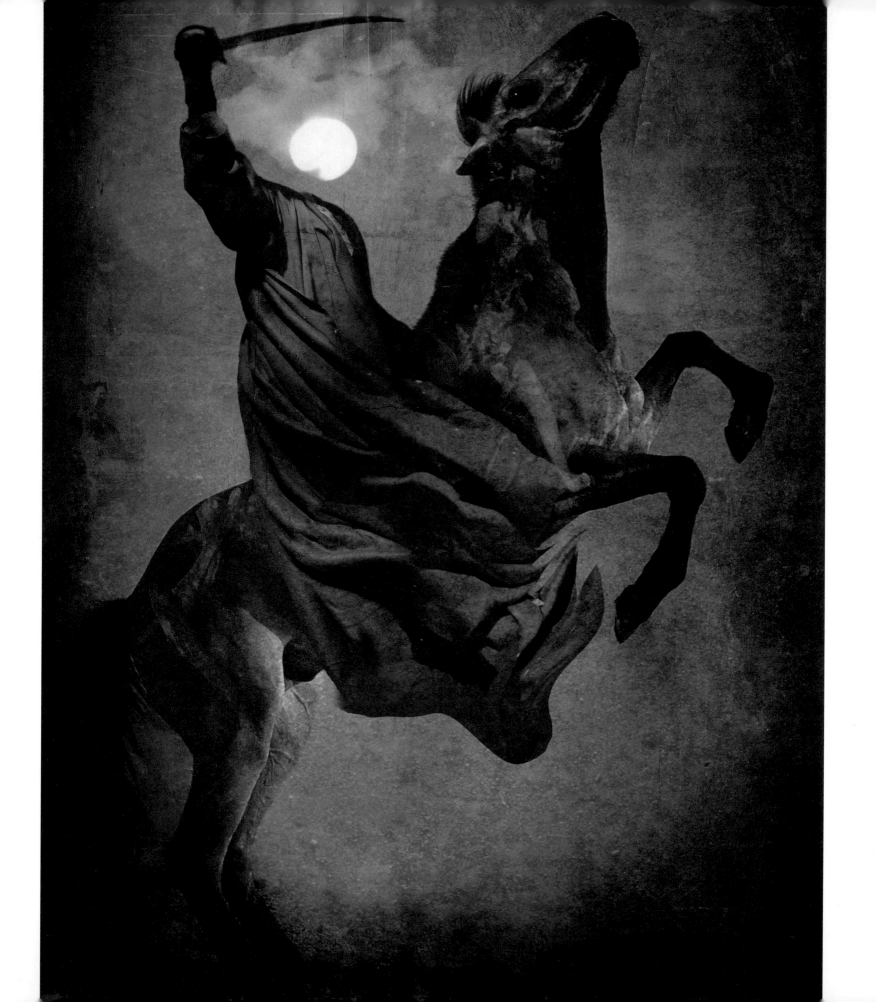

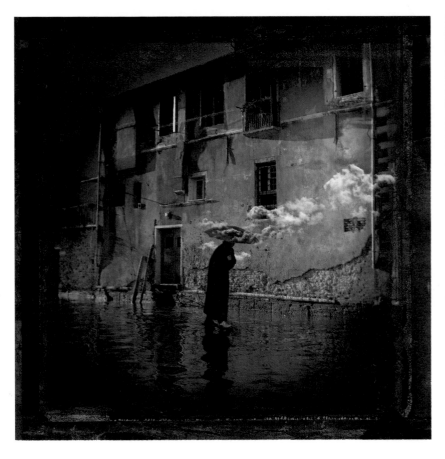 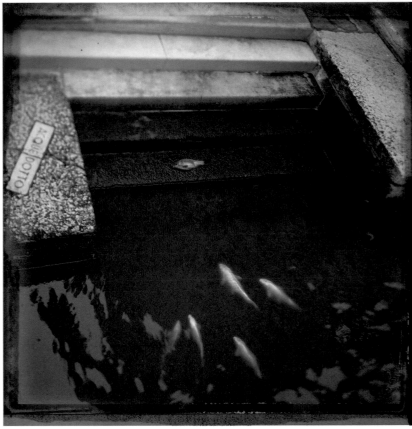

best possible end result, with Iain there is no end result – just a constantly changing state of reinterpretation."

## IN THE FUTURE

"The genres of science fiction and fantasy offer the best and the worst of culture. At their frequent worst they are reactionary escapist meaningless nonsense about fairies and space ships, fulfilling a desperate need for nostalgic childish naivety. The illustrations that accompany these works are similarly bland, crushed by literalness, obsessed by technique. The same old light-speckled airbrushy space thingies, the same old Penthouse pets in latex with alien attachments constantly reappear. It's all surface, no content or comment. If a sci-fi character walks through an airlock, I want to know what he's thinking and feeling, not how the airlock works.

"At its best, science fiction provides a place for imagination to speculate about life, looking at today from an odd camera angle, and with clear eyes. We are now living in sci-fi and fantasy – we can watch news and documentary footage of a mouse with a human ear growing on its back and what we understand about the building blocks of life are so much more bizarre and wonderful than anything in fiction. All that's left to do is to pictorialize how we feel about the world we find ourselves within.

"There seems to be more and more information around and less and less use for it. I still think the point to 'art,' high, low or indifferent, is to try to deal with this mess somehow. We will all become creative librarians, and the best artists will be the ones who know where to find the information. The ones who can weave the most convincing version of reality will find that reality wrapping around them as we all rush to the point where everybody gets a personal virtual life. You see it already in the monotone computer game experience, hundreds of TV channels, more music than can ever be listened to in a lifetime, niche markets for everything, the Internet view of life. I suppose my worry is that I only see life and art as having any value when it's between two people, not between one person and his or her machine – sex rather than masturbation.

"I don't want to be negative about the future. I do think that virtual life could represent a huge, and total, evolutionary jump. I also think it's important to have a positive voice in defining how this hugely powerful aspect of human life will be used."

*City 3* **(above left) &** *City 7* **(above right) from** *Option: Click,* **Alan Spiegel Fine Arts/Hourglass, 1998 Photography and digital**

Personal photographs combining shots of Venice with additional elements shot in England. The borders were created by microwaving Polaroids. "Different people interpret the world in different ways. I think in narratives – I can't help but imagine a story in everything around me. Even a single image implies a past and a future. I imagine the woman in *City 3* to be so distracted by her worries that she doesn't notice she's walking on water and I imagine the white fish in *City 7* shouting, 'What's it like out there ? Tell us,' as their cousin, the First Fish in Space, tries to catch his breath."

**Opposite:** *Sleepy Hollow,* **advance promotion poster, unused, 1998 Photography, acrylics and digital**

"This was created to promote Tim Burton's forthcoming film of the same name. Paramount Pictures spent several weeks experimenting with all manner of illustrative approaches but decided finally to use a still from the film. It's very difficult to get anything unusual through the Hollywood system."

# Bibliography

The following titles contain more pictures by the artists within this book.

*Infinite Worlds: The Fantastic Visions of Science Fiction Art*, Vincent Di Fate, Virgin Books, 1997.

*Spectrum: The Best In Contemporary Fantastic Art* 1–5, Cathy & Arnie Fenner, Underwood Books, 1994-8.

## ALAN LEE

*Black Ships Before Troy*, Rosemary Sutcliff, Frances Lincoln, 1993.

*Faeries*, Souvenir Press, 1978.

*The Lord of the Rings*, J. R. R. Tolkien (centenary edition), HarperCollins, 1991.

*The Mabinogion*, Dragon's Dream, 1982.

## DON MAITZ

*Dreamquests: The Art of Don Maitz*, Underwood Miller, 1993.

*First Maitz*, Ursus, 1989.

## BROM

*Darkwerks*, Friedlander Press, 1998.

## JIM BURNS

*Lightship*, Paper Tiger, 1985.

*Planet Story*, Harry Harrison, Pierrot, 1979.

*Transluminal*, Paper Tiger, 1999.

## RICK BERRY

*Double Memory: Art and Collaboration*, Rick Berry and Phil Hale, Donald M. Grant, 1993.

*Repent, Harlequin, Said the Tick Tock Man*, Harlan Ellison, Underwood Books, 1997.

*21st World Fantasy Convention Book,* 1995.

## STEVE STONE

*Nexus DNA*, Archangel Entertainment, 1998.

*Zero*, Archangel Entertainment, 1997

## DAVE McKEAN

*Black Orchid*, DC/Vertigo, 1991.

*Cages*, Kitchen Sink Press, 1998.

*Dust Covers*, DC/Vertigo, 1997

*Mr Punch*, Victor Gollancz, 1994.

*Option:Click*, Hourglass/Alan Spiegel Fine Arts, 1998.

*Signal To Noise*, Victor Gollancz, 1992.

*A Small Book of Black & White Lies*, Hourglass/Alan Spiegel Fine Arts, 1995.

*Violent Cases*, Titan, 1987.